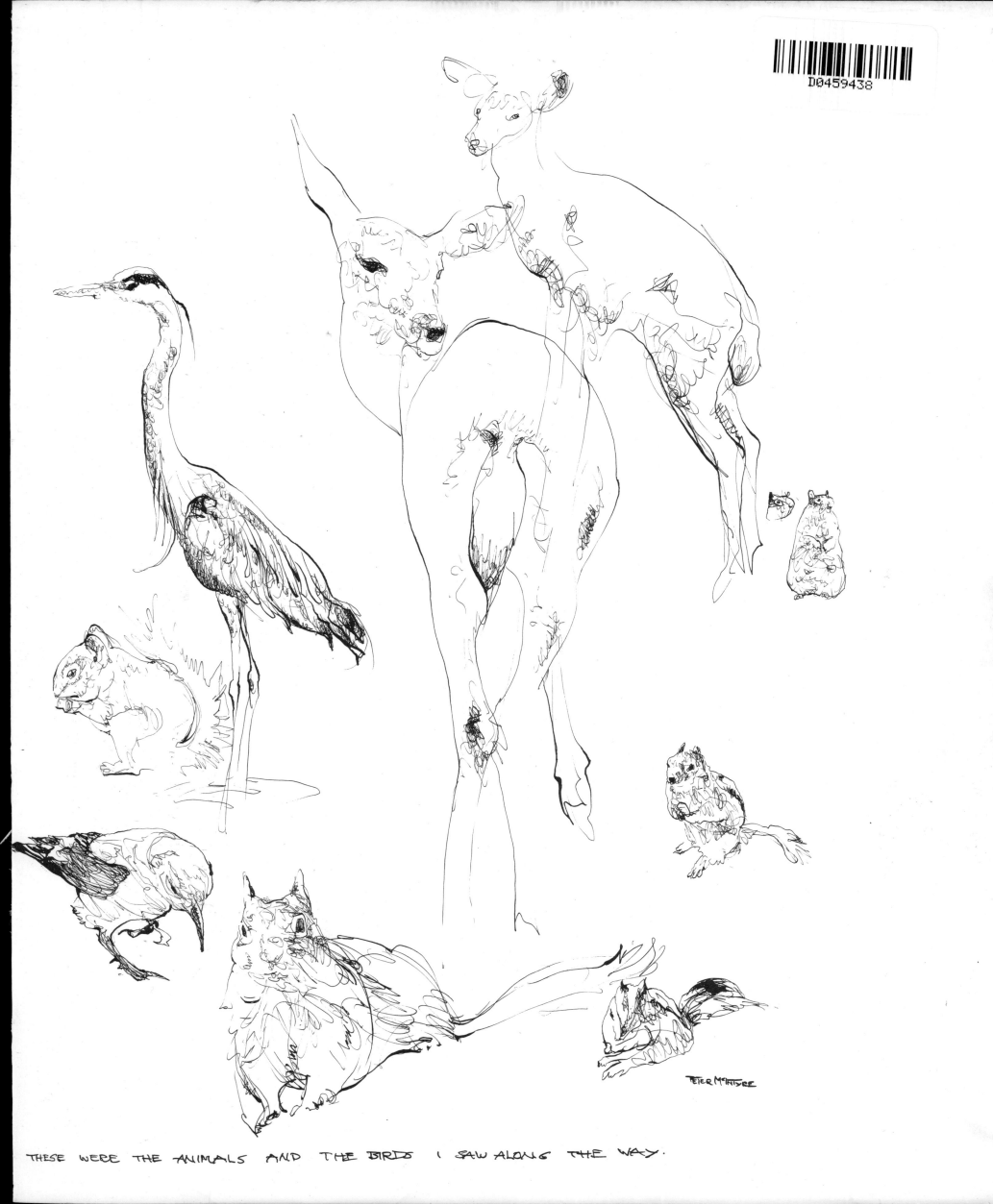

THESE WERE THE ANIMALS AND THE BIRDS I SAW ALONG THE WAY.

PETER MCINTYRE'S WEST

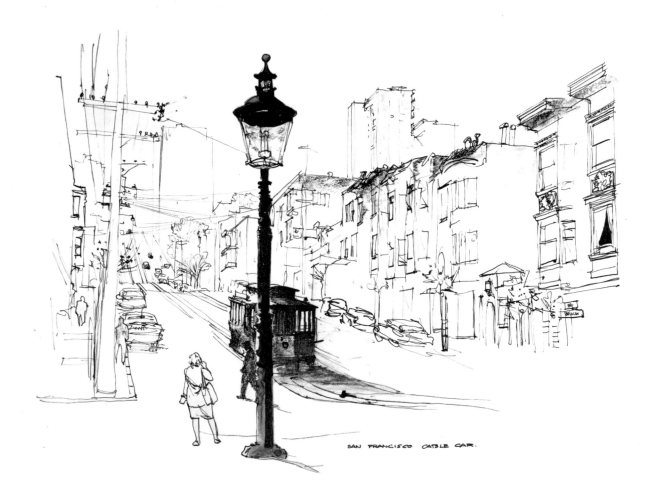

SAN FRANCISCO CABLE CAR.

PETER McINTYRE'S

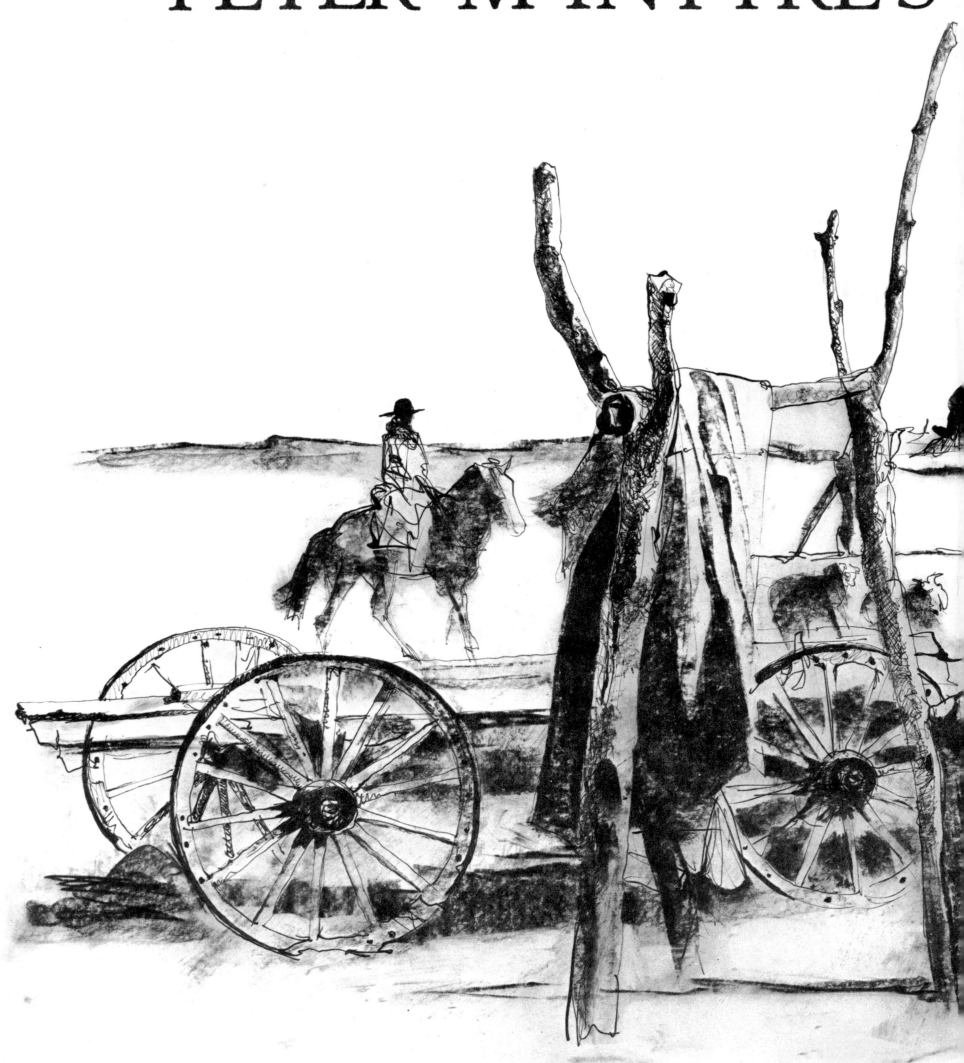

WEST

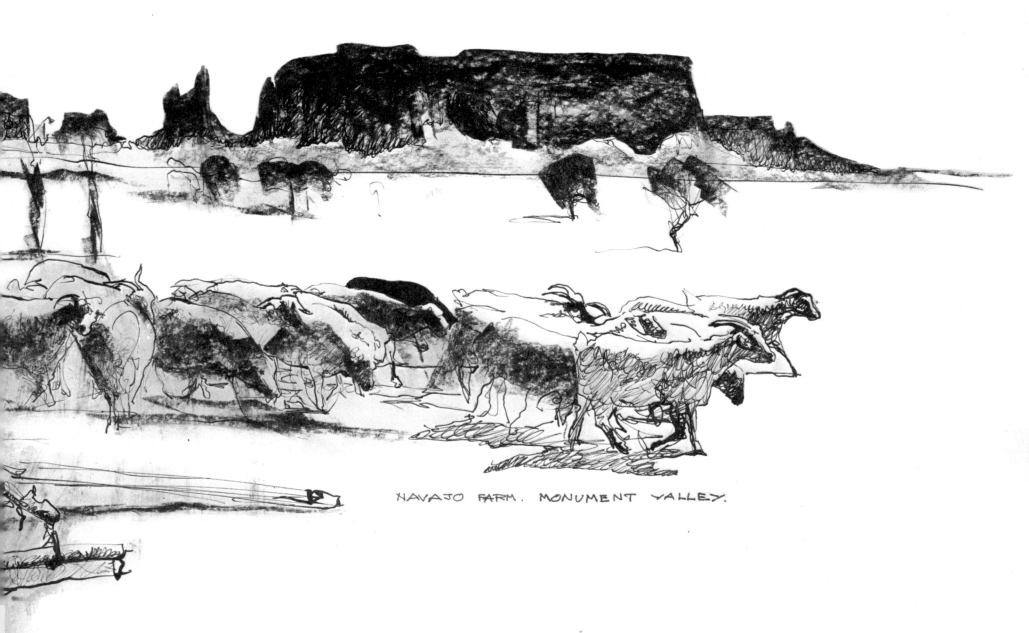

NAVAJO FARM. MONUMENT VALLEY.

LANE MAGAZINE & BOOK COMPANY • MENLO PARK, CALIFORNIA

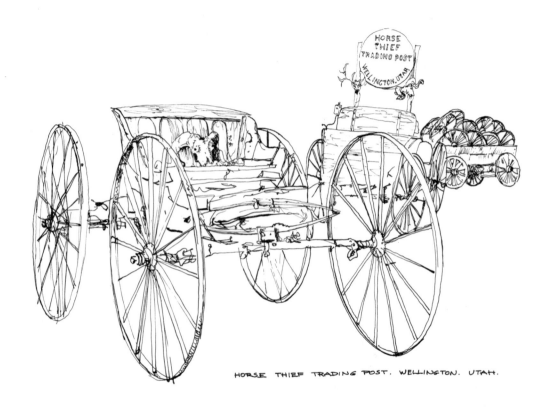

HORSE THIEF TRADING POST. WELLINGTON. UTAH.

TO SIMON AND SARA

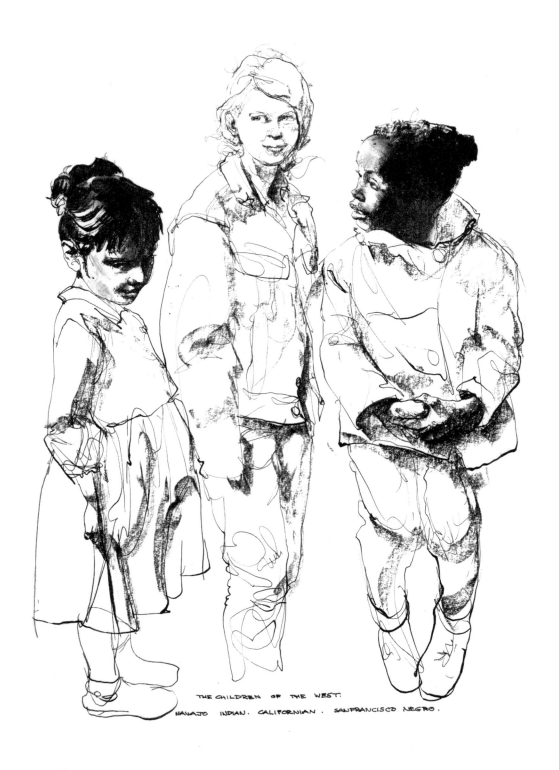

THE CHILDREN OF THE WEST:
NAVAJO INDIAN. CALIFORNIAN. SANFRANCISCO NEGRO.

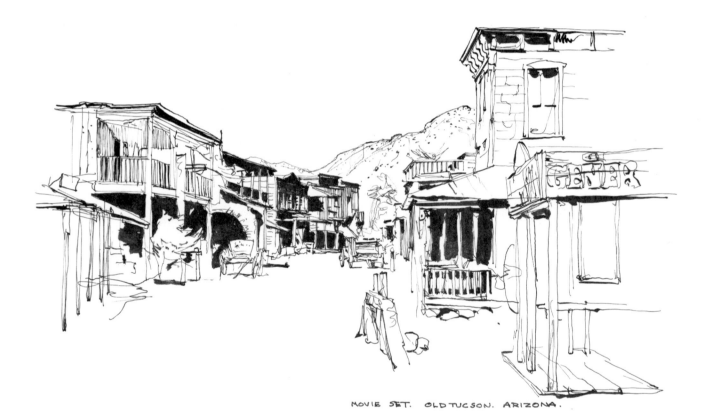

MOVIE SET. OLD TUCSON. ARIZONA.

THE COLOR PLATES

THIS INCREDIBLE WEST

WITH MY WIFE PATTY, I had come to the United States from New Zealand to paint and write this book on the American West. Our journey of discovery was to take us as far south as the Mexican border, east to New Mexico, and as far north as Alaska—a journey covering somewhere around 20,000 miles.

We were in San Francisco, and somehow you just can't set out on such a trip without some sort of dallying. When Dick Gump, an old friend, said, "Come to the ball game," I did—to the very first baseball game of my life. We play cricket in New Zealand, but for years I'd read up on American baseball. I could tell you those bits and pieces about ballplayers, like the time Brooklyn fans were goading Casey Stengel, and Casey hid a sparrow under his cap, stepped out onto the mound, and doffed the cap. Out flew the sparrow, and Casey had given Brooklyn the bird.

But I'd never really seen a baseball game. What happened that day at Candlestick Park? Gaylord Perry threw his no-hitter. Dick said that he'd been to five-hundred and seventy-six baseball games and this was his first no-hitter. It was mine too.

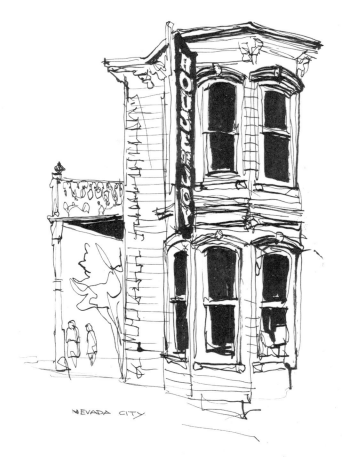

NEVADA CITY

OVER THE GOLDEN GATE and away. It's quite a feeling, with 20,000 miles ahead of you, and by evening Patty and I were sitting cosy in a bar that hangs out over the Truckee River in Gardner Mein's River Ranch, which has since changed hands. We'd met Gardner years ago in Tahiti, so the strangeness of a strange land was dispelled.

Below our window the trout rose in a pool among the pines, and in the morning the first early fall of snow had powdered the woods above us.

At nearby Squaw Valley, empty as yet of skiers, Alex Cushing took us up the mountain in a gondola to where we could look down on his empire, a picture postcard world of icing on sugar pine trees and snow meadows tumbling down to the ski village below.

We took a picnic day to make a side trip to Nevada City, a day in the heavy scented pine woods with the sun filtering through in golden shafts and the distant hills deep blue. Coming down into the cup of Deer Creek Ravine where Nevada City nestles, I felt we had stepped through a door right back into 1849, as though at any moment the miners would be back in this town of high-gabled houses, picket fences, and deep verandahs.

THE ROMANS OF
CAESARS PALACE
LAS VEGAS

Virginia City, for all its somewhat garish promotion, is still a gold rush town. As we drove in we paused on Gold Hill by the crumbling old hotel. On the hillside the headframe of a long abandoned mine stands gaunt and dead, yet it was here on this hill that Eilley Orrum, Queen of the Comstock, after consulting her crystal ball, staked out her claims and opened a boarding house. One of her boarders, unable to pay his bill, gave her his share in the Comstock mine—the mine that in 1863 alone yielded $20,000,000. In all, Virginia City produced $500,500,000 in silver and $700,000,000 in gold.

From the main street—by the way, we stayed in a room that in the golden days had been a butcher's shop—we could see the elaborate mansions built by the gold millionaires, so wildly incongruous among the bare, stark hills of Nevada. Here too is the old newspaper office of *The Territorial Enterprise,* where a young reporter named Sam Clemens began to write some wonderful tall stories of the gold fields and signed them Mark Twain.

Out across the deserts of the Humboldt with that wonderful sense of freedom that vast, open space gives, mile after mile of peaceful nothingness and the intriguing mystery of distance. Night in the anonymity of a strange small town—this one called Battle Mountain—where Patty played the five-cent slot machine, this being Nevada. She came out with a profit of fourteen dollars, a disaster to me that made her a chronic gambler and was to cost me ten times as much when we reached Las Vegas.

Las Vegas

At a later date we flew to Las Vegas, but I write of it here while on the subject of Nevada. I feel that the West without Las Vegas would be like a small town without a crap game.

"We'll get the real atmosphere," I said to Patty, whose gambling instincts had her straining on the leash like a bloodhound. So we booked ourselves into Caesar's Palace.

Las Vegas isn't so much a place as something that happened—it could just as well be put somewhere else. Nobody would notice as long as those lights were still flashing. Mickey Cohen, the gangster, wanted a place to gamble without interference, so he chose the most Godforsaken, remote bit of desert he could find, put a casino and a hotel on it, and was more or less killed in the rush. The place has grown like a mad mushroom in technicolour, and it is still desert. I opened a door at the end of a corridor in Caesar's Palace and nearly fell out onto a thousand square miles of it.

To savour the real Las Vegas you must see it in the early morning when the tourists have at last gone to bed and only the hard-core remains. I'd gotten up at six to make some sketches, and there in the huge casino were those hard-faced men—in shirt sleeves at this hour—still seated at the card tables. Workmen were laying new carpets for a spectacular that night, but the gamblers didn't even notice them.

By one table there still stood one of those incredibly developed girls dressed as a Roman slave in a sort of mini-toga, with her drink tray at the ready. This at six! "Faithful unto death," was the phrase that came to my mind. To my delight, however, the real homebody in her had won. She'd put on a cardigan!

Outside the main entrance a nude Roman athlete in white marble held one nude marble girl over his head while another sat at his feet. About and around them the fountains played against the early morning sun. Nearby a show-sign proclaimed in large letters, "Bottoms Up!" while under it in plaster stood Roman senators and maidens. They'd gone one better than the athlete; they were painted in full, lifelike colours.

Jiggs

To see America you must get off the highways, so at the cattle town of Elko we took a side road to nowhere and came to Jiggs. You know when you're in Jiggs because there's a postoffice and a bar. When we walked into the bar the woman behind it looked at Patty and said loudly, "What the hell are you doin' here?"

"I was wondering about that myself," said Patty. It turned out she looked like someone else, but the moment had its flavour.

The barman spends many hours scouring old Indian hunting grounds in the surrounding desert, time being of no great value in Jiggs, and on the wall behind the bar is a wonderful collection of flint arrowheads. But to me the plum was a photograph of the entire population of Jiggs in a Volkswagen— all nine of them.

The barman and his wife posed for me—she with a tame bobcat around her shoulders. It could happen only in Jiggs.

Back on the highway and in the late afternoon sun I climbed a hill in Nevada and looked down and across the Great Salt Lake Desert into Utah, beyond the white crust of the Bonneville salt flats to hills of black-brown rock that rose like islands from the desert, and on to snowcapped mountains blue in the distance. This was the country that William Lewis Manly, who took part in one of the great treks to California in 1849, described as "...black and desolate ranges and buttes of the south, great dry plains, salt lakes and slippery alkali water to which we walked, only to turn away in disappointment...."

Yet, the Mormons built a great community on and around this desert.

JACKSON HOLE AND YELLOWSTONE

Coming up from the south toward Jackson Hole, one is eased gently into that breathtaking scenery across the lonely grasslands of Wyoming where the cloud shadows chase each other across the hills into the great river valleys of the Grand Tetons.

But then there is Jackson. We took one look at the saloon and shop fronts garishly proclaiming sportsmanship and frontiersmanship and drove through, but fast. "Worms, Ice Creams, and River Trips!" screamed the signs, amidst heaps of antlers, stuffed elk, and even stuffed bucking broncos.

We found solace and incredible beauty a few miles away at Jackson Hole, with a log cabin beside a lake under the towering majesty of the Grand Tetons. Years before I had seen the movie *Shane*, made here, in which, fortunately, neither of Alan Ladd's two expressions was able to distract from the beauty of the background, and here it was in all the gold and russet blaze of autumn.

Through this paradise the animals roam undisturbed and you can see them across the glades in the woods: great herds of elk—so many that in winter it has become a problem to keep them from starvation—buffalo, and deer in profusion. We called on Margaret Murie, the writer, a gentle and charming person, in her log cabin in the woods. She is the widow of Olaus Murie, who did so much to preserve the beauty of this country, and those who have read their books *Two in the Wilderness* and *Wapiti Wilderness* will know the dedication of the Muries.

We watched the birds come to eat from Margaret's hand while the chipmunks scampered unafraid around us. Here is a person whose whole being radiates the beauty and serenity of her surroundings.

Jackson Hole had its riproaring days when it was a rendezvous for fur trappers, and later it was the scene of bitter wars between sheep herders and cattlemen. But the figure that looms large from the past of both Jackson Hole

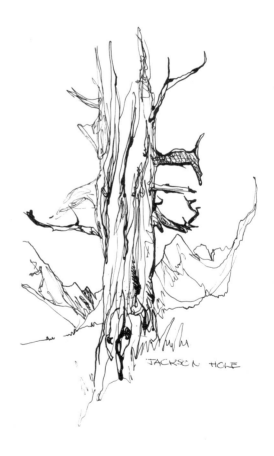

JACKSON HOLE

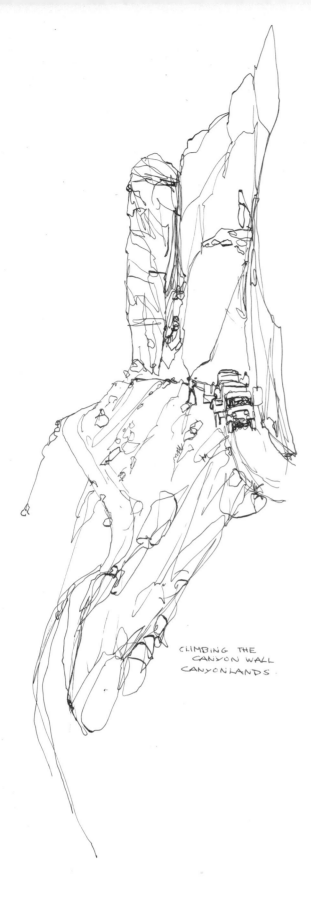

CLIMBING THE
CANYON WALL
CANYONLANDS.

and Yellowstone is that of John Colter, who came west with Lewis and Clark in 1803.

In the depths of the winter of 1807 Colter set out to inform the Indian tribes of the new trading post at the mouth of the Big Horn on the Yellowstone. His was one of the most extraordinary travelling-salesman journeys of all time. In five-hundred miles he crossed four mountain ranges and passed through the terrifying area of steaming geysers, boiling mud, and shaking earth that is now Yellowstone Park. His description of it gave it the name of "Colter's Hell" long before it was named Yellowstone.

We saw "Colter's Hell" in comfort, spending the cold evenings before a roaring fire in the charm of the old inn built of enormous logs. By day there were the same scenes that Thomas Moran had painted so grandiosely back in 1872. As a critic rightly said, "Moran made the Grand Canyon of the Yellowstone about four feet wide and four miles deep." Moran had his difficulties even getting to Yellowstone—four days in a stagecoach without stopping, and all the risks of robbers and Indians—but he did not have to cope with the visual clichés of Yellowstone created by countless thousands of photographers.

I MADE A LITTLE SIDE JOURNEY from Yellowstone over into Montana. Along the Madison River the cattle-lands sweep to the snowy mountains and only a lonely barn stands dark against the foothills all the way to Ennis, where I longed to stay and fish for those big trout. Then over the hill to Virginia City, an old gold rush town smaller than, but not unlike its Nevada namesake. Board walks and old wooden false fronts, and in the bar over huge beakers of icy beer there was nostalgic talk of home with a man who had been with the United States Marines in New Zealand during World War II.

UTAH

Back down through Salt Lake City, I was intrigued to find my own book, *Pacific*, in the window of a bookshop, and I signed it for a slightly startled bookseller. South of Salt Lake we paused at the sight of a picturesque conglomeration of old wagons, carriages, and plowshares. The sign said "Horse Thief Trading Post—Wellington, Utah." Wellington is our home town in New Zealand, so we stopped and made a friend.

Dave Nordell was a rancher, and a good one, but with the years the "artyritis," as he calls it, crippled him—his body, that is, not his spirit. Dave opened a sort of combination museum and antique shop that he calls the Horse Thief Trading Post. You can spend hours there among his treasures. There is everything from old stirrup irons to a surrey with the fringe on top. You can also just listen to Dave talk: "Them Government fellers goin' take away our guns? Them Russkies'll just come'n git us!"

By the time we left Dave he had presented Patty with an assortment that ranged from a copper bowl to a piece of dinosaur bone. He still writes to us.

Canyonlands

We had gone into Moab, Utah, hoping to find a way into the never-never world of Canyonlands National Park. We were feeling rather like children lost in a moonworld, when from a distant line of dust came a jeep bumping across the mesa and there was a string-bean of a man chewing tobacco. His name was Kent Frost, and he spoke a sort of "Ah'm a goin', ain't y' comin'!" cowboy talk.

"See Canyonlands?" he asked. "Well ah'm a goin' out t'morra—six days er so—whyn't y' come?"

So we did, and had some of the best days of all our travels in the West, out where there were no people at all and, perhaps best of all, no highways or roads. Lying in my bedroll the first night out, on the floor of a deep canyon, I could see the stars between the rock walls far above me. Regularly the hoot of an owl would echo in ghostly tones made near and intimate by the great stone soundbox of the canyon. In the first grey light of morning I could see, on the smooth rock wall above me, giant figures that had been painted nearly a thousand years before. They seemed aloof and armless, as though wrapped in blankets. I was to see those identical figures again, aloof and wrapped in blankets but alive, when I saw the Indians of Taos Pueblo.

Kent Frost has explored this region for years, working out ways of getting his jeeps across a wilderness. Old mining roads into and out of the canyons have overcome the worst difficulties, but even they can be quite hair-raising. As our little train of jeeps zig-zagged up the canyon that morning, one woman simply clung on and cried her heart out, but for most it was such a spectacle that we forgot to be scared.

So for days we rode along the mesas or wound down into the canyons. We camped one night on a canyon rim so high that at evening to look down into the hazy depths below gave one the feeling of sitting on a rock in the sky. We grew to know each other, we strangers thrust together by chance, and evenings by the campfire became hilarious. As for Patty and me, all the way from New Zealand and the only foreigners present, never once did we feel ourselves outsiders and we loved it. I felt I was discovering America—and the Americans. Maybe I could add a little "y'all" to my British speech once in a while.

Perhaps the most spectacular camping ground of all was in what is known as Doll's House, an array of tremendous sandstone figures, majestic and mocking, that with the changing light take on all sorts of expressions. Once when I woke in the night a face far above was staring straight down at me. The bright moonlight had caught it and fixed on it a knowing maniacal grin. In the unreality of night and halfwakefulness there seemed to be a remote but distinctly personal contact as when you catch a stranger's eye in a crowded street. It had taken rain, wind, and the Colorado River a million years or so to create that creature above me.

We were sad to see the last campfire die out, sad to see friends we would perhaps never see again disperse across the country, to Dallas and Tucson, to Inverness and Bakersfield.

Monument Valley

The sand-jeep—that's the only way I can describe it—roared across a flat and then, incredibly, headed up a great, high mountain of sand across a face that seemed almost perpendicular; at least to me it was, I being seated on the downward side. More incredible still, it kept going up and up until we breasted the top where the earth was solid again.

This was the way a young schoolteacher from Kayenta, Arizona, took us to the top of the mesa to look out over Monument Valley. It was approaching dusk, and the last rays of sun were just catching the tops of the monuments, and Totem Pole, a formation as high as a 45-story building, was thrusting a finger up and above the mesa. Below us was spread one of the most awesome and striking views in the world, a panorama that was some 50,000,000 years in the making.

This is the land of the Navajo. After the Anasazi (The Ancient Ones) fled south from the great drought, the nomadic Dineh (the Navajos) came out of the north, adapted to the desert, and have dwelt here ever since. They have

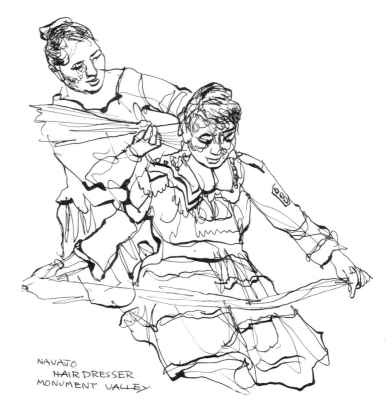

NAVAJO
HAIRDRESSER
MONUMENT VALLEY

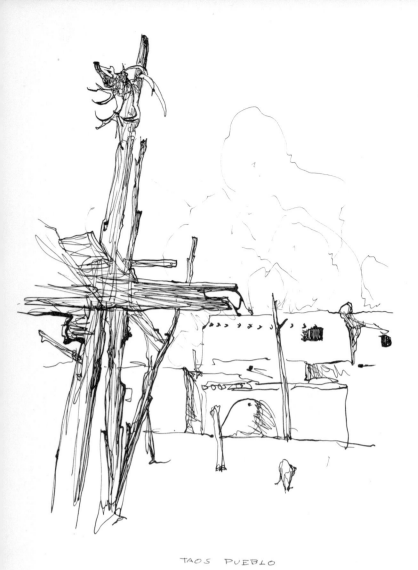

TAOS PUEBLO

never been completely conquered, for even when Kit Carson's troops rounded up the Navajos from Canyon de Chelly and herded them into a sort of concentration camp, the Navajos of Monument Valley held out under their last great leader, Chief Hoskinini, on the heights of Hoskinini Mesa and never surrendered. They still live here.

At Gouldings Trading Post, Maurice and Rosemary Knee welcomed us and showed us their wonderful collection of Navajo rugs, pots, and silver. In the store of the trading post there were those splendid Navajo faces, noble and high-cheekboned with skin like polished saddle leather.

COLORADO

The tones of autumn covered the hillsides, and along the route, which is roughly the old Spanish trail to Santa Fe, the whole of Colorado seemed a blaze of gold and russet. Up over the Continental Divide the hunters were coming by the thousands. I don't know about the deer, but seven hunters died on opening day, including one who hid behind a bush and made animal noises as a joke on his friends. All three shot him.

In Durango we found a delightful, old Western bar for me to sketch, admittedly reconstructed, but with the original chandeliers and such. What a lot we lost when we abandoned opulence! There was the traditional girl in black mesh hose and red garter. She was a ski instructress in winter, barmaid in summer, she told us. We loved the streets of towns like Durango, particularly the quiet back ways lined with two, three, and even four rows of trees, in fall a riot of colour. We were also a bit sad, for so often these are the streets that towns bypass in favor of "progress." I sometimes felt I was seeing the end of the American dream rather than the beginning of it.

NEW MEXICO

If I didn't have my cottage on my trout stream in New Zealand, in all the world, Taos, New Mexico, is where I would like to live—although I have my reservations, since "*they*" were criminal enough to put a highway through the middle of town. Taos has been an artists' colony since 1890 and just to wander down its lanes tells why. Lovely old adobe houses behind high walls, tiled courtyards, and over the streets giant cottonwood trees giving shade. All around stretches the sagebrush desert, ever changing, ever beautiful.

The difficulty in Taos is getting any work done, since life is much too pleasant. Someone asks you to breakfast and you don't get home until five.

Taos, of course, is full of characters, genuine ones of a rich and heady vintage, and to lonely travellers such as we, they were a haven and a joy. Don Blair, who runs the Blair Galleries in Taos and Santa Fe, and his wife Bettina Steinke, the painter, took us under their wings and gave us Taos. By coincidence, Don had bought a book of mine without any idea of ever meeting me while I, in New Zealand, had bought a print of a Bettina Steinke painting. With such a start it was inevitable that they have become a part of our lives. Then there was Sally Howell who *is* Taos. Sally and Jim Webb, a California friend of ours, bought a little church just to preserve it, and it is shown in this book in the drawing facing Plate 28.

We drove out to Ghost Ranch to visit Georgia O'Keefe, and she received us with that solemn dignity that marks everything about her. She was seated in her courtyard against a brown earth wall, dressed in a simple kimono-like black dress with a touch of starched white at the neck and with a great silver Indian belt. Along the bench beside her were arranged the bleached bones and

skulls she collects from the desert—the shapes that appear with such majesty in her paintings. Here, in her paintings and in Georgia O'Keefe herself, is simplicity pared and sculptured to great beauty.

But Taos would not be complete without Brett. Everyone simply calls her Brett, but she is the Honourable Dorothy Brett, and she came to Taos back in the twenties with D. H. Lawrence. Brett was brought up at Windsor Castle when her father was an advisor to Queen Victoria. When she was a girl her first date for a dance was Winston Churchill. An individual if ever there was one, she came to a party for us dressed in the style that is hers alone: a helmet with the signs of the Zodiac around it, an Indian robe, wide satin Turkish pantaloons caught at the ankle by turquoise-blue cowboy boots. Brett is one of the most charming and amusing people I have ever met. We had gone to the same art school in London—the Slade—but of course with a number of years between us. Years, however, mean nothing at all to Brett. "Did you go to Augustus John's parties?" she asked. "I always left before his orgy stage."

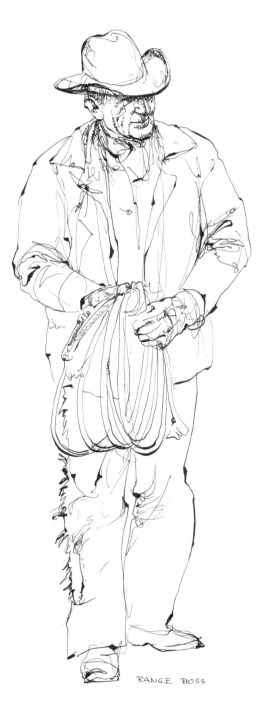

RANGE BOSS

OVER THE MOUNTAIN from Taos lies the yellow-grass cattle country, vast sweeps of gold fading away to a powder-blue line of mountains, and there we made an expedition with several other artists from Taos to watch the roundup on Dick Wooton's Ranch.

This country around Cimarron and Wagon Mound is right on the Old Spanish Trail to Santa Fe. In fact, Wagon Mound was a guiding feature on the trail, its wagon shape standing clear and abrupt above the plain. Cimarron also has its history of a later day; you can still see the bullet holes in the ceiling of the bar there.

Not since my student days had I gone out sketching with fellow painters, so this was like old times to me. There was Bob Longheed and his wife Cordy from Connecticut, Ned Jacobs from Denver, and Eugene Dobos, whose witty sculptures adorn the galleries of Taos.

Out in the cold, grey dawn stood a knot of horsemen—heads down and shoulders hunched, huddling together against the morning wind, horses and waving grass seeming to move together, colours muted in the flat dawning light—and there you have the cover of this book.

All day the riders moved across the yellow prairie, appearing and reappearing on the waves of the land, a horseman galloping along the skyline, a knot of cattle appearing over a rise, and once a herd of distant antelope sped like fleeting dots across the undulating land. In the late afternoon sun the growing mob of cattle spread out before us, moving in ever fading tones of reddish brown into the enveloping dustfall. Calves bellowed to mothers; riders slumped wearily in the saddle; and I had seen my first roundup and gathered another fragment of the American West.

We were in what was, to us at least, a remote part of the world, but the name Wagon Mound rang a bell somewhere and there in Patty's address book was a name given us in New Zealand: Mr. and Mrs. Macarthur, Wagon Mound. We phoned, and Western style it was insisted that we come and visit.

The old Spanish adobe Macarthur ranchhouse gave us a glimpse of a wonderful era. Great iron gates surmounted by a bell opened onto a tiled courtyard, all overhung with vines. Cool and welcoming rooms and deep couches were a soothing balm to our motel-weary souls—so were long, cool drinks.

By one of those freaks of coincidence, Mr. Macarthur had once dined out with Patty's sister and brother-in-law, the Douglas Frasers, while travelling through New Zealand, so New Mexico moved a little nearer to distant New Zealand.

In the morning we watched the hands at work with the cattle coming into the yards, and on hearing the cowboys speaking Spanish were reminded of New Mexico's past. Almost like an arranged finale, out on the prairie two huge

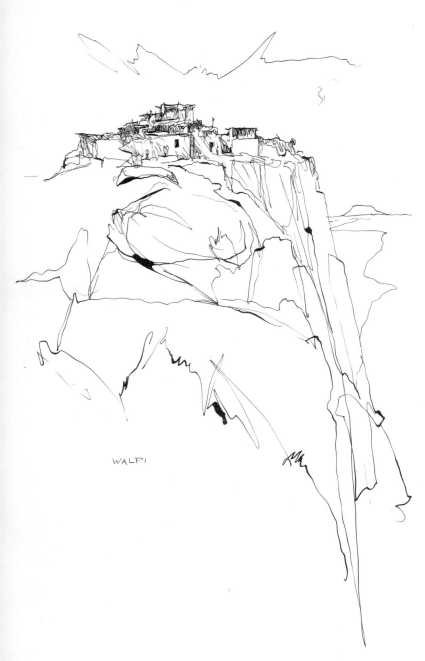

WALPI

bulls staged a spectacular fight, heads down, horns locked, and dust flying, while a third lumbered in and out around them for all the world like the referee at a boxing match. These were the sights, this was the land, and these were the people that brought New Mexico out of the lines of a map into sharp, full, rich colour for us.

ARIZONA

Before coming to the American West my vision of it was composed partially of a hill over which a long line of horsemen suddenly appeared, and partially of a telephoto view of Highway 66 with the billboards and hamburger stands looming up into the lens. This combination of the movies and *Life Magazine* did not prepare me for the truly vast stretches of open country, awesome and lonely, that still make up the biggest part of the West.

When we crossed the Indian country of the Painted Desert we found a land that seems to live in the past, where Indian villages, such as Walpi, still cluster defensively at the top of high mesas surrounded by cliffs and where, across the desert, you may still see a distant Indian on a piebald pony. This past is well preserved, too, in Hubbell's Trading Post in Ganado, Arizona, a place that has traded with the Navajos for 90 years and still does. It is a genuine relic of life in pioneer days, with superb adobe rooms containing rare old furniture and floors covered with Navajo rugs and littered with priceless Americana. Here Lorenzo Hubbell entertained with legendary hospitality; Teddy Roosevelt called him Lorenzo the Magnificent. He was friend and helper of the Navajos, and he lies buried on the hill above the Trading Post beside his Navajo friend Many Horses.

Canyon de Chelly

Of all the great Canyons of the West, Canyon de Chelly is one of the loveliest. As we walked down the zig-zag path carved in the rock face, we were enthralled by its beauty. Above and around us rose towering smooth walls, striped like banners by weather of the ages and glowing in the reds and ochres. Down on the canyon floor the autumn trees appeared as a flow of gold along the stream's edge.

When you peer over the edge of Canyon de Chelly you look down into history, for much has happened here. The Pueblo people built their cliff houses somewhere between 1100 and 1300, but the disastrous drought of the 1200s drove them out and away to the south. The Navajos came some five-hundred years later, and their raids along the Rio Grande brought the Spaniards in reprisal. A battle was fought here in 1805, and many Navajos were killed in the fortified rock shelter now known as Massacre Cave. Kit Carson and the U.S. Cavalry came in 1864, and the Navajos began the "long walk," as they call it, to a reservation where many died. After four years they were allowed to return, and today you can still see here and there their patches of cultivation on the floor of the canyon.

Grand Canyon

An actor friend once described Gary Cooper as "suffering from Epicitis, or fear of being asked to play Abraham Lincoln." I feel much the same at trying to write about the Grand Canyon. Yet to anyone who has sat at evening on the rim and watched the last sun play on that theatre of the gods, it is one of life's rare experiences.

Statistics usually give me a pain, and those of the Colorado River, as it

flows through the Grand Canyon, are too immense to digest in any case, but here are two of them. In flood in 1898 its flow was 300,000 cubic feet per second! The loads of solids and dissolved materials it carries along in flood have reached 27,600,000 tons per day!

My problem, of course, was how to paint this magnificent, beautiful monster of a cliché. I settled for a rain storm that caught me half-way down the trail into the canyon. It soaked me to the skin, but it turned the limitless grandeur into something of a poetic backdrop to a somewhat theatrical tree and a red-earth stage.

I have a fond memory too of a pleasant but wildly enthusiastic Jewish physician who was on his honeymoon and who befriended us. He had taken his bride all the way to the bottom of the canyon and back by donkey just the day before. This day he wanted her to walk it. She was slithering and slipping down the somewhat terrifying trail in sneakers, legs stiff as ramrods.

"Marilyn!" he wailed. "Listen to me, Marilyn. Is it down the Grand Canyon you should try to walk with the knees stiff?"

Tucson

There is a man in an Albee play who always wants to give up and go and live in Tucson. Perhaps he has got something there; the air is clear and dry under the shelter of the Santa Catalina Mountains.

Out in the tall cactus country along the Old Spanish Trail, where the Spaniards, Mexicans, Apaches, and Americans actually fought a hundred years ago, we watched an episode of *High Chaparral* in the making. To me, the movies had always been a part of the West, if not all of it, and here was a show we had sometimes watched with the children at home.

The set was a re-creation of old Tucson as it was around 1860 and was originally created for an epic called *Arizona* in 1940. It was quite remarkable for its convincing atmosphere. It gave us a peculiar sense of having been there before to be amongst Blue Boy, Big John, and Victoria. The scene, being short, involved two camels for some reason, and an actor was saying "Why, that's the doggondest *mule* I ever did see." When we left, some hours and many retakes later, he was still saying "Why, that's the doggondest...."

Before coming to the United States we had wondered how our New Zealand accents—sort of half British, half Boston, so I am told—would be received. We needn't have worried; apparently they are cute as all get-out, but down on the Mexican border at Nogales we heard the penetrating comment. We'd gone into a bar for a drink and the Mexican barman cocked an ear at us.

"Where you folks from?"

"New Zealand."

He pondered that for a bit. "What language they speak there?"

"English."

"Ah," he said, nodding. "Real English, not Boston!"

A New Zealand friend of mine was once in San Francisco at the Top- of the-Mark and, using his best British accent, went over and asked a woman if she could tell him the name of some building or other down below. Without even answering him she grabbed her husband's arm and said, "Listen to this!"

"Yeah, I heard," said the husband. "Keep him talkin'."

I'd corresponded some time back with a rancher named Frank Appleton, who lives at Elgin, south of Tucson, and when he found us more or less on his doorstep, he and his wife Ariel kindly had us stay over. The Appletons have done a wonderful thing, having turned their ranch over to the nation as a trust for the study of the ecology and conservation of the land. When the whole world is only beginning to realize that man is well on the way to the ruination of his own environment, this magnificent gesture is most timely.

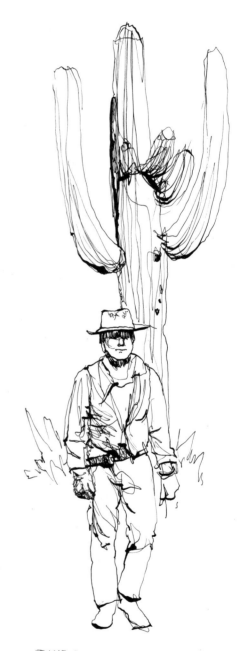

BLUE BOY
OF HIGH CHAPARRAL

Driving by jeep across the ranch, we watched gazelle and deer bound away over the rolling grassland. Here could be at least one beginning to saving the land and its creatures, a whole nation's heritage, before it is too late.

CALIFORNIA

Californians will tell you that San Diego is where civilization began. Don't be shaken by this. They really mean civilization in California, but it would never occur to them to say it that way. San Diego's origins of course were Spanish: Don Gaspar de Portolá and Father Junipero Serra established the first presidio and the first mission in 1769.

We never did quite find our way on the highways of San Diego. Once when we went to dine at the famous old Hotel del Coronado I missed every turnoff and finished up in La Jolla (the locals call it Luh-Hoyah), which is one of those situations in which you might as well relax and enjoy.

We had another try at the Coronado and made it for lunch, which was a delight. How wonderful, after months of motels and small-town restaurants, to say nothing of Joe's diners, to sink gratefully into luxury and the sort of service that mostly disappeared around 1914.

Best of all we met Duck again, a very lovely girl we'd known in Tahiti, and here was Duck, married, happy, and pregnantly blooming. Her mother gave us a very gracious party and I felt at last we were off those highways and really inside San Diego.

I painted the zoo, a glorious zoo, perhaps the most attractive in the world. I painted Mission San Diego, but drew the line at Ramona's wedding place, settling for my memories of Dolores del Rio.

Joshua Tree National Monument

The Joshua tree, which, by the way, is simply the *Yucca brevifolia,* was named by the Mormons who saw it as Joshua forever raising his arms to heaven and pointing the way. Nature has piled huge formations of beautifully shaped stones in Joshua Tree Monument, piled them in such skyreaching grandeur that they appear as altars surrounded by exhorting Joshuas. I had the sensation of wandering through vast open cathedrals that went on and on over the desert edge. There was a slope, too, that was covered with a profusion of gay and beautiful cholla known as the Teddybear cactus, its silvery spines dense as wool catching the early desert sun in a halo of prickly light.

Los Angeles

Driving into Los Angeles on the freeway for the first time brings that screeching roaring nightmare, the world of the future, into jarring focus. Five deep the cars race, nose to tail, sixty miles per hour, and then you have to move over two lanes with a truck like a runaway warehouse on your right. Put out your flipper and pray.

Somehow we made it to Malibu and the cliffside haven of friends Ed and Marguerite Meagher. Ed writes for the *Los Angeles Times,* and we'd known them since our Hong Kong days. Looked down on from above, Malibu beach is just another beach with too many architecturally monstrous beachhouses, but it has its own memories: John Gilbert drinking champagne from a slipper —was it Clara Bow's?—Marion Davies in her $1,750,000 shack that Hearst built for her. W. C. Fields' ghost still lumbers along the sands with an ice bucket of martinis. Mae West still lives here.

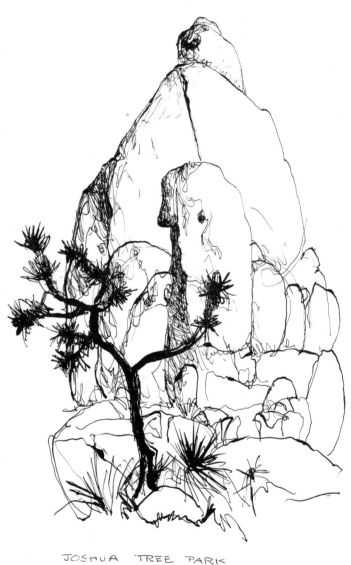

JOSHUA TREE PARK

But in this city of tomorrow it was yesterday's seediness, in the form of Venice, that appealed to me. Reaction to the brassy opulence of Wilshire Boulevard? Inverted snobbery against Beverly Hills? Maybe. But the poetic sadness of the abandoned amusement park had its own special smog-wrapped beauty. Old people out there at a bridge table on an empty beach were suspended from reality on a yellow, smoggy stage. They seemed to have achieved Fred Allen's greatest wish; they had retired from the human race.

Most cities look their best in the early morning, and so if you drive from Santa Monica along Sunset Boulevard and every so often peel off up into Beverly Hills and peer out over the city, Los Angeles has a certain charm of its own. Our friend Irma Attridge, the painter, had a party for us in her home in Beverly Hills—a stone and glass studio house set in a cool, green, enveloping mass of foliage—and it was as delightful as though we were a hundred miles from the freeways.

The trick of course is to drive all the way in on Sunset Boulevard until it becomes a bit honky-tonk. At least in me it evoked odd bits I'd read over the years, of Charlie Chaplin, Douglas Fairbanks, and Mary Pickford. But before your illusions become too shattered you rip over onto Wilshire Boulevard and all the way back to Santa Monica Pier and the Pacific.

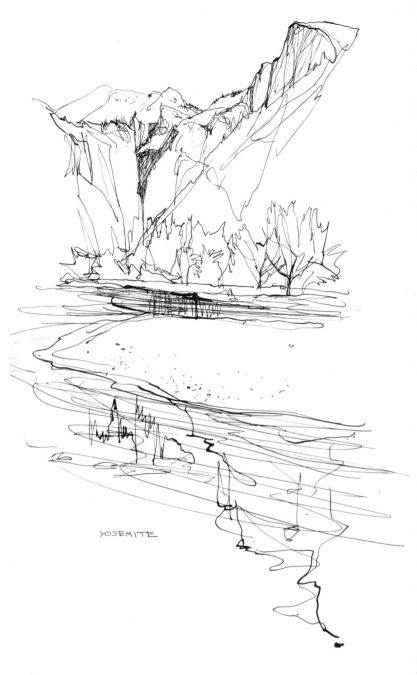

YOSEMITE

Laguna Beach

There was a guard at the entrance to the community where our friends the Hubleys live, a sad comment on life in our times, but it did give a sense of security, a feeling of freedom from such blights as the motorcycle gangs that plague even my quiet country. As in a village of a century ago, everyone in Laguna knows everyone. A young man bare to the waist coming up from crayfishing off the rocks stops to pass the time of day, and coffee is always ready. Trees are treasured, gardens bloom, while above the rocks and the surf, terraces cantilever into airy space. Perhaps in this age of terror such places foresee a return to something like the guarded life of those old villages one sees clustered on the tops of crags in Italy. In any event, life as our friends live it in Laguna seems very pleasant indeed.

We came back to San Francisco by way of the Owens Valley. There above Lone Pine in the Alabama Hills, under towering Mount Whitney, is one of the most dramatic and awesome areas in the whole of America. Why the place is not made a National Park before it is too late I cannot understand. Already those little bungalows are creeping in among the most magnificent and oldest rock formations on the American continent. From dawn to dark I climbed among them until I knew each brooding group almost as personalities, and all day the changing light revealed one scene after another of immense and timeless splendour.

All the way up this great valley the snow-topped Sierra was above us. Mono Lake lay black with its strange tufa formations appearing to float exactly like the drifting chains of icebergs I had sailed past in the Antarctic. What a fantastic area this is—the whole Sierra Nevada and its surroundings. As John Muir wrote back in 1869, "...a country of wonderful contrasts, hot deserts bounded by snow laden mountains...cinders and ashes."

Yosemite

Dusk was falling as we came into Yosemite, and with darkness came the first fall of snow, so we sheltered for the night in a wayside cabin, grateful for a wood fire in an old-fashioned round stove. In the morning, as we drove in a world of white, around a curve came a huge snowplow and near-disaster. There seemed no room to pass, and I braked instinctively only to glide in one long,

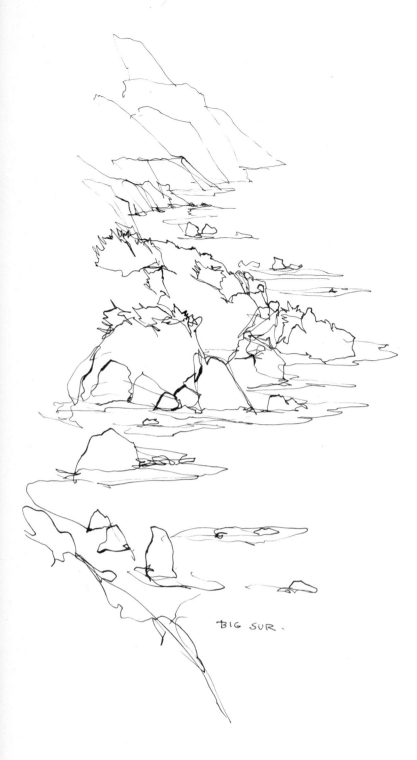

BIG SUR.

beautiful skid with a crash into the blade, like a toy swept up in a dustpan. However, our battered mud guard was soon pried off the wheel with a spade, the ranger was notified, and we were once more on our way.

In the Merced River the great boulders were coated like cakes with icing sugar and were overhung with a filigree of whitened branches that stood out against the grey-black water. All around us incomparable Yosemite displayed its domes, its towering rock-faced waterfalls, and its mirrored lakes.

Exchanging the American winter for the New Zealand summer at our fishing cottage, we flew home to spend Christmas with the children. I went shooting wild goats with my son Simon, fished for trout, and began to recover from the tensions of freewayitis. Best of all, at a distance I began to get a perspective on my subject, the West. The highlights were becoming simply a part of the immense picture and soon I was itching to be back, to be on a strange road again, not knowing what lay beyond the horizon.

Such is the change in global time that we were back in San Francisco ten minutes before we left home, having departed New Zealand at 7:20 P.M. on Sunday and arrived at San Francisco at 7:10 P.M. the very same day. There we found my publisher Mel Lane, and his wife Joanie waiting to point out to us how green was their California.

Big Sur

Before taking off for the north there was material to gather down at Carmel and Monterey. Cannery Row came out of my reading memory so clearly that I could not quite realize that I hadn't been there before. I really expected to see Steinbeck's Doc delving among the rocks along the shore.

There was Big Sur, and then Nepenthe, a colorful restaurant with a grand view of the Pacific. Lolling on the sunny terrace, a glass of wine in hand, the surf surging white far below along the balmy coast, we agreed that this was truly paradise.

Two hippies came and sat beside us, both long-haired, bare-footed, free as birds. For a while I thought, I've lived it rugged at home, and mine is a country well suited to the simple life. Why not? Then as I looked at what seemed to be the male, I wondered how long it would last. But this was Nepenthe, and she was gazing at him in simple unwashed adoration. He was gazing at a seagull. I had a conviction that he was thinking of a drink—he had waved the waitress away—or what a bath would be like.

I admire the bravery of these young people, and who wouldn't like to say "the hell with it" to this grinding machine we live in? But we can't get back to the Garden of Eden; it's closed. Still, I have always had a sneaking envy of that Thurber character. Remember the man lying on the floor and the woman explaining to the arriving guests, "That's my brother Ed. He's given up."

North Coast

Over the Golden Gate again, this time going north, but old hands enough by now to pause for the local institution, brunch at Sausalito, and a last nostalgic look at San Francisco across the Bay. Perhaps if I were younger this is just where I should have said "to hell with it" and never left San Francisco, but for better or for worse we were headed for Alaska.

For some reason the coast of Northern California has not been overwhelmed in the population rush (*everybody* wants to come to California), and so you can drive along the coast road through peaceful countryside to places,

such as Inverness, that have become quaint and lovely bastions of a vanishing American way of life.

Here too, like islands in time, are the groves of giant redwoods, so tall, so huge, that we drove and walked in a twilight with only the slanting rays of the sun far overhead, through stands of trees that were there before Christianity came to this earth.

Yet these are but a few of the great forests that flourished here; a few have been saved, and only just saved at the last moment. Here in the loss of these forests is one of the lessons in what could happen were the Philistines to have their way with the heritage of a nation. Even now the hazards are not all overcome, as for example witness a local Chamber of Commerce man who said, "If the people want to have hamburger stands in the redwoods, why then they should have them!"

Mendocino

On the cliff tops above a river estuary stands Mendocino, to me the gem of the whole Northern California coast. There is a touch of New England in those severely white-painted wooden houses with their high, gabled black roofs. There is an air of fantasy in the wooden towers of an old windmill. There is a jewel-like perfection to this town of the 1800s, and it is capped by the white painted group of figures that tops the Masons' tower.

We stayed in an old hotel in a great, spacious, whitewashed room that opened through French doors onto a railed verandah that, in turn, looked out across fields of wildflowers to the cliffs and the sea. Great timbers still jut out among the wildflowers on the low cliffs where once cables ran logs to ships anchored in the estuary below. In the morning the fog drifted in and transformed the town into a whispering, ghostly wonder of greys and whites, of vistas of houses dimly revealed and lost again by the rising and falling of a damp curtain. Beyond the cliffs a foghorn boomed its measured, muffled tones of warning. The logging people who built the house-turned-hotel built it well and with superbly good taste.

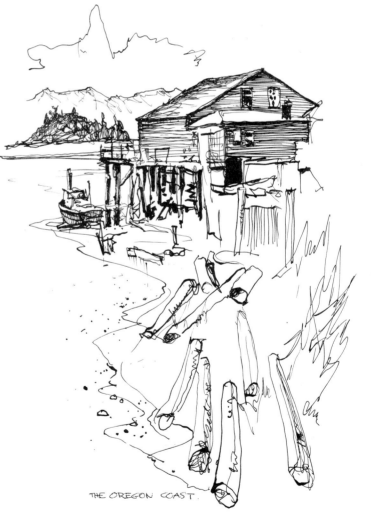

THE OREGON COAST.

OREGON

Up through Grants Pass and over the Rogue River there is rugged country of rocky, timber-covered ridges and deep ravines, with some superb stands of redwoods along the river banks. In the evening, at a place called Cottage Grove, we found one of those motels, complete with golf course, that offers a whole way of life, including, so help me, two chocolates in a plastic container placed on the bed pillow and bearing the legend "A goodnight kiss!" We were kept awake all night by that hazard that is so very familiar to today's weary traveller, the hell-raising convention.

Portland, and lolling around a quiet home—that of old friend Bob Burns —soothed our weary spirits. Along the Columbia River we visited Bonneville Dam, where the salmon go leaping up the cascades. We were fascinated by the eerie sight of huge eels working their way upstream by clinging with their mouths to the smooth walls, their long bodies thrashing in the rushing water like whips, but inching their way along in clusters. As fast as one cluster disappeared up and over, another lot would form to take its place.

Out on the magnificent Oregon coast the rocks of Cannon Beach reared out of the sand and the surf like jagged teeth, but with evening the sea fog came in, a great creeping layer of it, and changed them to islands floating on the fog. All along the beaches of Oregon huge logs lay heaped in wild profusion among the rocks, the unneeded surplus of the vast forests.

WASHINGTON

It's supposed to rain ninety-nine days out of a hundred on the Olympic Peninsula, but not for us. In something like seven months travel in the West we'd had three wet days. Even in the rain forest the sun shone, and the shrouds of moss that hung from the trees and covered the forest floor were golden yellow instead of green. At Lake Quinault, and the old-style lodge, how wonderful it was to find in this age of singularly unspacious motels a vast lounge, roaring log fire, deep and ample couches, and heaps of glossy magazines instead of those pamphlets. At dinner, minute hummingbirds hovered, poised like midget helicopters by the window, taking honey from the lip of a bowl.

We trolled the lake for trout in the early morning and actually caught two—cutthroat, I think they call them. We picnicked by the river and explored the woods until we could find no other excuse to stay.

Still the sun shone throughout the Peninsula, even on the snow of Hurricane Ridge on Mount Olympus. I remembered making drawings for war history on the original Mount Olympus in Greece at the end of World War II, and finding the graves of some of my countrymen who fought a rear guard action in Olympus Pass in 1940. But the sun was shining on this Olympus and the old was far away.

Port Townsend

It was Sunday morning, and we breakfasted on bacon and eggs by the boat harbour of Port Townsend, which was gay and busy as the boats prepared to put out into those wonderful sailing waters that stretch from Puget Sound to the San Juan Islands. This is another Victorian gem of the past, this lovely and stately old town of Port Townsend. Along its quiet streets the ornate and elaborate wooden mansions stand like dowagers of some long-forgotten tea party, aloof and superior, high above the waterfront that once had as bad a reputation as San Francisco's.

Tacoma

We found how pleasant life can be up here in the north when Tacoma's human tornado, Fred Haley, and his wife Dottie, took us under their kindly wings. There was dinner on the terrace with the most interesting company and a beautiful, great salmon; there was breakfast at one of those homes you dream about, in its own woods beside a mirrored lake—a Frank Lloyd Wright house beside a salmon stream; there was a day among the old boathouses and fishing wharves of Gig Harbour. These are memories we will treasure.

We took the ferry out from Anacortes to spend a day among the lovely San Juan Islands, sailing from island to island, often close inshore, and calling in at the little communities dotted among this wooden maze. We stopped over at Victoria on Vancouver Island, a city so stately that we felt the change of pace from places like Tacoma and dropped back automatically into our British ways with the ritual afternoon tea at the Empress Hotel.

ALASKA

This is a sombre land, but it sits in towering majesty, snowcapped and aloof, wooded dark green from the water's edge. By ferry from Seattle we sailed among endless islands. Here and there a fishing hut or a lonely village clings on a threadline of shore against the woods, and great glaciers cascade right

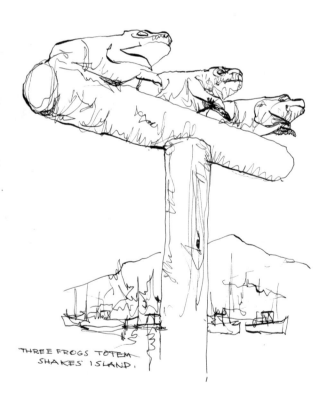

THREE FROGS TOTEM
SHAKES ISLAND.

down to the water. North beyond Petersburg, even in summer, small icebergs drift along the shore.

We dropped off the ferry for a few days in each of the fishing ports along the coast—Ketchikan, Wrangell, Petersburg. Here were boats coming in laden with salmon and halibut. Salmon from 40 to 60 pounds were commonplace, while the halibut when strung up were as big as a man and sometimes as much as 8 feet long and 3 feet wide. As for the salmon, the record one caught on rod and line is in a glass case in Petersburg: 160½ pounds.

Shakes Island

The giant totem poles standing like guardians of the coast evoke the Alaskan past with a real spectacle. In Wrangell, on tiny Shakes Island, which was a Russian port and trading post back in 1810, totems make a magnificent array. There were three frogs most beautifully carved, but made as an insult to the neighbouring tribe; a bear atop a pole with his footsteps leading up; foxes, frogs, and their ancestors, all of which tell stories and legends. The tragedy of progress has come at last to Alaska, and soon the drab pall of industry will fall on these parts. The totem poles may well become the only reminder of the wild and sombre splendour of the Alaskan coast.

Skagway

On August 17, 1896, a miner named George Carmack and two Indians, Skookum Jim and Dawson Charlie, were prospecting on what is now known as Bonanza Creek in the Klondike. In the creek bed they found flakes of gold and set off the most colourful gold rush of all history. A mad stampede followed, miners landing by ship at Skagway and carrying their entire equipment on their backs over White Pass and Chilkoot Pass to the Yukon River and on to the Klondike. By 1897 Skagway had become a town of some 20,000 and was said to be little better than a hell on earth.

Up over White Pass the long line of men toiled under appalling conditions. So many horses died that a gully is still known as Dead Horse Gulch. Today Skagway is much as it was in the gold rush days, for when the gold ran out there was nothing to change the original boardwalks and the saloon fronts. In the river gorge leading up to White Pass you can still see the built-up stones of the trail of '98 protruding from the snow, and under the trees by the river are the graves of many of the gold miners, old wooden railings and headstones all awry in the sleepy quiet, for nobody comes here any more.

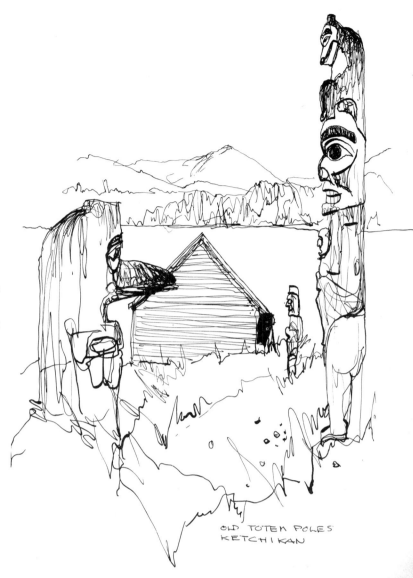

OLD TOTEM POLES
KETCHIKAN

BRITISH COLUMBIA

Forested mountains tower above Vancouver, rising from the water's edge just across Burrard Inlet from downtown. The Fraser River bounds it on the south, and to the west is the Strait of Georgia. Beaches are right under blocks of apartments, and a superb, heavily wooded, high promontory forms a park practically in the city. There can be few such settings for a modern city anywhere in the world. It lacks the inspired, creative go-go of San Francisco, but it is full of a charm that is enhanced by its own British dignity.

Driving across British Columbia, our abiding impression was of a profusion—an endless spectacle of wooded mountains, deep flowing rivers, and myriad lakes. As a government official told me, "We can give you fishing information on two-hundred odd lakes; the rest we're a little hazy about." Unfortunately, the summer heat had sent the trout and the salmon to the bottom, there to lie doggo. At Salmon Arm, for instance, the sky was a brassy haze and the temperature 95 degrees in the shade. But the rise up into the Rockies and the Banff country brought scenery so spectacular that all else faded.

At Lake Louise our room looked straight up the lake, so glassy smooth that the whole scene at the lake head, of towering ice faces and snow shelves, was doubled and a canoe left a line like a gash in a screen of silk. At evening a piper in full kilt and flanked by attendants marched down the lawns to pipe the flag down, taking me back to my childhood in Dunedin, a town of Scottish settlers in New Zealand, and the memory of my brother Bob marching just so up and down the garden path practicing the bagpipes. The difference was the tourists taking photographs of the pipers here at Lake Louise. Nobody ever took any pictures of Bob.

We drove down through Waterton Lakes—perhaps the prettiest lake of them all shared by Canada and the U.S.A.—through Glacier Park to the highlight of Going-to-the-Sun Road. Wandering across snowfields where patches of wildflowers broke through in blankets of yellow, we came on a meandering stream with icy banks that disappeared under a snow bridge to emerge again as a waterfall.

In Idaho, there were roadside signs that said, "You are leaving the best fishing in the world!" but the summer heat still hung like a leaden pall. Out on the lakes the boats trolling for those huge Kamloops trout were drifting listlessly and unreal in a haze of heat. But they do catch huge trout here, the Kamloops being the largest version of the rainbow; in fact, the world record was taken here in Lake Pend Oreille.

We had an invitation to stay with Buddy and Louise Magan at Hidden Valley Ranch in northeastern Oregon, and we made our way around the Wallowa Mountains through the Wallowa River Valley—Valley-of-the-Winding-Waters, as it was known to the Nez Perce Indians.

We came to a classic, old Oregon barn, its loft door jutting out like a beak, its unpainted boards mellowed grey, an abandoned blacksmith shop beside it, and there slipping into the hills was Hidden Valley, green and beautiful. Buddy and Louise run a dude ranch for children, and there they came, some twenty of them riding out of the woods, a little piece of Americana I had never seen. They finished their riding day by rounding the barrels at full gallop, and ride they could. A wonderful sight, for there are superb horses in this part of the world and the children rode with great dash and a casual grace.

I will never forget those days in Hidden Valley—days of fishing the stream that flows through the ranch and catching more than thirty brook trout; of jeeping with Buddy up into the woods to see the elk; of going with twenty children to buy a piglet and hearing the girls sneak out at dawn to feed it from a bottle. In winter the deer used to come to the door at Hidden Valley to be fed, but they became so tame that the hunting season was a massacre, and so they have to be chased away for their own good. The time came when we had to finally leave, but we both felt warmed by a very happy experience and by this slice of Western life.

I had learned by now to expect the most fantastic contrasts in the West. In the morning we were driving through country striped gold and brown in swathes that followed the rolling contours as the harvest was gathered, and by evening, after following the Columbia River for many miles, we were driving through a snow storm on the lower slopes of Mount Hood. When we reached Crater Lake the snow lay heavy, and the wind-bent trees above the lake made a fantasy of black and white as it clung heavily to one side, leaving the other bare. Crater Lake was a giant bowl of swirling snow. Yet, within a day, there was the rich, yellow grass of Northern California where we rested at the Lane ranch near Cottonwood, our journey nearly over.

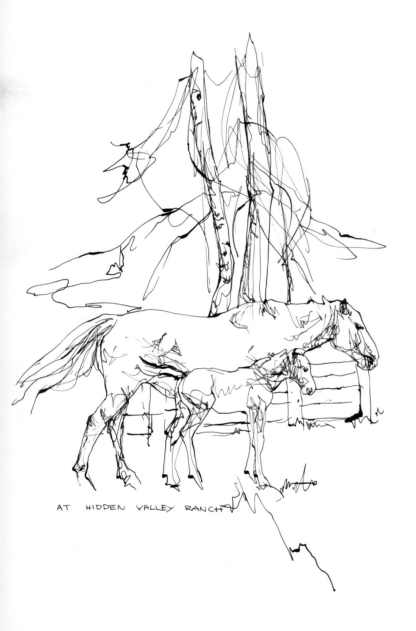

AT HIDDEN VALLEY RANCH

GOLDEN GATE BRIDGE again, Union Square, and a long, cool drink in a Hofbrau around the corner. For all our love of San Francisco, thoughts of home and our children in New Zealand crowded in. It was time for skiing on Mount Ruapehu. Flying home from the States, there was Hawaii for a few days, bronzing on the beach, a farewell to things American, the cliffs of Na Pali, a last glimpse and reminder of the spectacular sights that the West had given us in such profusion.

Lingering with us was a profound love of the American West, the most incredible area on the surface of the earth, and of people who had been more kindly than any other we had ever travelled among. Man is comparatively new in the West; yet in the çanyons, 50 million years of this planet's life are clearly revealed and man stands in awe, made aware of his own puniness and his shortness of time. In the gold rush country we had felt we were walking through history; we had crossed vast deserts and high mountains; we had felt the heat of Death Valley and seen the glaciers of Alaska.

These are troubled times, not the least in the American West; but here in the West is hope for mankind, for it is here that civilization will survive or die.

PETER McINTYRE

Kakahi
King Country
New Zealand
February, 1970

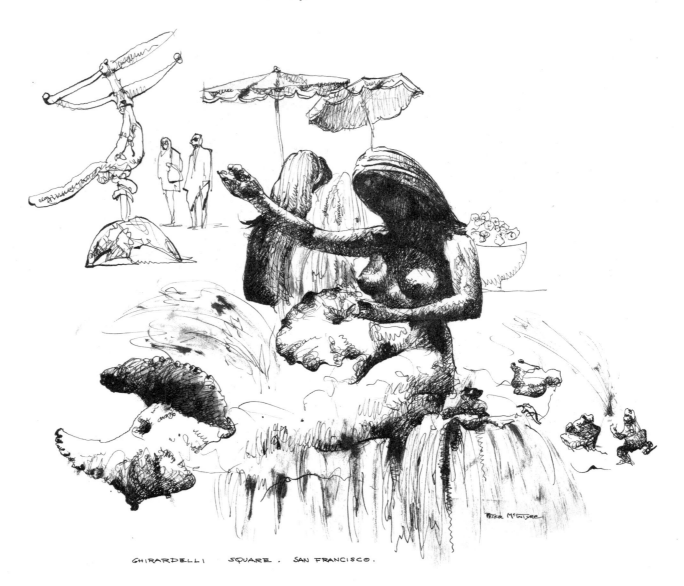

GHIRARDELLI SQUARE . SAN FRANCISCO.

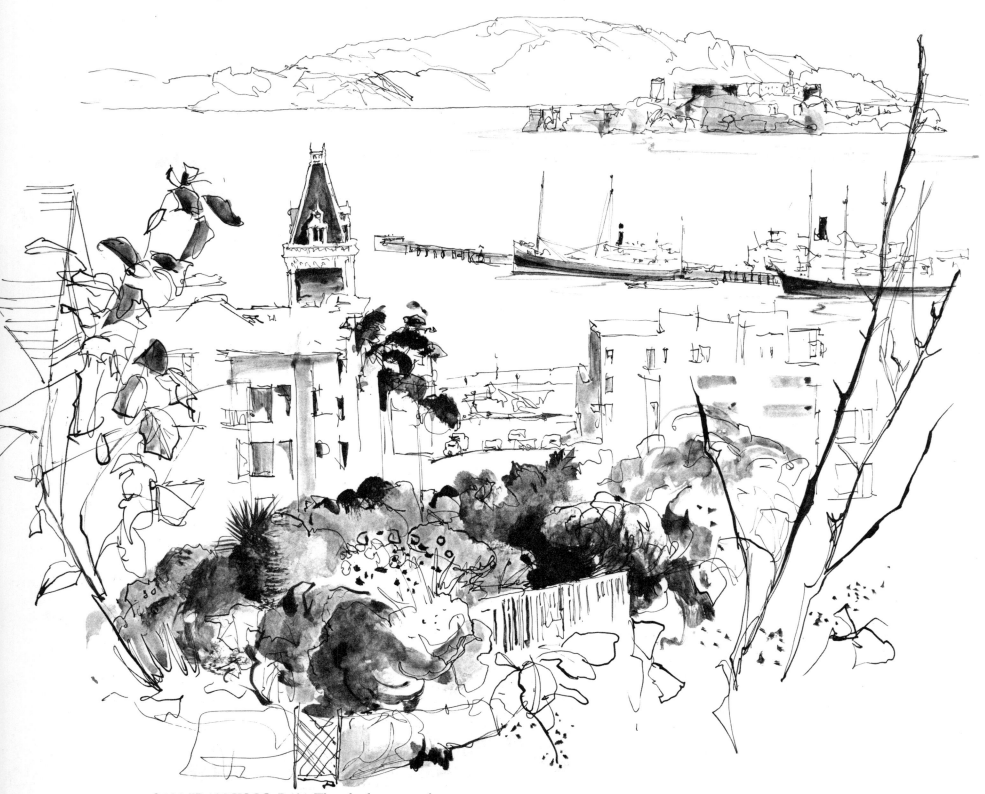

SAN FRANCISCO BAY. The clock tower of
Ghirardelli Square, old chocolate factory
turned cheerful shopping center, looks out across
the bay to brooding Alcatraz, once a federal
prison, from which no man was ever
known to escape and live.

NORTH BEACH, SAN FRANCISCO **PLATE 1**

Of all the cities of the world, this is the one I love. It is Paris without French waiters; it
is Wellington, my hometown in New Zealand, with the same cable cars forever
climbing and wooden houses clinging to hills that reach for heaven. For my wife
Patty and me it was the beginning of a journey that took us from
Arizona to Alaska, from California to Colorado.

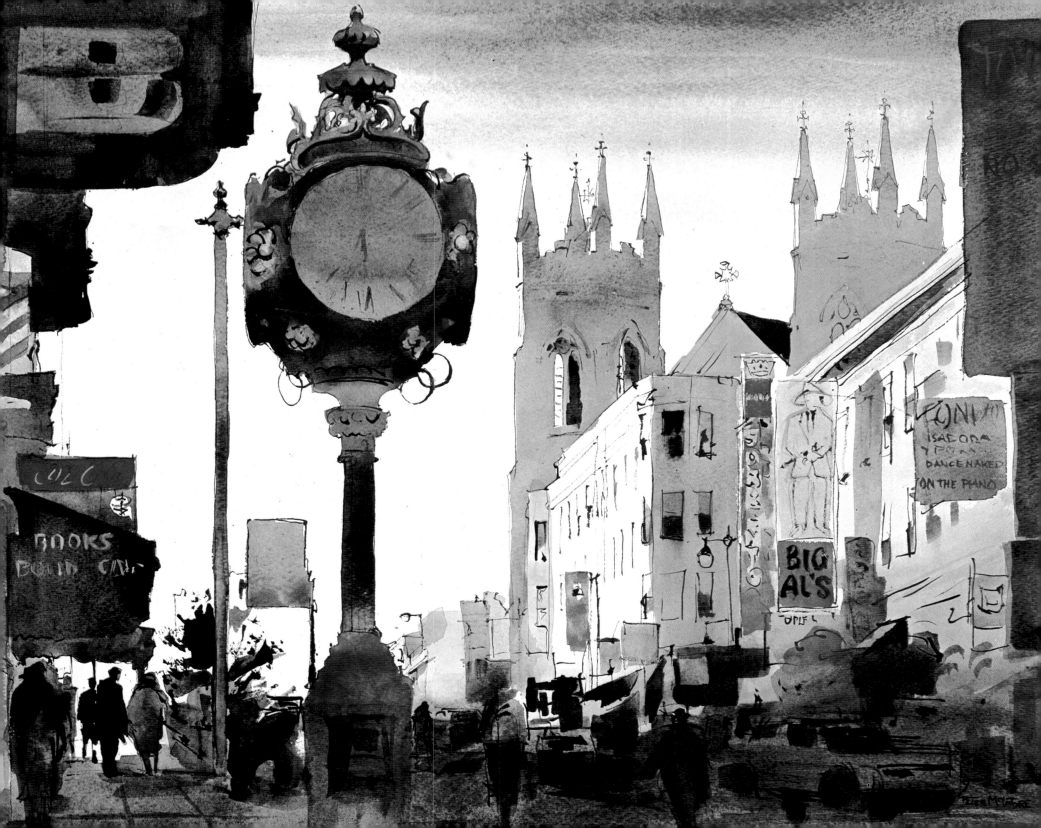

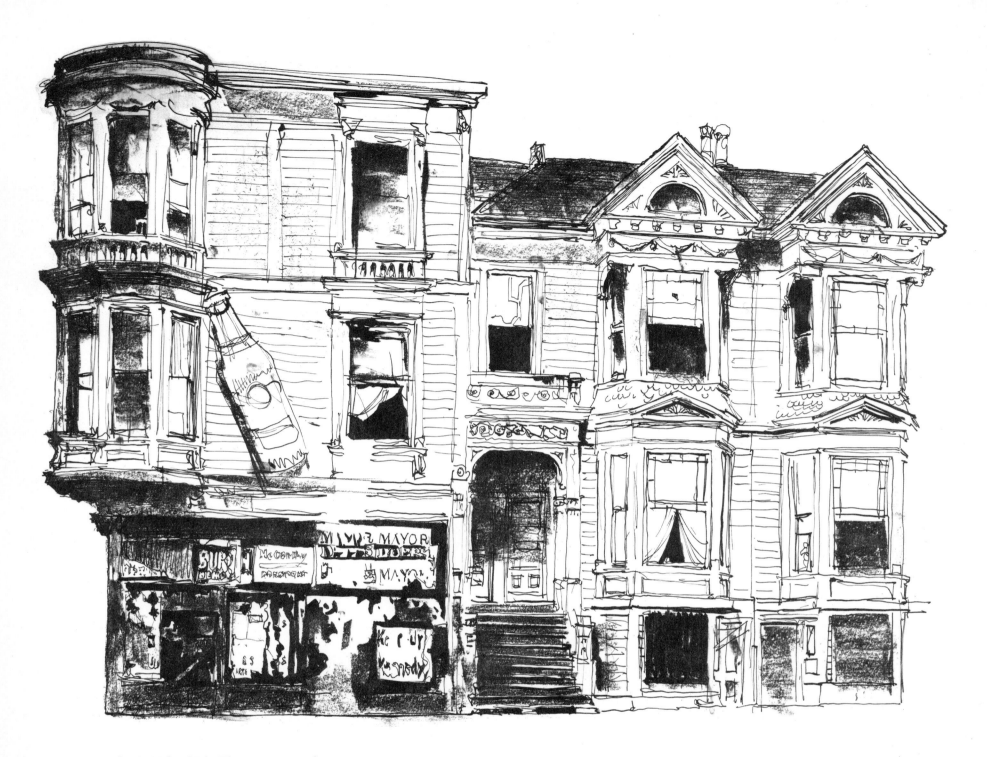

OLD HOUSES. They wear seediness
like an old tramp in a frock coat, an old crone
bedecked with tarnished baubles. But this is
part of the panache that give San Francisco its
wonderful personality.

CHINATOWN, SAN FRANCISCO **PLATE 2**

Here is my beloved Hong Kong again, gaudily exuberant with signs that are all the
more decorative if you cannot read them. To fifty-five thousand
Chinese-Americans, this is home.

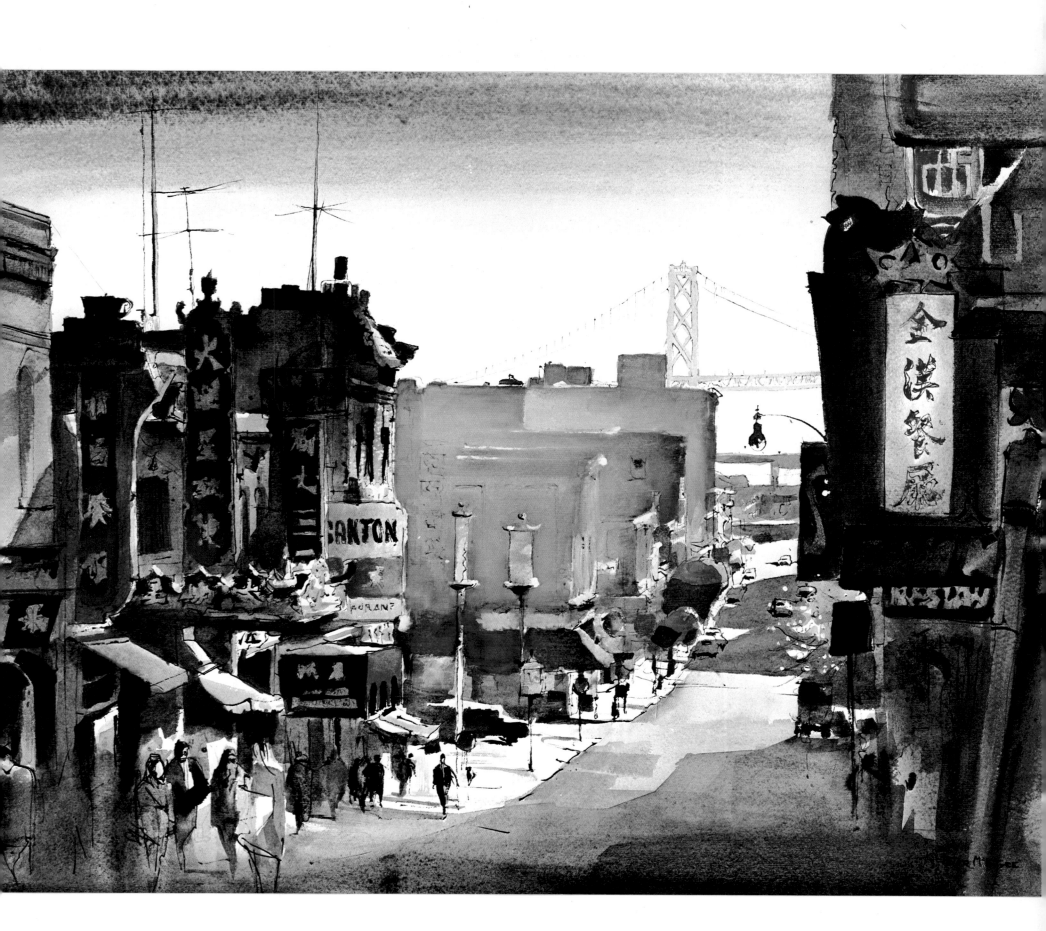

OLD FIREHOUSE, NEVADA CITY

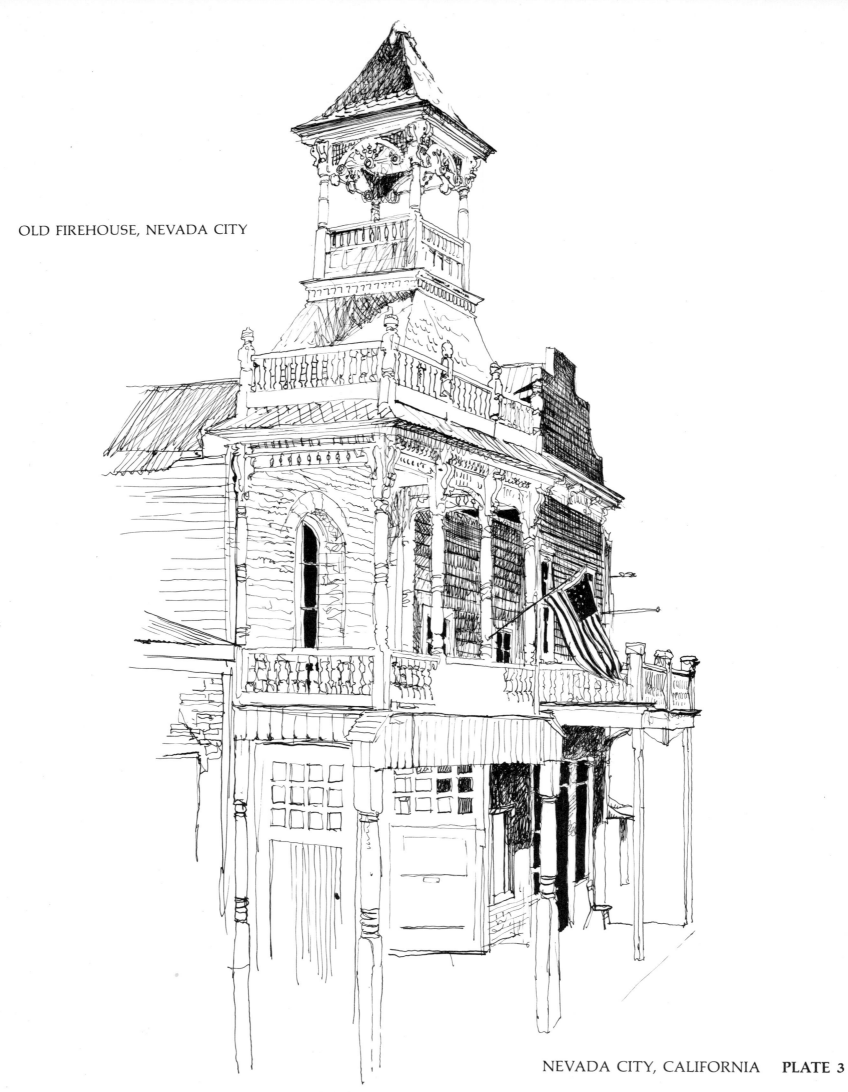

NEVADA CITY, CALIFORNIA **PLATE 3**

We drove through scented pinewoods on a road dappled with sunshine, to find
Nevada City asleep in a bowl in the woods. Time had stood still for a hundred years
here, as though the gold had just run out and the miners had left only yesterday.

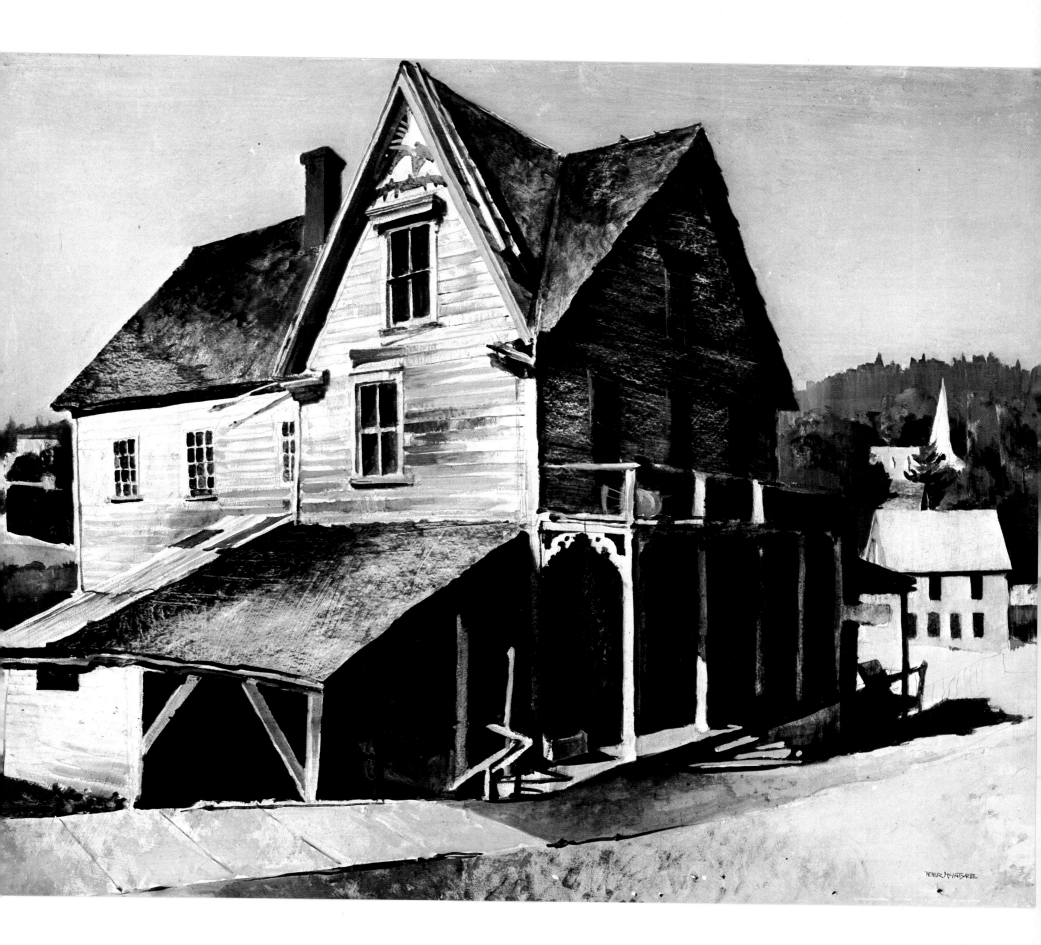

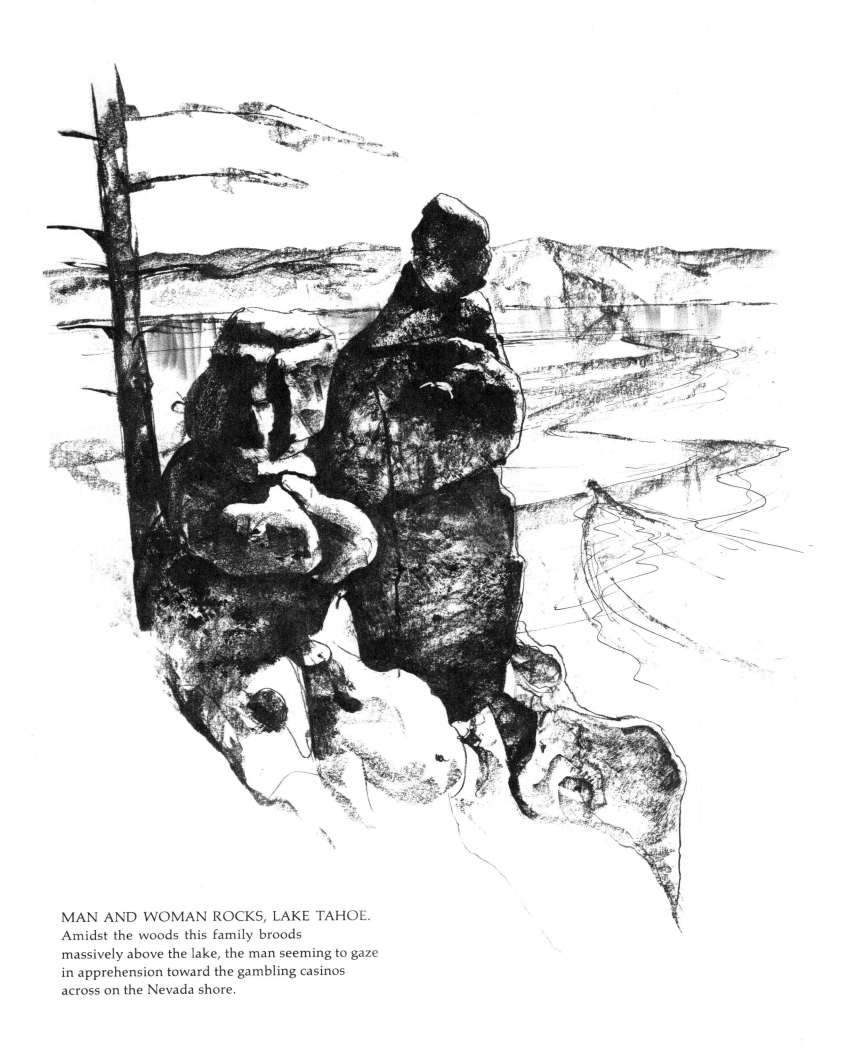

MAN AND WOMAN ROCKS, LAKE TAHOE.
Amidst the woods this family broods
massively above the lake, the man seeming to gaze
in apprehension toward the gambling casinos
across on the Nevada shore.

LAKE TAHOE, CALIFORNIA **PLATE 4**

Pinewoods and time-worn rocks line the trails above bays that lie sparkling in the
sun, as Tahoe in all its beauty tries to hold back the march of civilization.

ANGELS CAMP, MOTHER LODE. A lovely
name and old machinery mark what was once a
boom town in the gold rush days. Mark Twain
came here in 1864 and wrote himself into immor-
tality with "The Celebrated Jumping Frog
of Calaveras County."

AMADOR CITY, CALIFORNIA **PLATE 5**

Great wealth came to Amador in the 1850's from the rich Keystone mine on the
hillside above the town. But inevitably the gold ran out and Amador went back to sleep.

YOSEMITE VALLEY

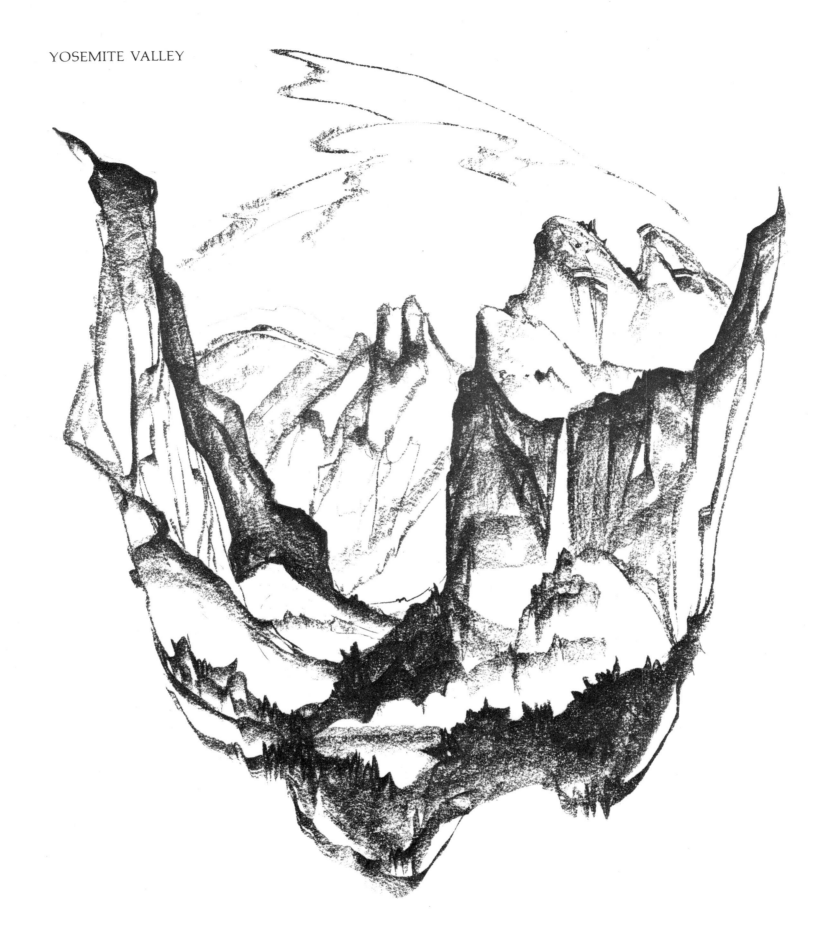

FIRST FALL OF SNOW—YOSEMITE **PLATE 6**

Driving into Yosemite as darkness and the first snow of November began to fall,
we sheltered for the night in a wayside cabin. In the morning we drove on in a white
world of incredible beauty and skidded gracefully into a snowplow. However, a
battered car was a small entry fee to the most strikingly grand and beautiful place I
have seen since I sailed into Hallett Bay in Antarctica.

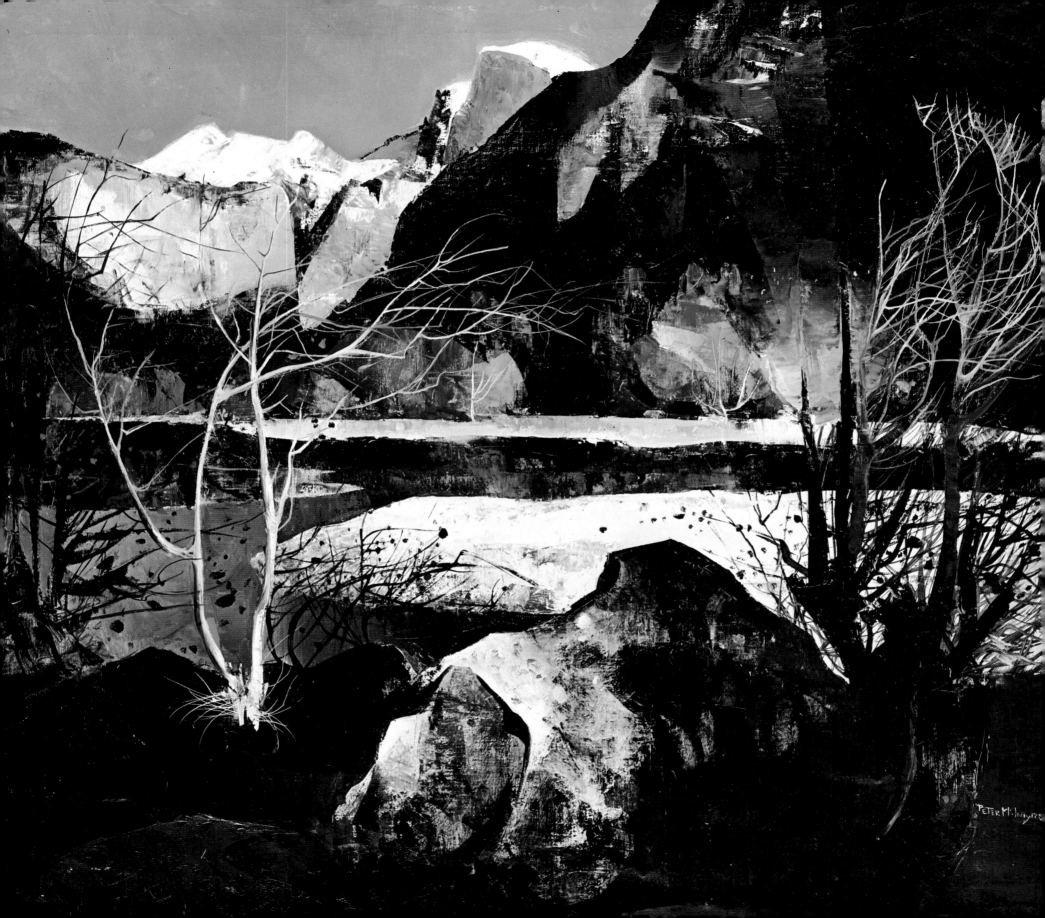

MONO LAKE, CALIFORNIA. Going down the
lovely Owens Valley, one comes suddenly on
this dead and eerie volcanic lake, the tufa
formations seeming to float like icebergs in a
black sea, whose waters, to quote John Muir,
"once mixed with fire."

MOUNT WHITNEY FROM THE ALABAMA HILLS **PLATE 7**

I wandered happily for days among these giant rocks, watching them rise like
monsters in the morning sun and turn gold in the evening. As I painted them, their
shapes seemed to take on such definite personalities that I began to look on them as
people or even, since they are said to be the oldest formations on the
American Continent, the first inhabitants.

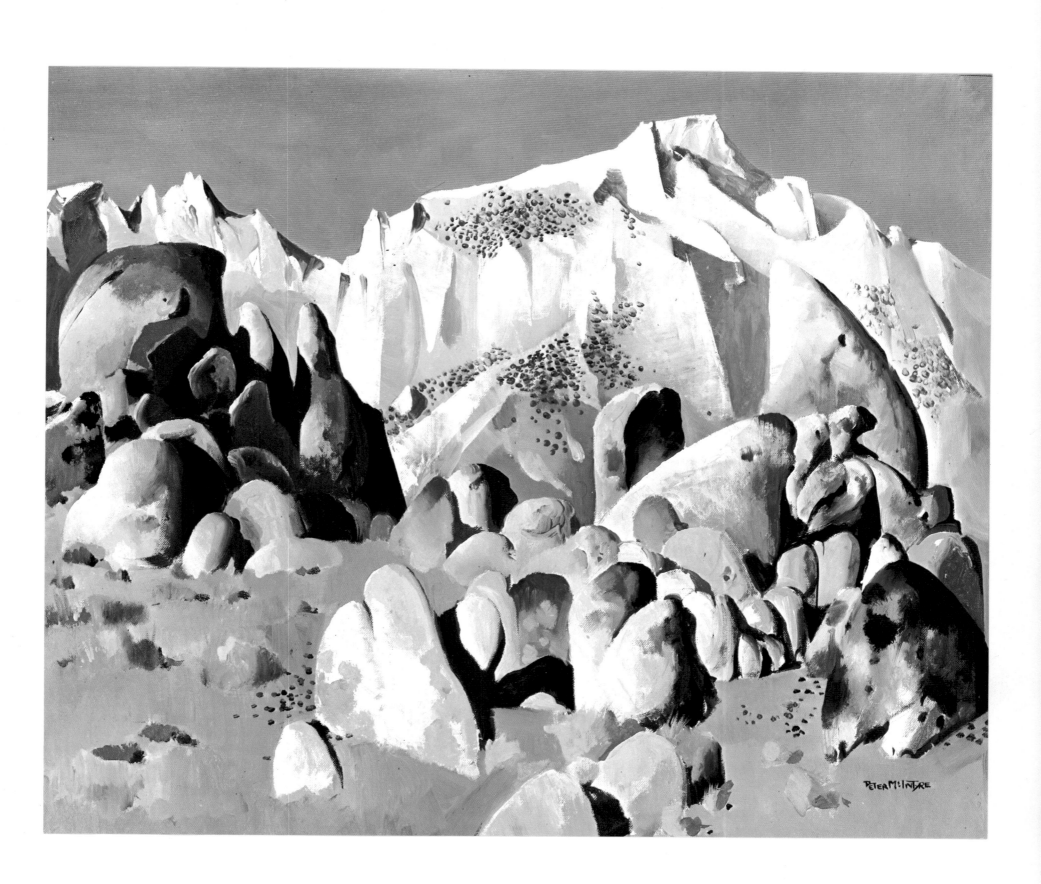

DEATH VALLEY, CALIFORNIA

SAND DUNES OF DEATH VALLEY **PLATE 8**

One hundred and fifty miles long, this is a valley of desolation, where in summer the temperature reaches 120 degrees. On seeing it, I remembered reading of the first white woman to enter Death Valley. In 1848, when thirteen men of a party crossing Death Valley on their way to California died of thirst, her willpower and courage saved not only her husband and three sons but several other men as well. She was Juliet Brier, a tiny, fragile woman.

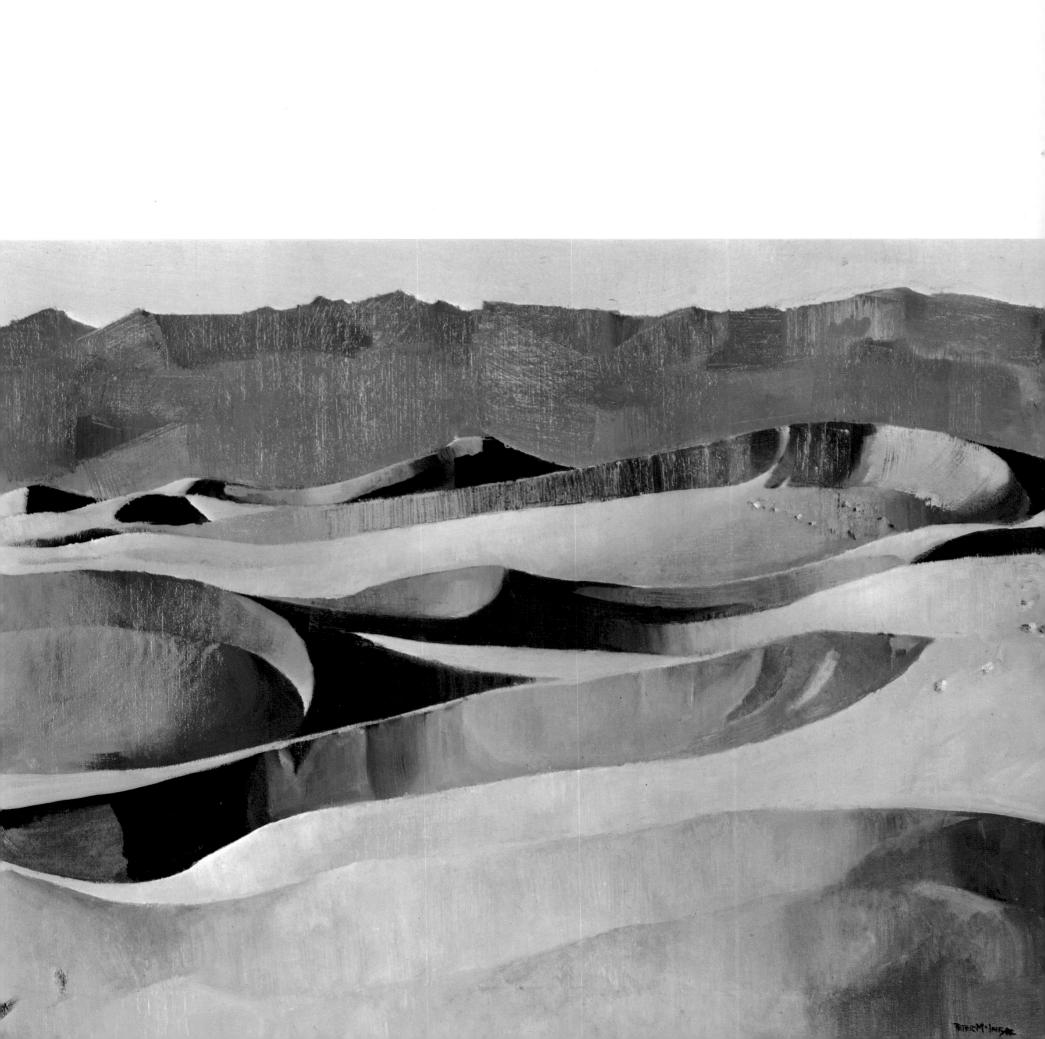

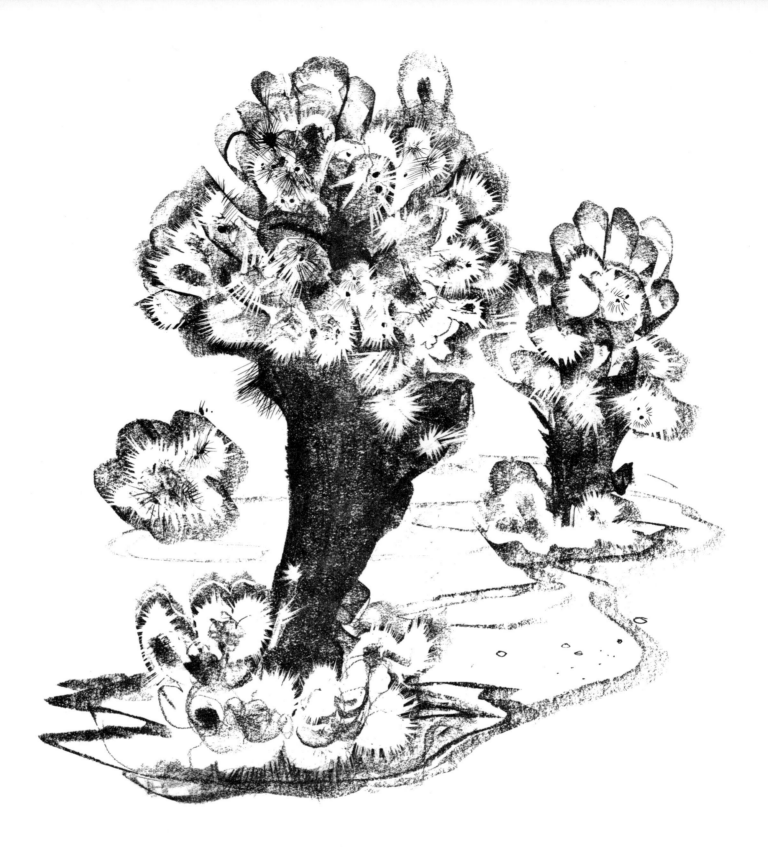

TEDDYBEAR CACTUS. In the vast California
desert garden that is Joshua Tree National
Monument, a whole hillside is gay with chollas,
whose silvery spikes give them a woolly look and
their teddybear name.

JOSHUA TREE MONUMENT **PLATE 9**

The rocks stand in monumental structures seemingly shaped and formed as a vast
altar. Around them the Joshua trees remind one that the Mormon fathers named
them thus since, like Joshua, they raised their arms to heaven.

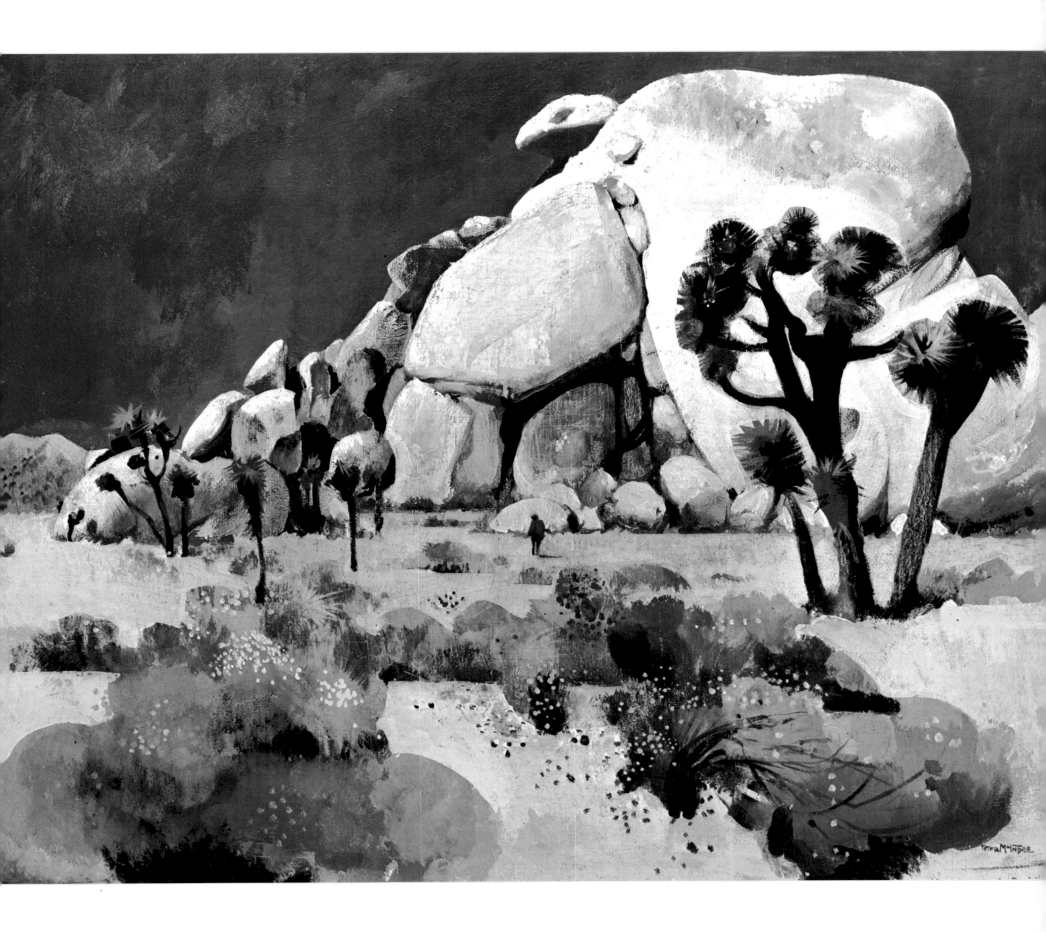

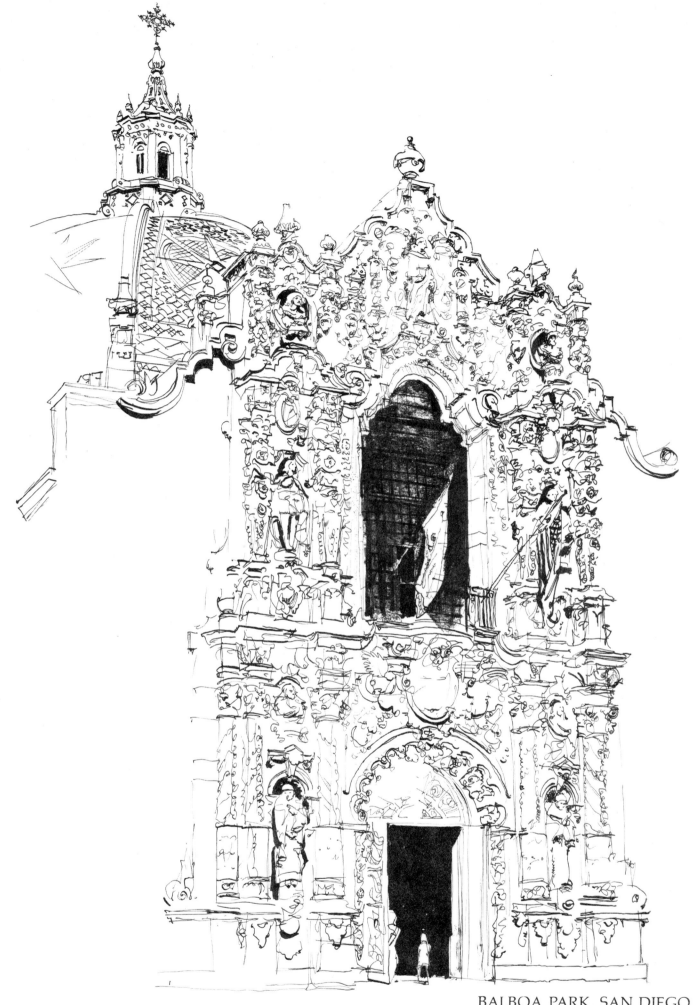

BALBOA PARK, SAN DIEGO **PLATE 10**

There was almost a sensual pleasure in drawing these old exposition buildings in
Balboa Park, the pen seeming to wander hypnotized among the exuberant intricacies
of Spanish Renaissance that serve as a reminder of San Diego's Spanish ancestry.

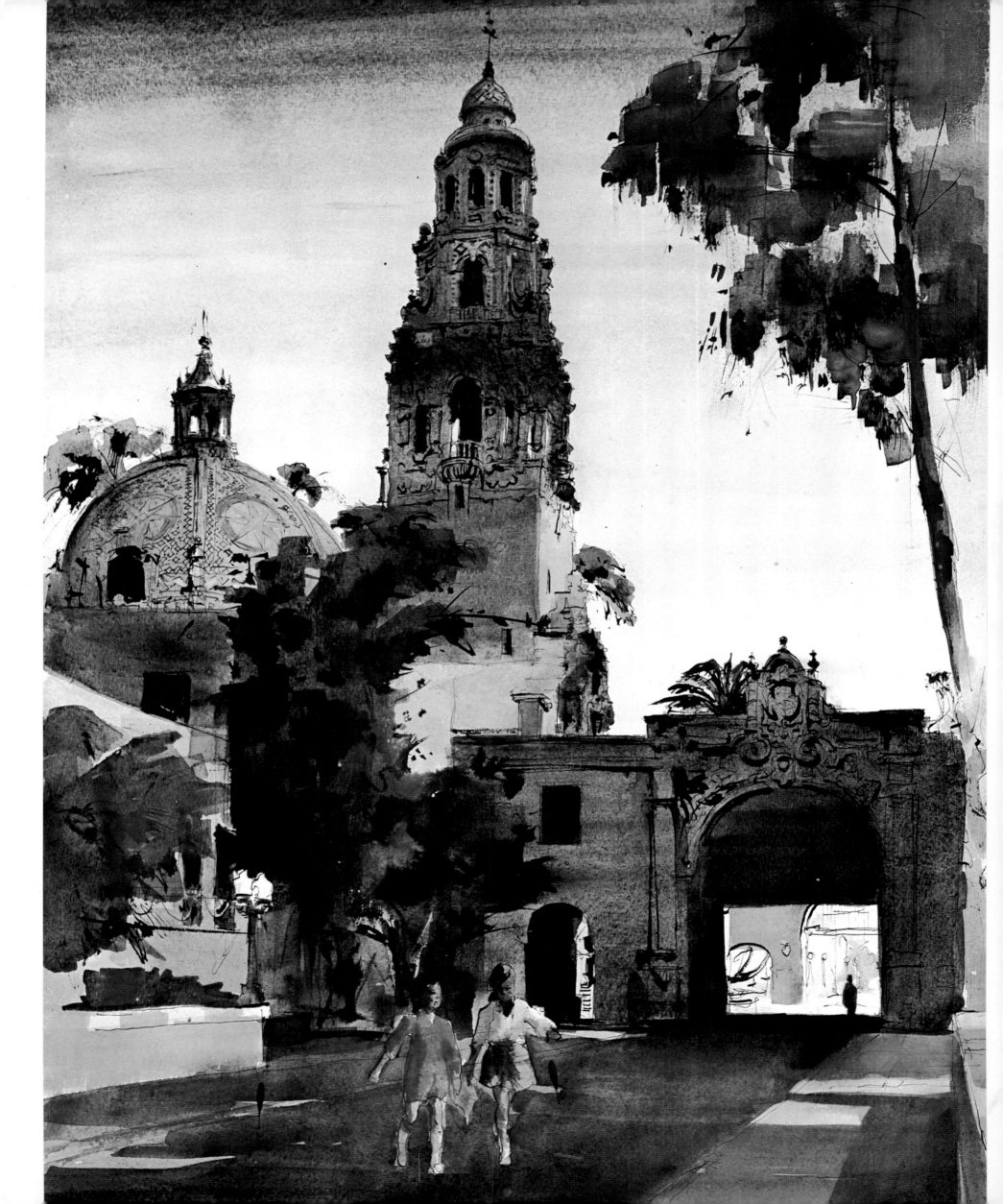

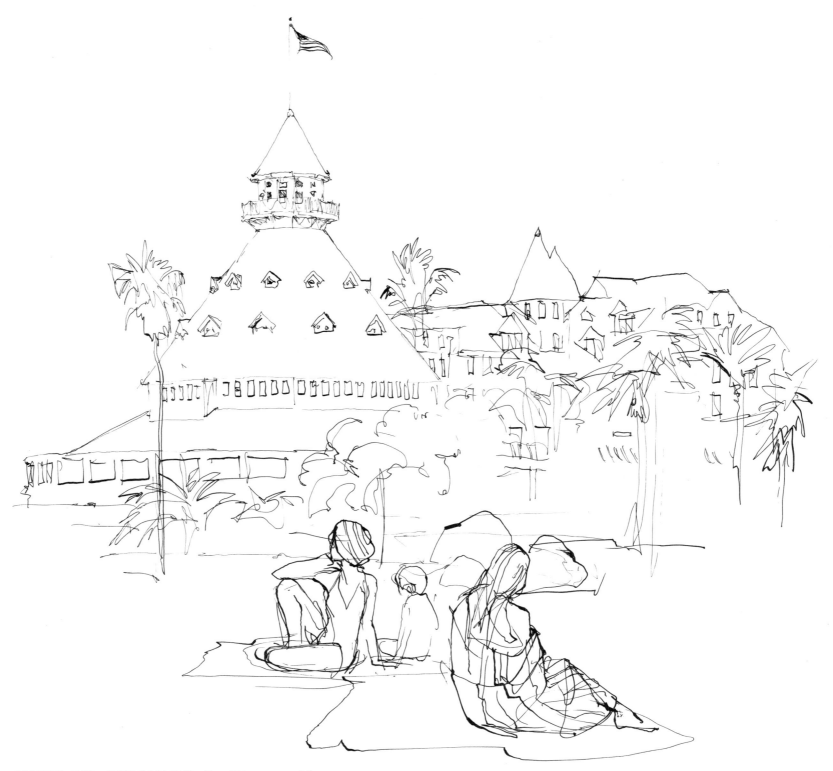

HOTEL DEL CORONADO. San Diego would
not be itself without this glorious piece of
Victoriana that is still a place of
charm and graciousness.

MISSION SAN DIEGO **PLATE 11**

Founded by Father Serra in 1769, and first in the chain of Upper California Missions,
San Diego de Alcalá's simple battered façade befits its turbulent past. Burned
in an Indian attack, later destroyed by earthquake, it has been
rebuilt and restored many times.

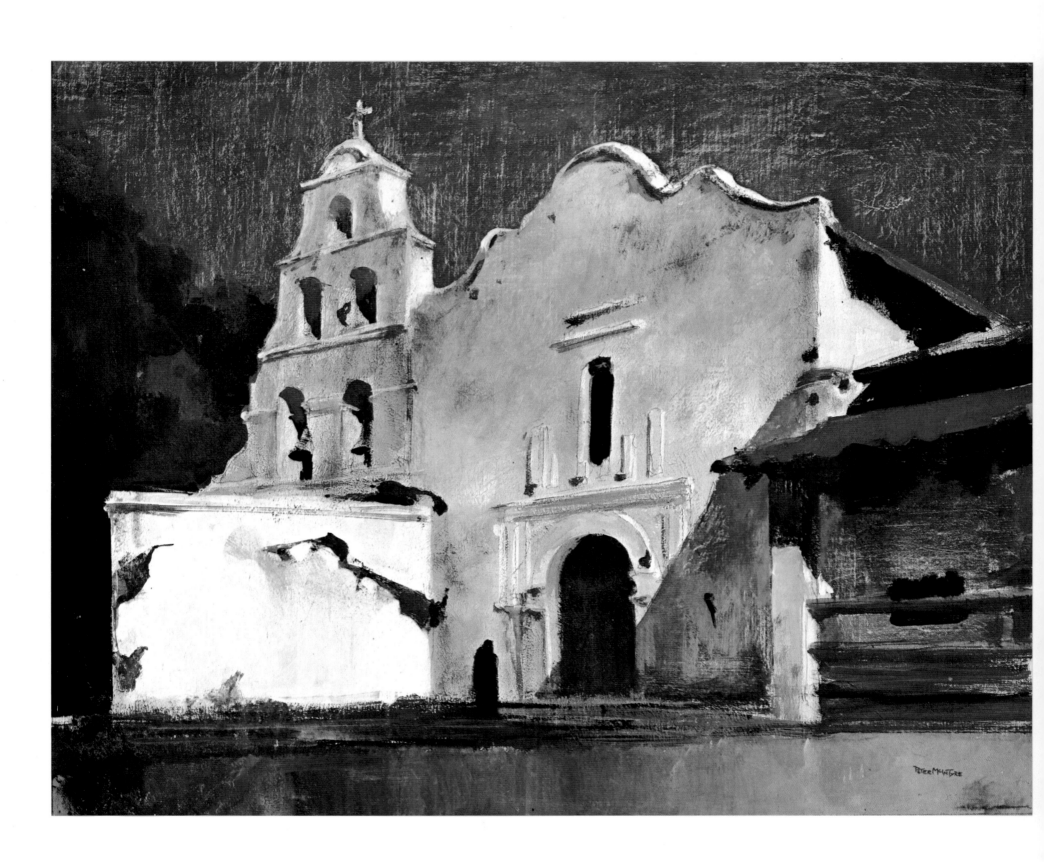

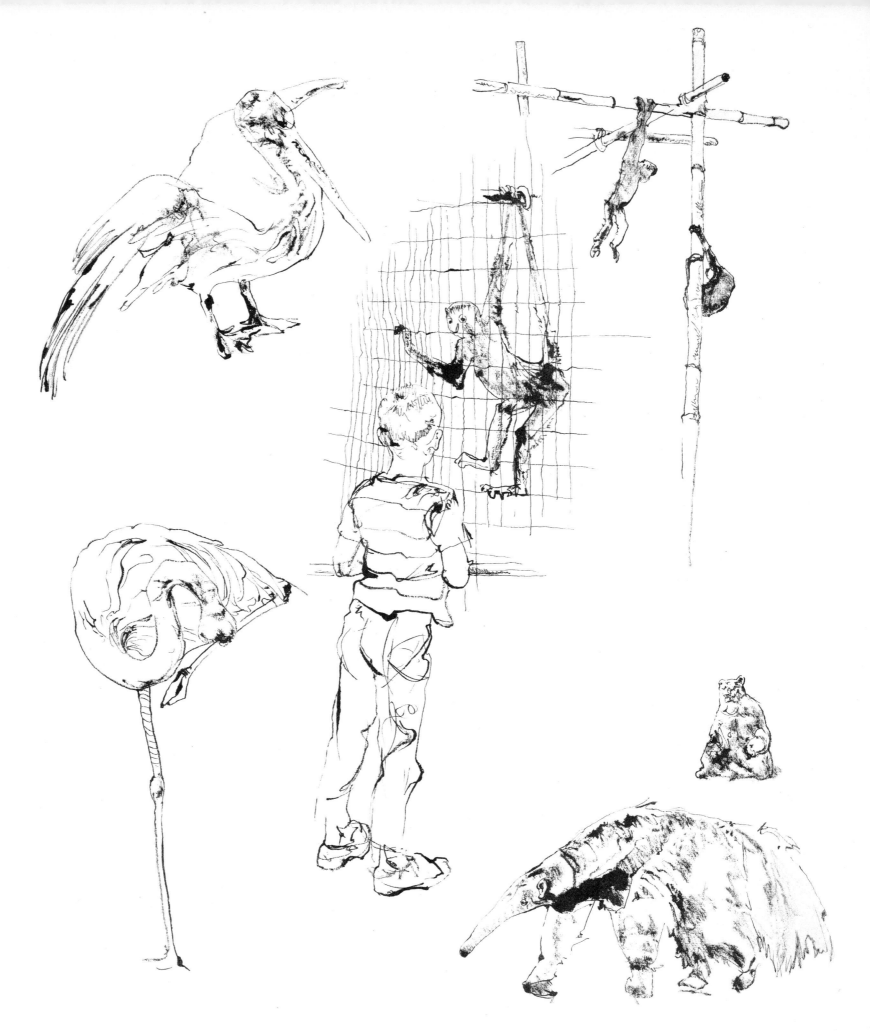

SAN DIEGO ZOO **PLATE 12**

My wife, Patty, had an awful time getting me here. "Go to the Zoo? Why?" I wailed.
I loved it and couldn't resist painting it—the most attractive zoo in the world.
Tropical birds fly among a luxuriance of exotic trees; leafy paths wind into canyons
where pelicans dive and the creatures of the earth walk without fear.

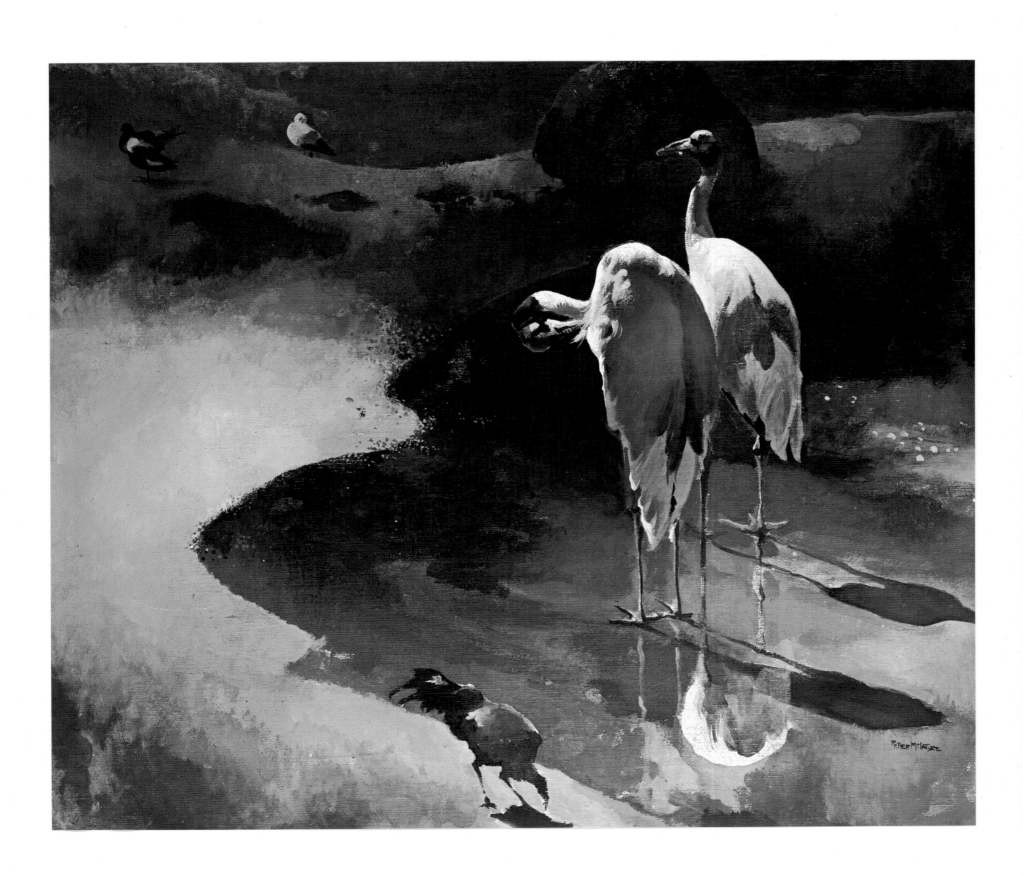

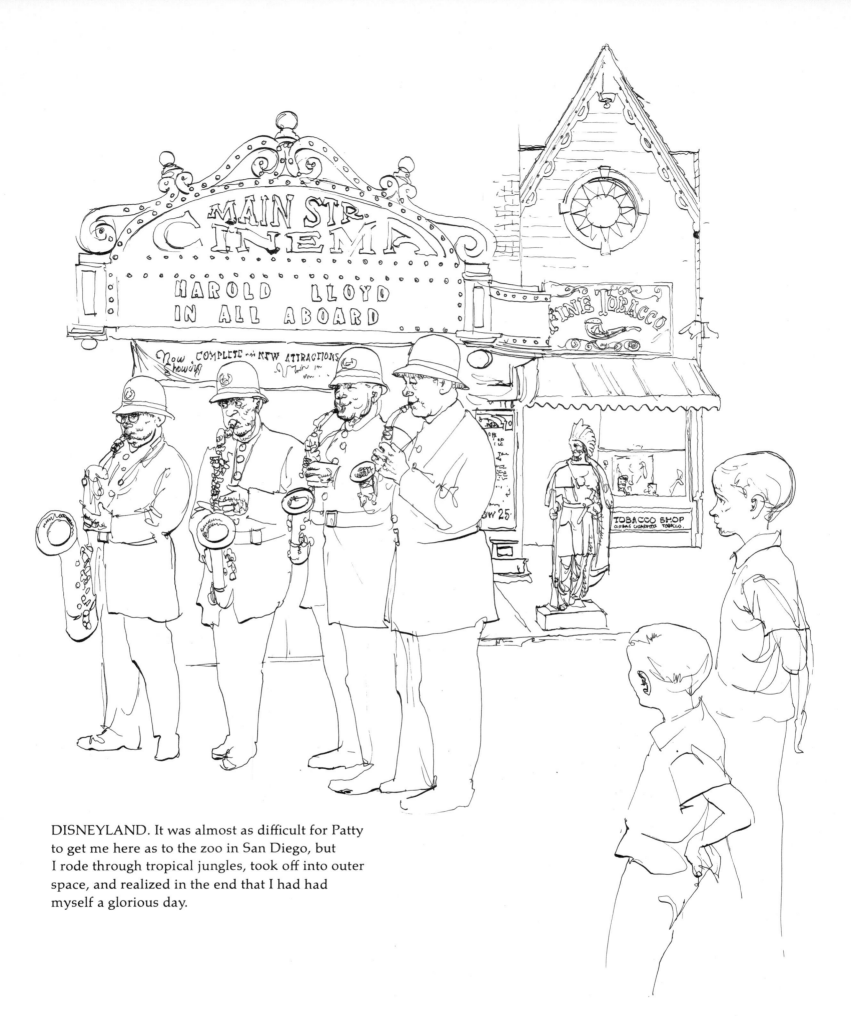

DISNEYLAND. It was almost as difficult for Patty
to get me here as to the zoo in San Diego, but
I rode through tropical jungles, took off into outer
space, and realized in the end that I had had
myself a glorious day.

LAGUNA BEACH **PLATE 13**

After the dazzling make-believe of Disneyland, we went to Laguna, where we found
very real and very happy Californians living in houses that hung out over the surf
or nestled under huge shade trees. The freeways might as well have been a
thousand miles away. We were tempted to stay forever.

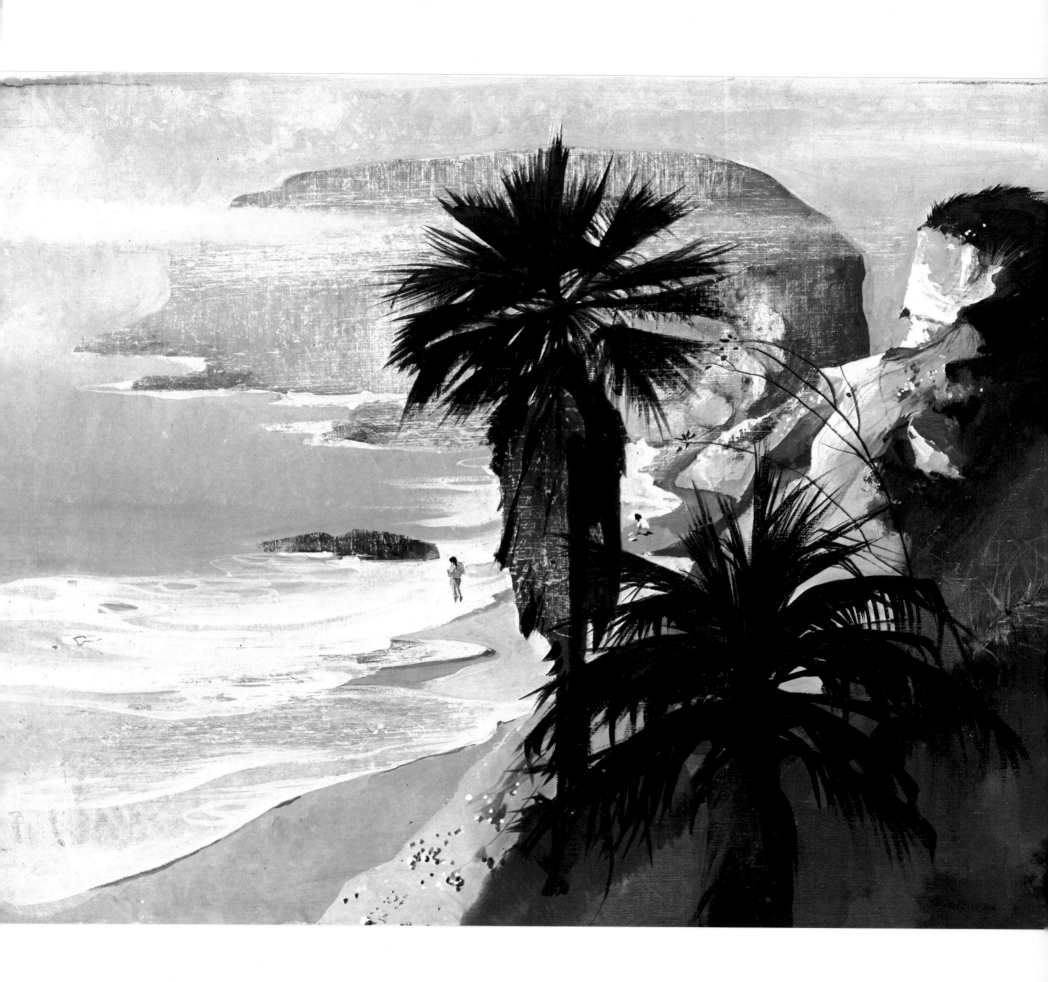

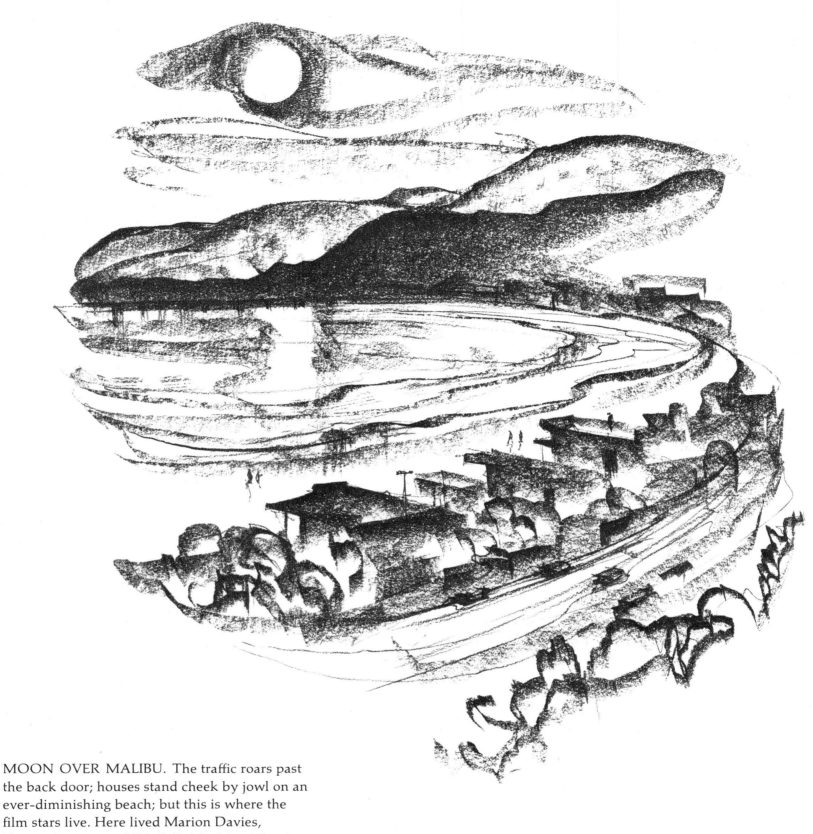

MOON OVER MALIBU. The traffic roars past
the back door; houses stand cheek by jowl on an
ever-diminishing beach; but this is where the
film stars live. Here lived Marion Davies,
Norma Shearer, and W. C. Fields. Mae West is
still here. Malibu also has some of the most
expensive real estate in America.

LOS ANGELES COUNTY ART MUSEUM **PLATE 14**

For me, driving on the freeways into Los Angeles for the first time (nose to tail, five
lanes deep, sixty miles per hour) was a nerve shattering experience. Yet in the
luxury of Wilshire Boulevard there is spacious charm, even a peaceful oasis, such as
this pond with its Calder Mobile. But that was at six in the morning.

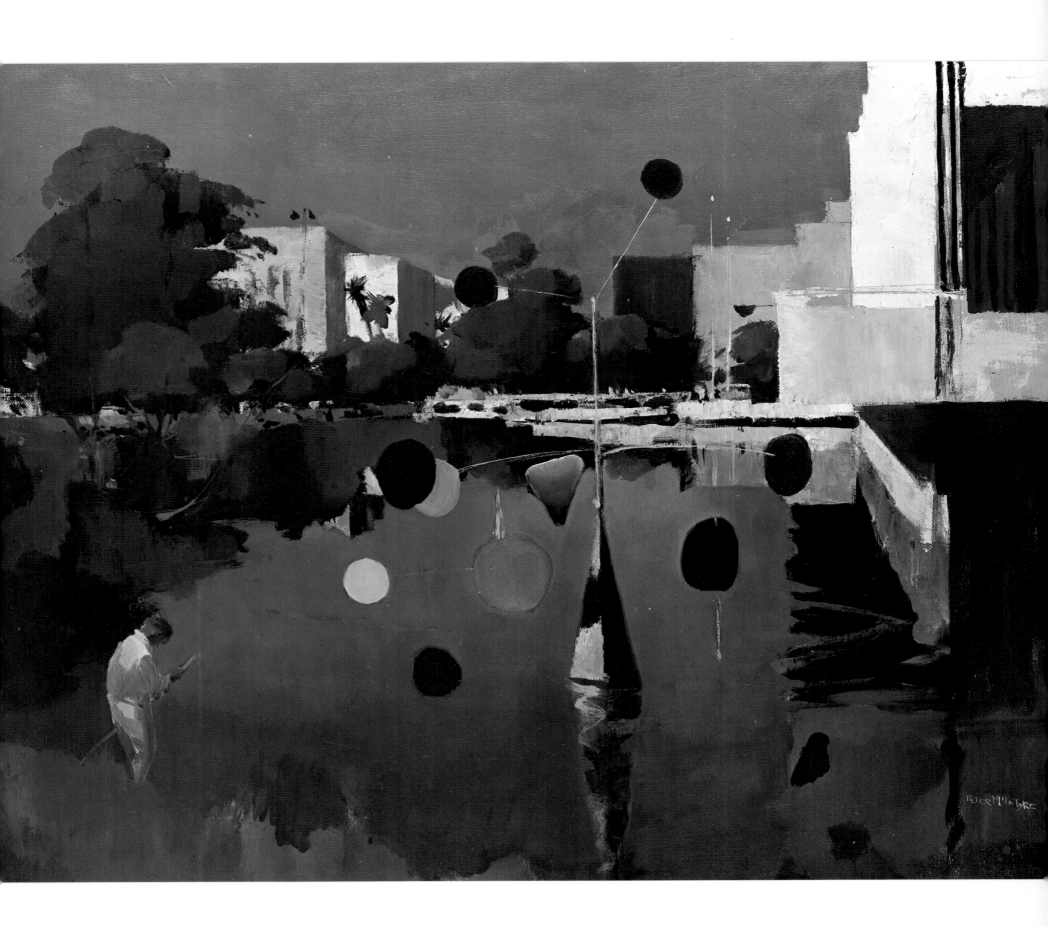

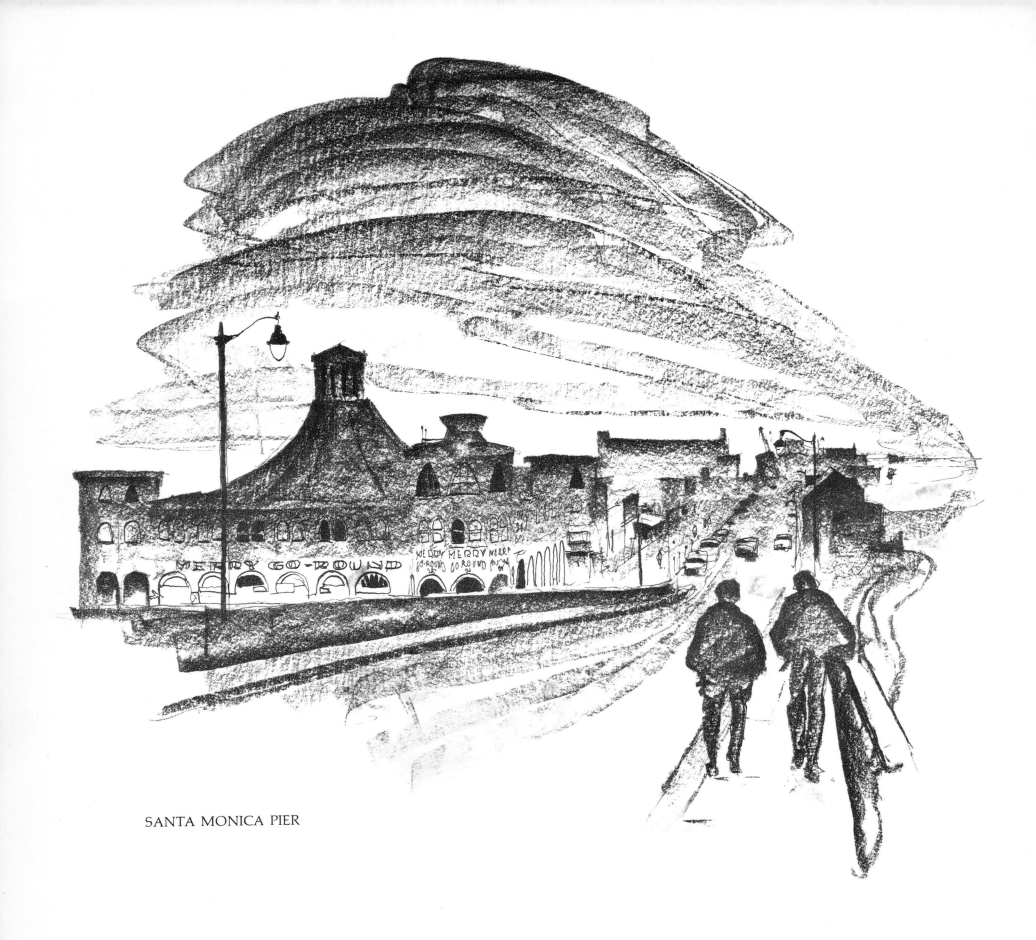

SANTA MONICA PIER

VENICE, CALIFORNIA **PLATE 15**

You simply can't paint Los Angeles—its vast ocean of nothingness with immense
vitality—but in the aged seediness of Venice I found what I wanted: a surrealist
suspension of life embalmed in a shroud of smog.

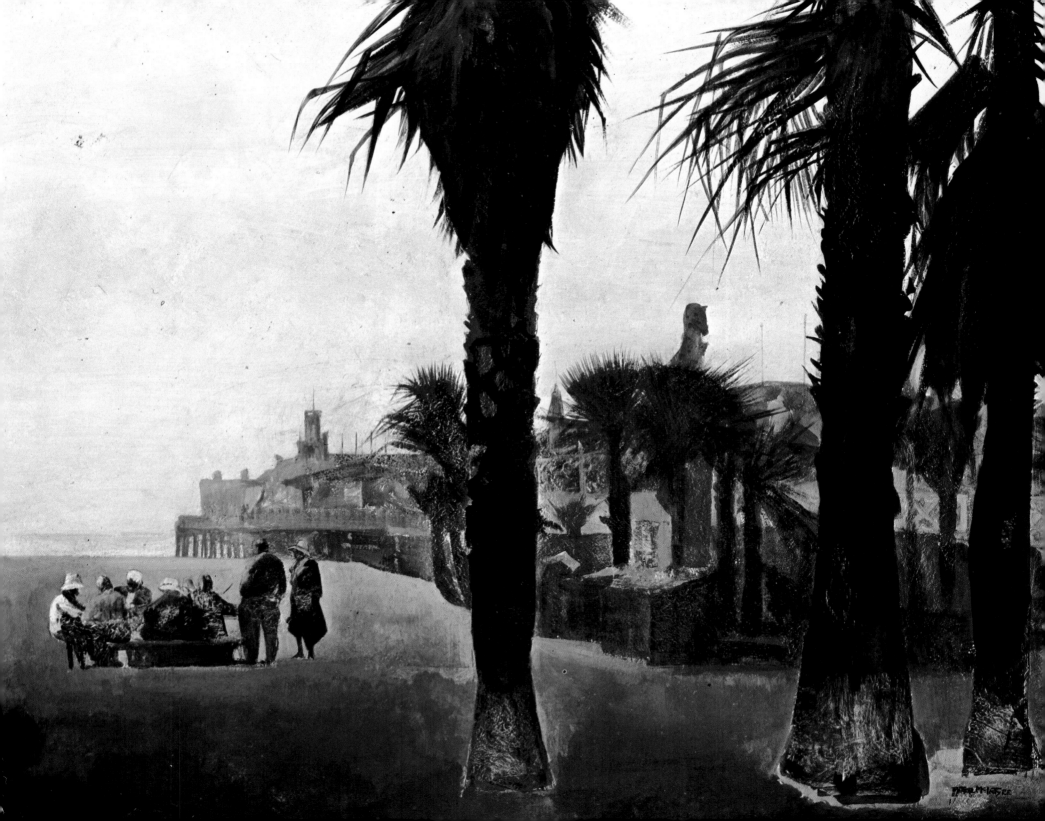

BOYS FISHING ON SANTA BARBARA PIER

PONY MEET NEAR SANTA BARBARA **PLATE 16**

For nearly two hundred years—almost since the founding of its mission in 1786—
Santa Barbara has meant palm-shaded luxury and a gracious way of life. We
wandered its lovely streets, wishing we could buy almost every one of its tile-roofed
houses. We shopped under Spanish arches. We had tea in one of those old
fairytale Spanish castles with a very gracious lady who still lived in the
manner of old Santa Barbara. We were even greeted at the door by
a venerable English butler called Billings!

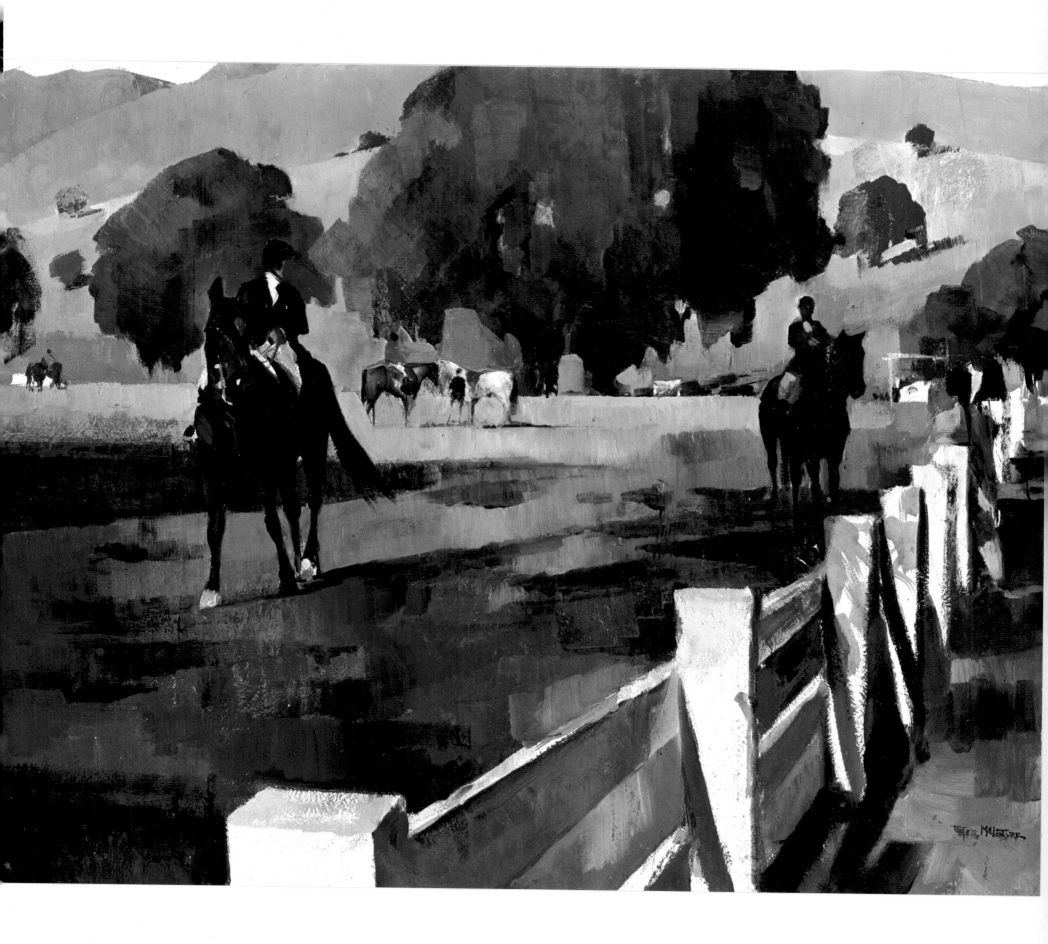

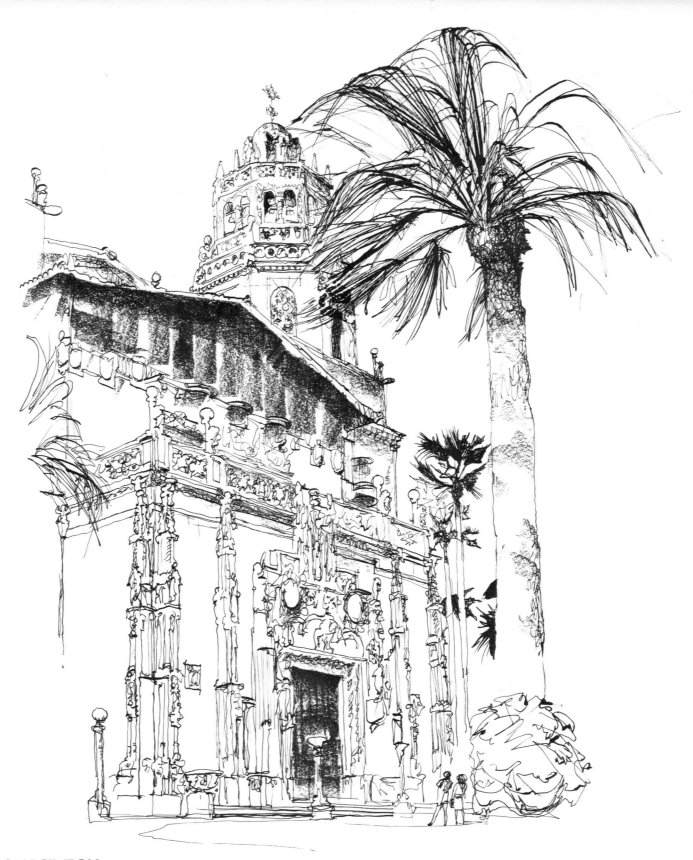

HEARST CASTLE, SAN SIMEON.
William Randolph Hearst called it home, but it's
every romantic's dream castle. While not exactly
to everyone's taste it certainly has glamour—
glittering, gilded heaps of it.
 I like the story of Marion Davies spending
Easter there. The only other guest was the then
President of the United States, Calvin Coolidge.
Said Miss Davies, who spoke with a stutter,
"It was t-terrible. I had n-nobody to t-talk
to but H-Hearst and C-Coolidge!"

MORRO BAY, CALIFORNIA **PLATE 17**

In the late afternoon sun, small boys heading homeward and the fishing boats
unloading formed a setting for Morro Rock. From Morro Bay to Ketchikan, Alaska,
the boats come in laden with the bounty of the Pacific.

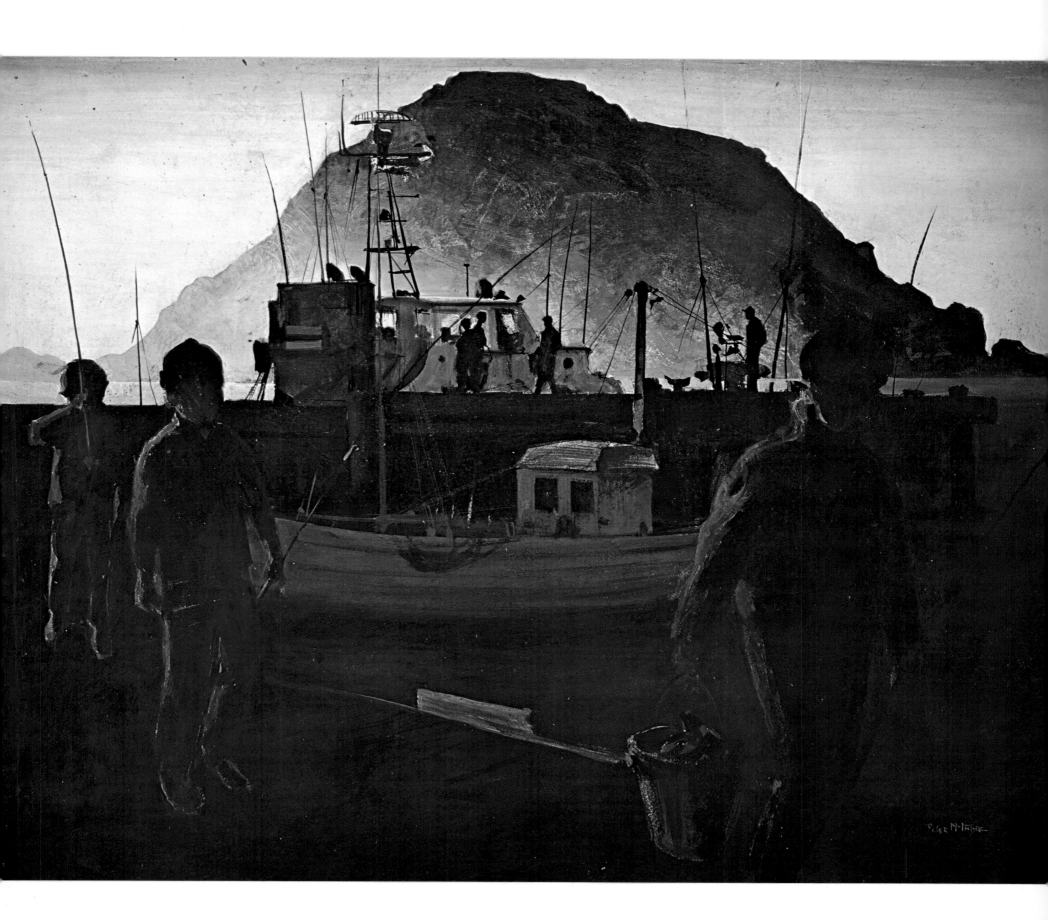

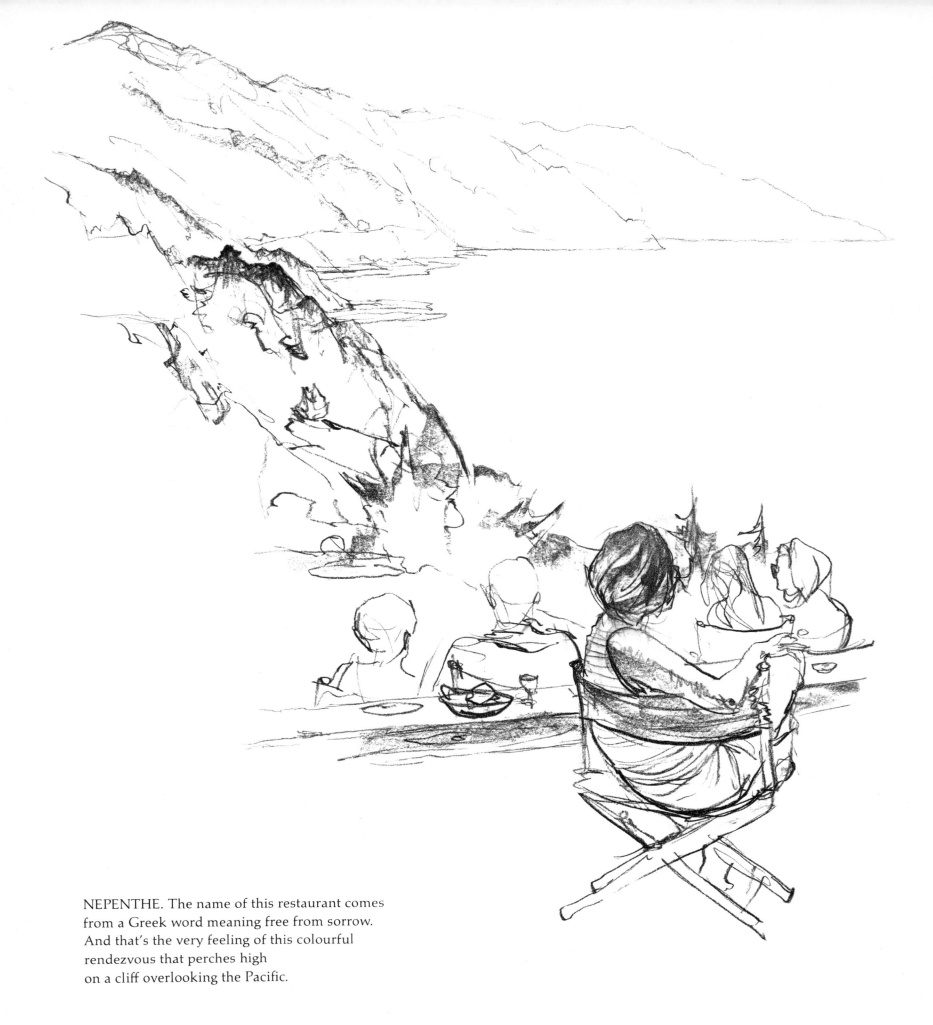

NEPENTHE. The name of this restaurant comes
from a Greek word meaning free from sorrow.
And that's the very feeling of this colourful
rendezvous that perches high
on a cliff overlooking the Pacific.

BIG SUR COASTLINE—CALIFORNIA **PLATE 18**

Sit in the sun with a glass of wine and watch the surf sweep white over black rocks
far below. The sound of insects fills the air; seagulls swoop and circle; and the flower
people wander barefoot in search of the elusive paradise that lies at their feet.

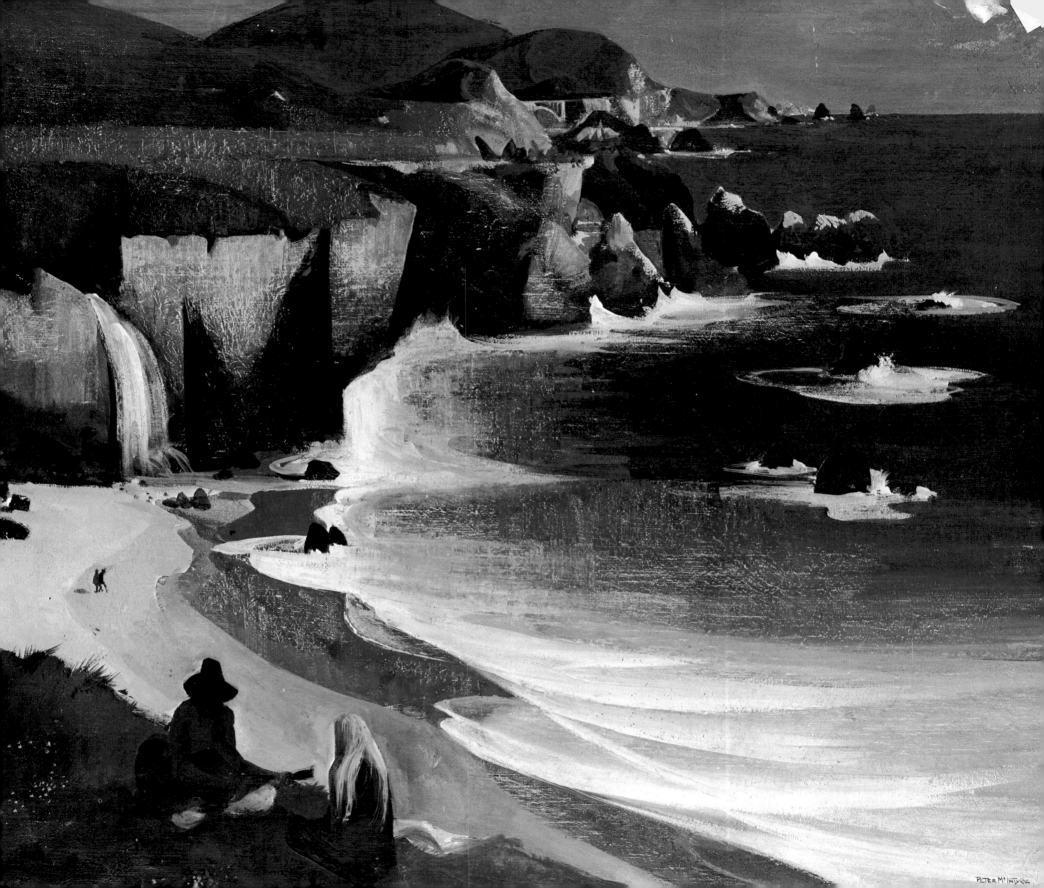

CARMEL BEACH. It was my birthday, the 4th of
July, and I watched the young people—hippies,
flower children—thronging Carmel Beach. I tried
to remember my own youth as an art student
in London, and across that great gap of years
there wasn't much difference after all, except that
I've forgotten what I was indignant about.

CANNERY ROW, MONTEREY **PLATE 19**

Nostalgia for things past. It can come to you in a place you've never seen before—
but then, years earlier, I'd had my Steinbeck era and had practically lived here in
my mind with Doc and the rest. Here it was, suddenly, real with that strange mixture
of daydream and harsh reality that is Cannery Row.

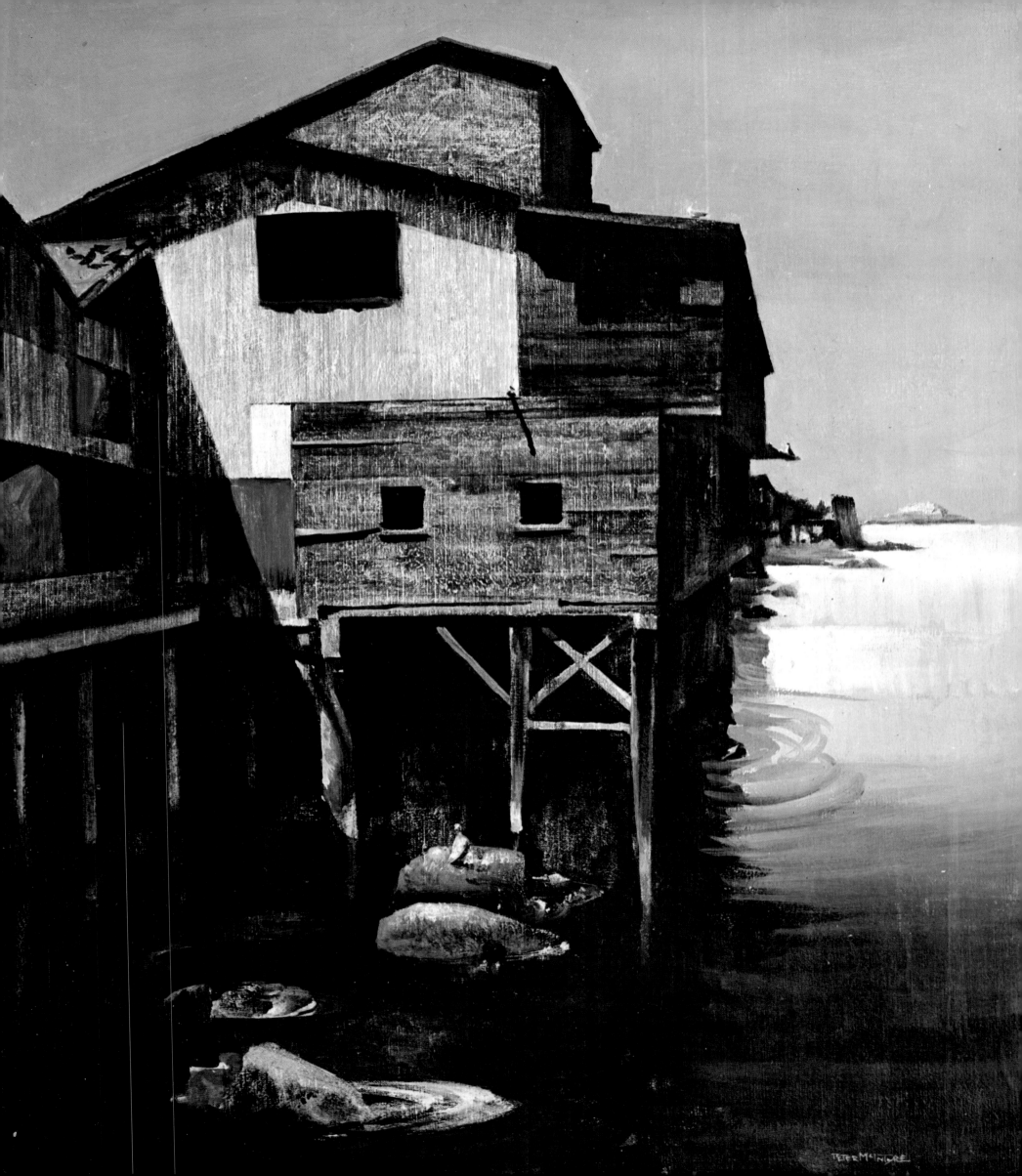

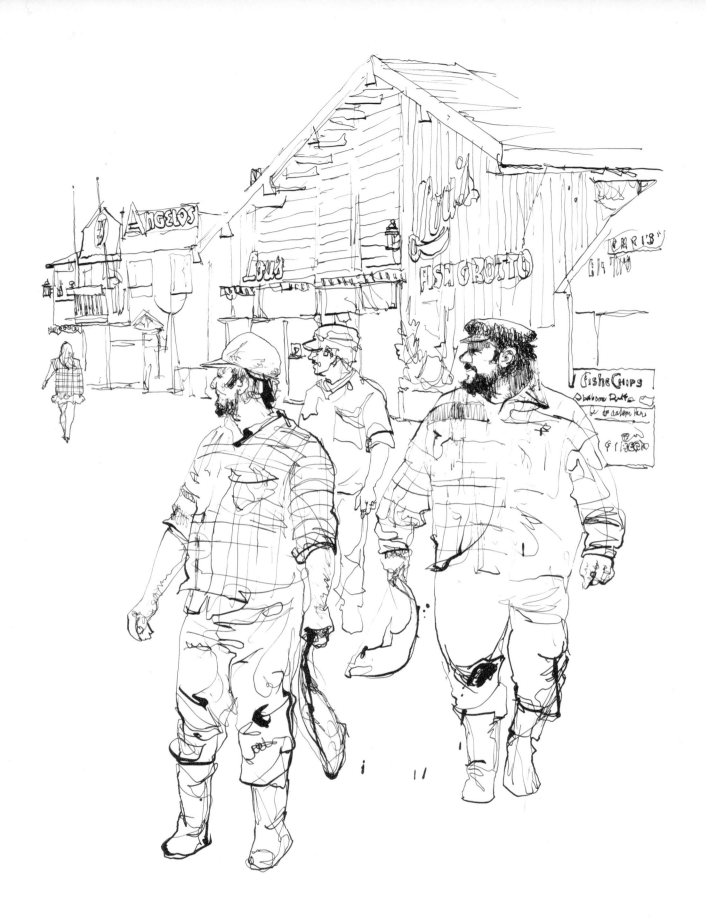

FISHERMAN'S WHARF, MONTEREY **PLATE 20**

Its past is Spanish. Cabrillo discovered Monterey Bay and claimed it for the
King of Spain, way back in 1542. Now on the Wharf the Italians seem to have taken
over with all the uninhibited gusto of their race. From the feel of
the place, I might almost have been in Naples.

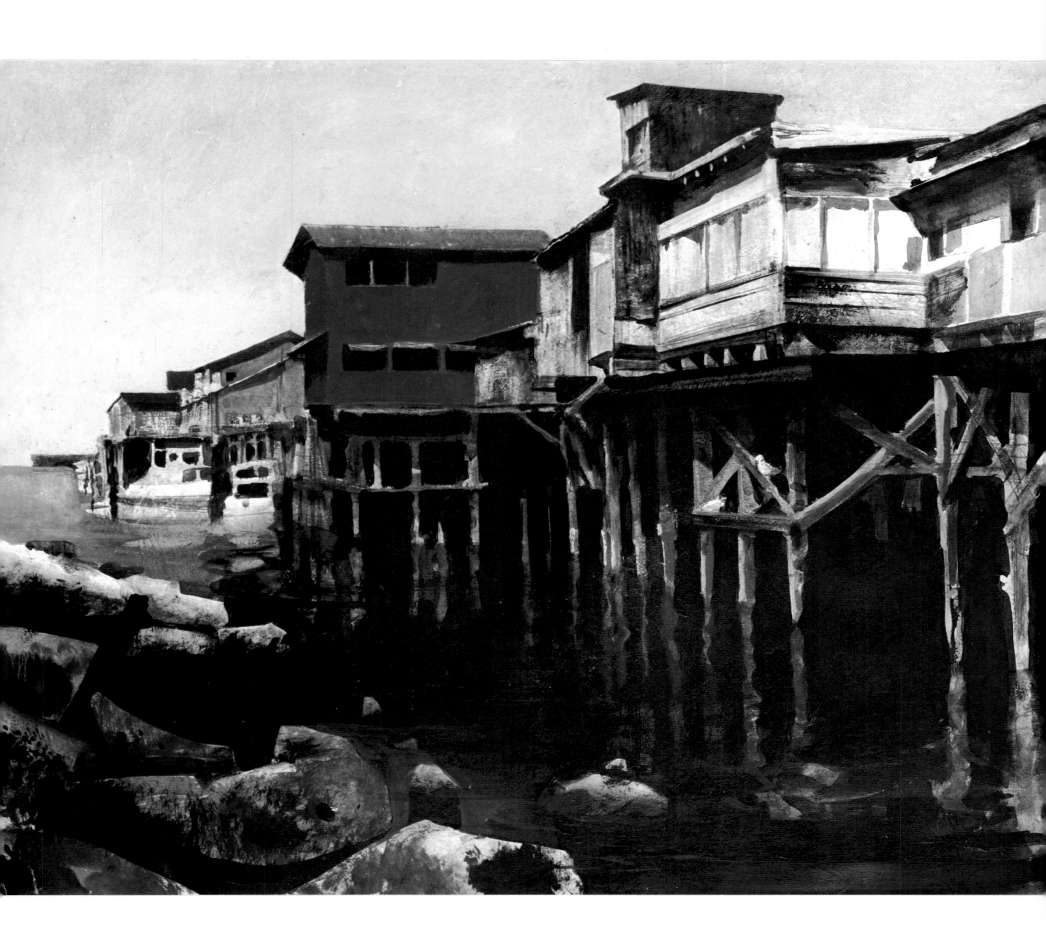

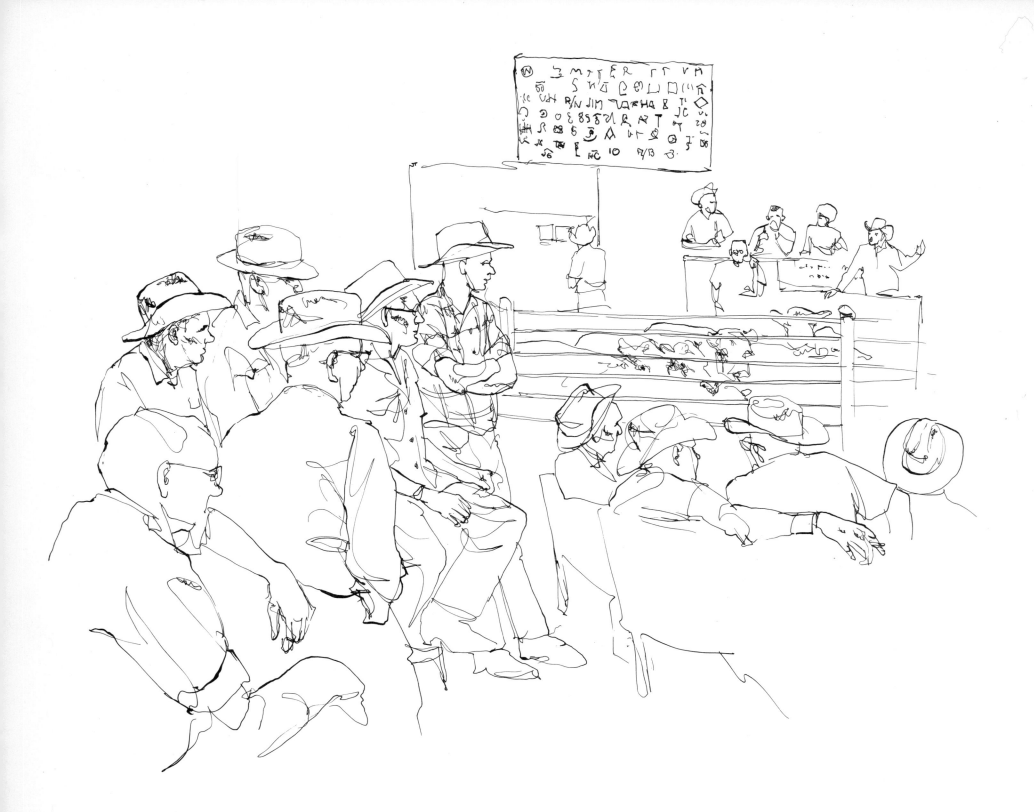

STOCK SALE AT COTTONWOOD.
Northern California has its own type of rancher.
He wears a straw hat instead of a Stetson, but
he has a shrewd eye for a cattle-beast.

GIANT REDWOOD GROVE **PLATE 21**

Stand in these groves on the Northern California coast and gaze up and up and
through shafts of filtered sunlight. The smallness of our stature, the shortness of our
time on earth are brought home in the hushed, awesome silence of the glade.
These are the tallest of all living things, and are older by far then Christianity.

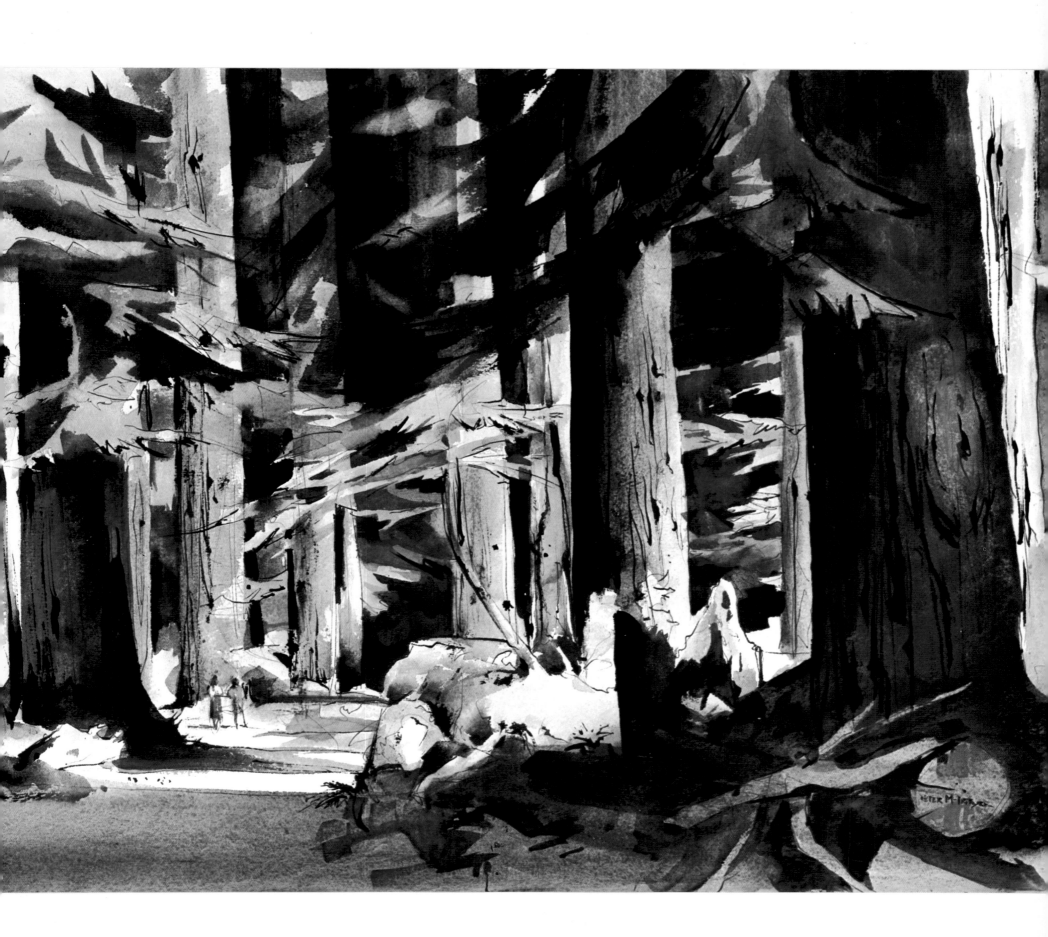

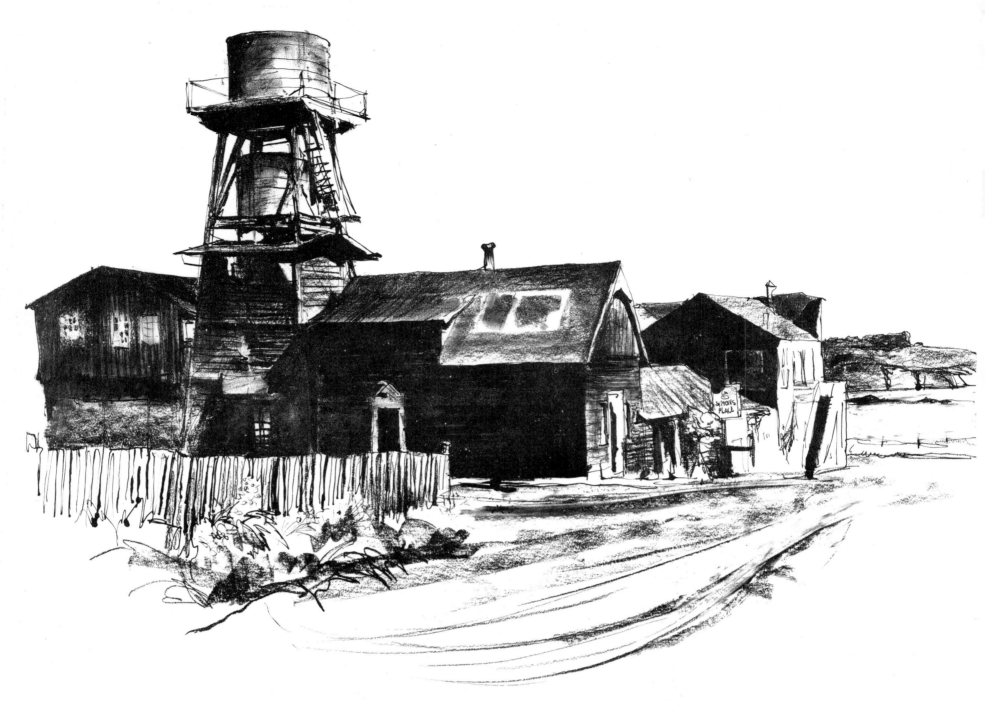

BACK STREET IN MENDOCINO

CEMETERY—MENDOCINO, CALIFORNIA **PLATE 22**

We slept in a four-poster in a room with whitewashed walls whose balcony looked
out over fields of wildflowers to the cliffs and the sea. The town was a perfect jewel—
houses with simple white walls and high-pitched roofs. Tall windmills dotted the
town. Then the sea fog rolled in and Mendocino appeared through a lifting and
falling veil in soft greys and luminous whites. A fog horn echoed eerily
through the mist. Here was New England come to California.

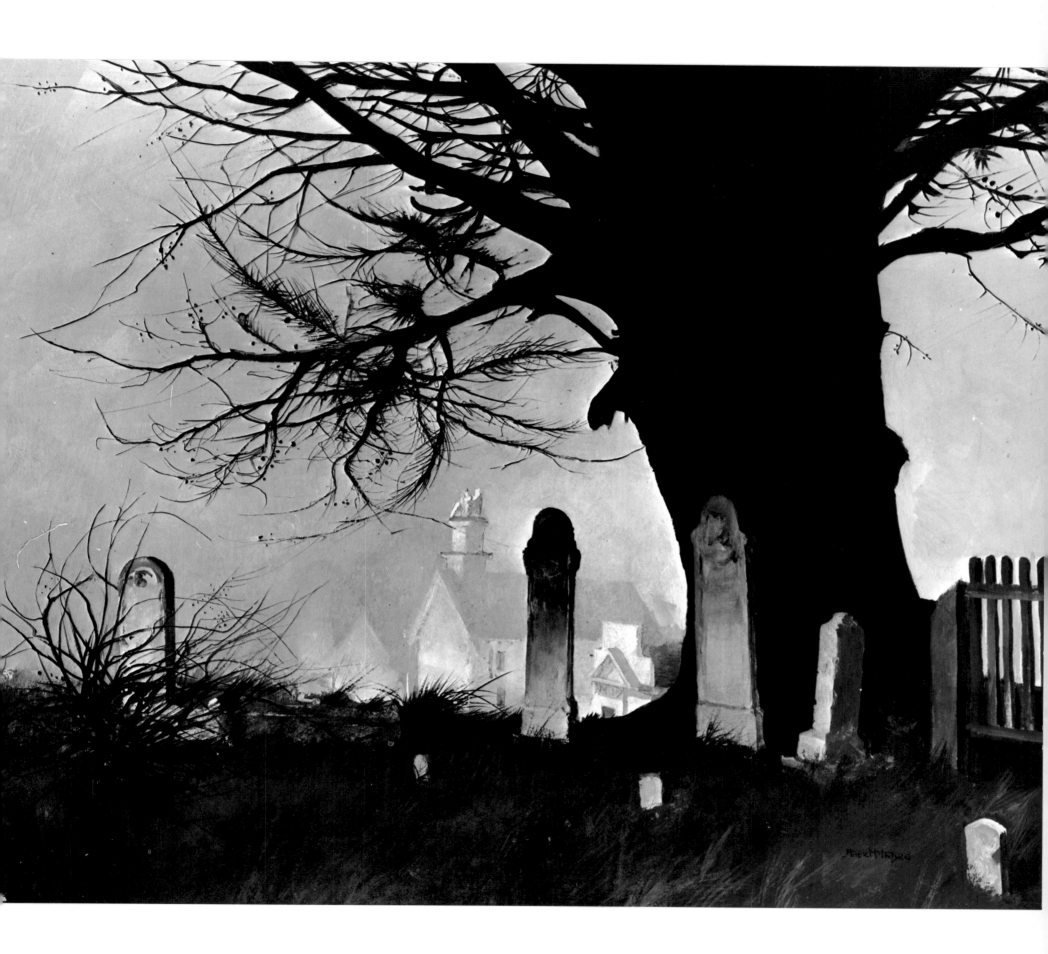

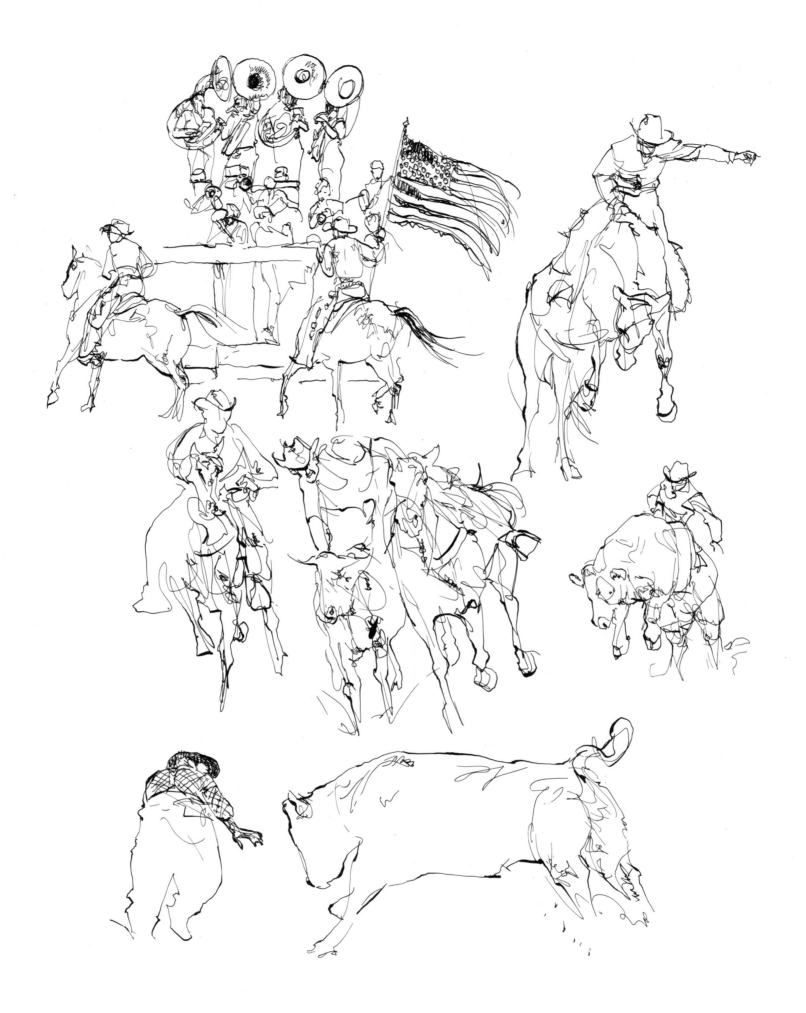

RODEO AT TUCSON, ARIZONA　**PLATE 23**

The great Western sport. Highly dangerous and requiring lots of plain guts, this
descendant of the old cowboy days is wonderfully spectacular and popular...and
it pays more prize money than golf. In Tucson we saw the
University of Arizona put on its own rodeo.

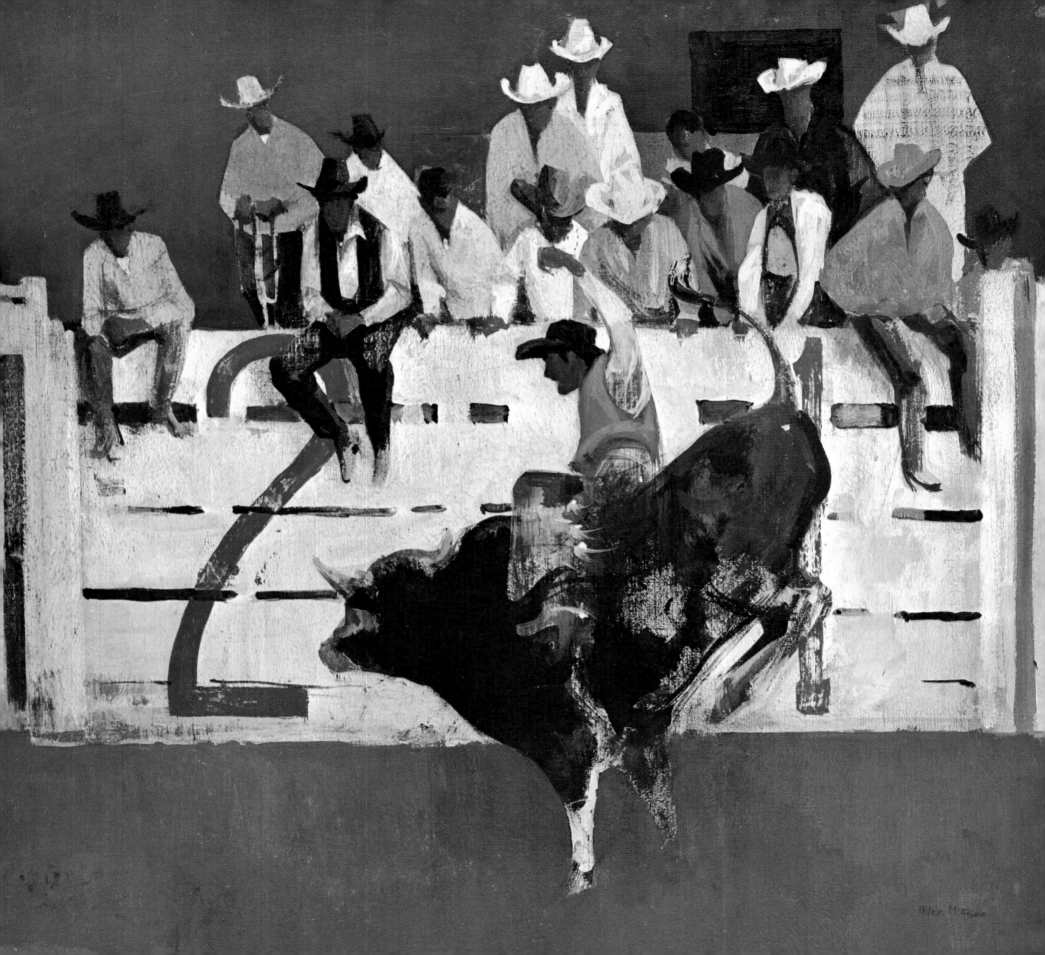

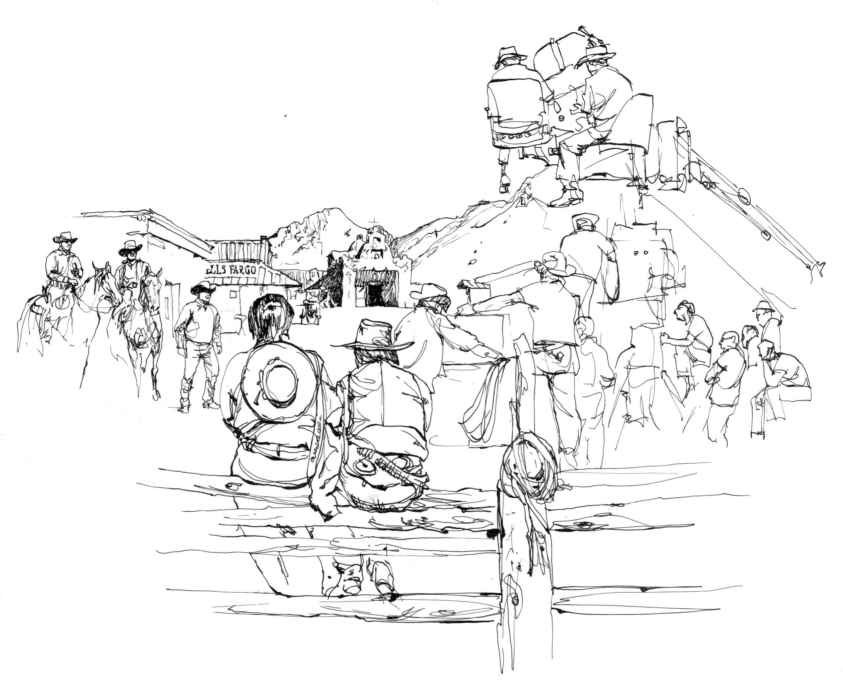

FILMING *HIGH CHAPARRAL.* It was a little strange to sit around among people whose faces and clothes were more familiar than those of the next-door neighbors, but then we often watch *High Chaparral* on TV at home in New Zealand. There was Blue Boy looking bored, and Big John and Buck playing poker. They film from sunrise to sunset six days a week for one hour of television.

MOVIE SET—OLD TUCSON　**PLATE 24**

Built for a movie, *Arizona,* in 1940, the set is a nostalgic physical re-creation of the Tucson of a hundred years ago. Many of the buildings are more than mere shells, serving as shops that cater to the curio conscious visitor.

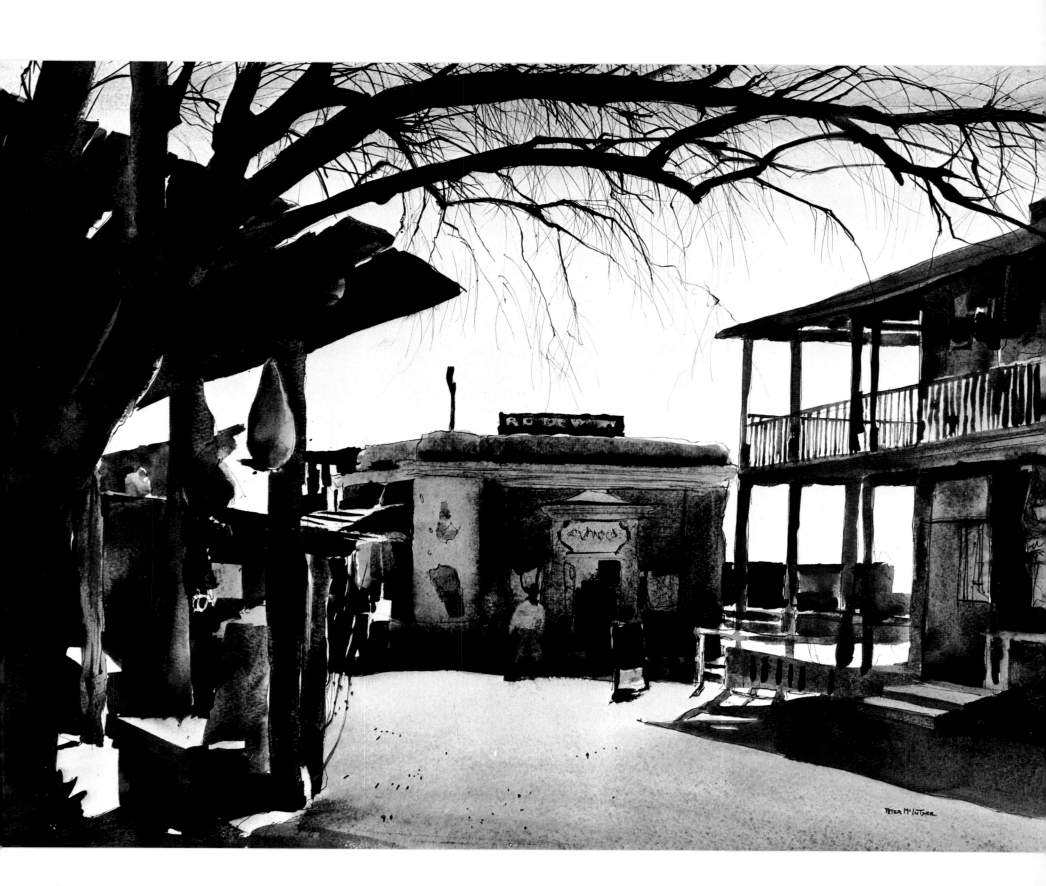

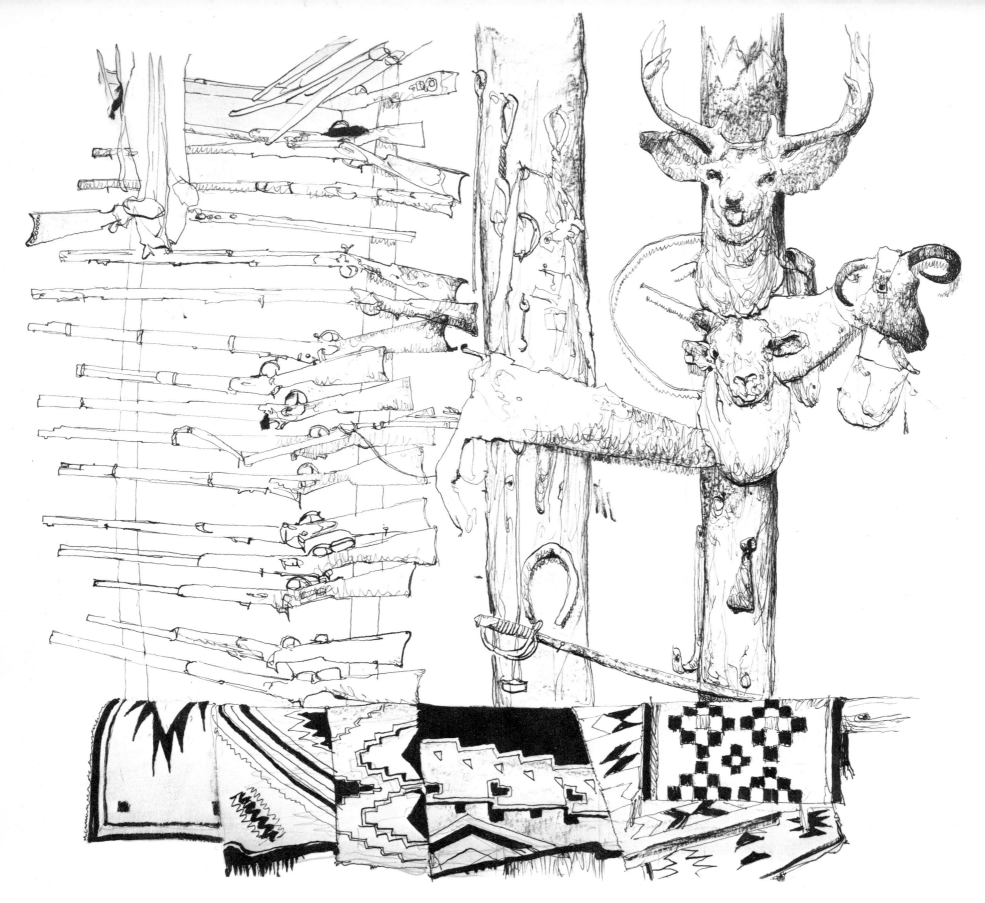

HUBBELL'S TRADING POST, GANADO,
ARIZONA. In 1876 the pioneer Lorenzo Hubbell
came to trade with the Navajos. Today the old
trading post remains as a perfectly preserved
and genuine piece of the Old West.

PAINTED DESERT, ARIZONA **PLATE 25**

This is Indian country. Here the Hopis and the Navajos still live. Here russet-reds,
yellows, and greys seem as if painted on the vast canvas of the desert.

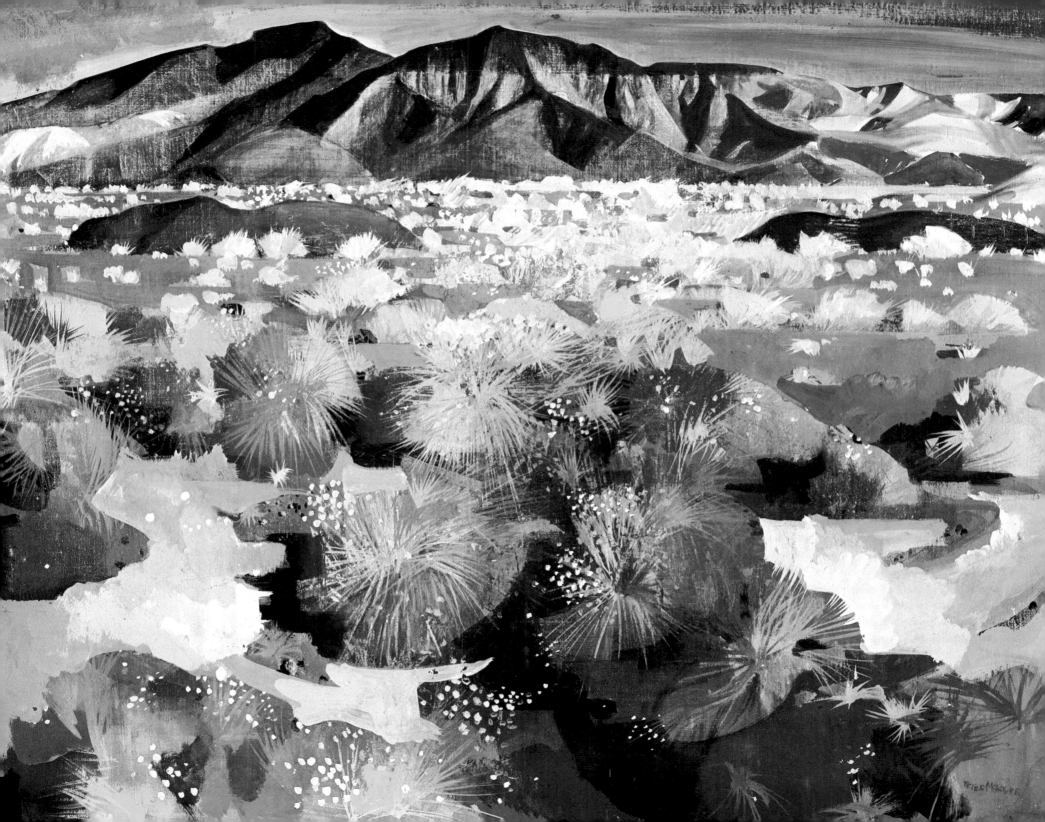

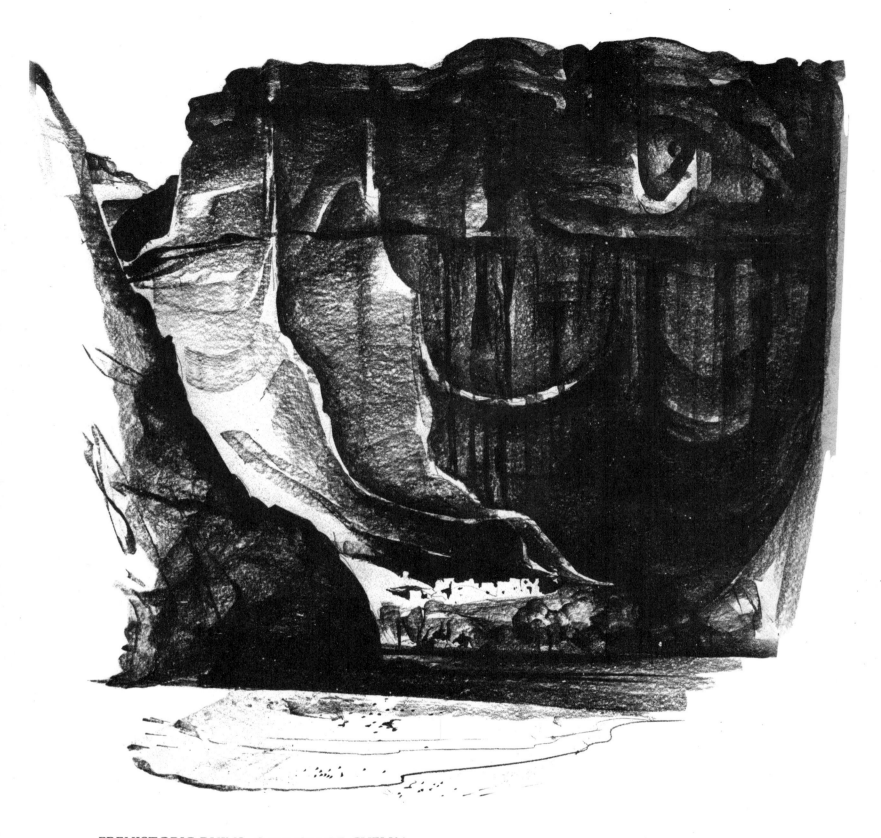

PREHISTORIC RUINS, CANYON DE CHELLY

CANYON DE CHELLY **PLATE 26**

The Spaniards in 1805 and Kit Carson in 1864 fought the Navajos here. The man-
made structures were built nearly a thousand years ago by people who abandoned
them in a great drought around the year 1300. One of the loveliest of Arizona's
canyons, in autumn it is a blaze of colour.

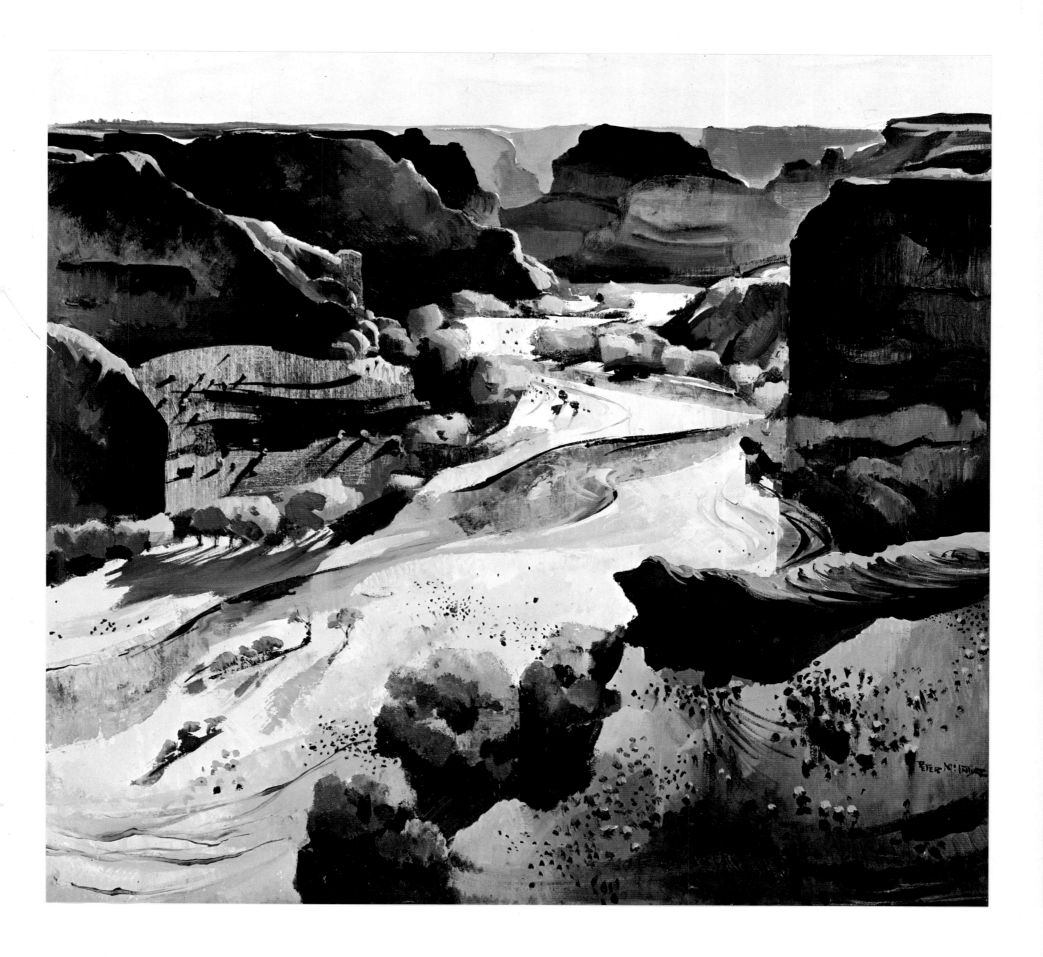

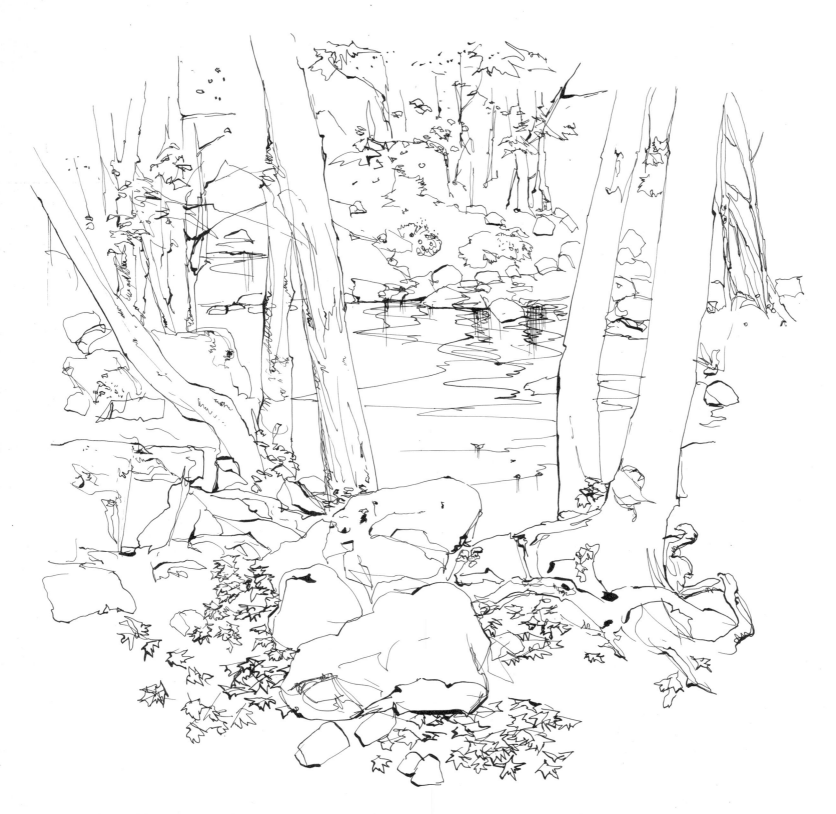

OAK CREEK CANYON. After the overwhelming grandeur of Arizona's Grand Canyon, the little pools and leafy glades of Oak Creek Canyon, just south of Flagstaff, restored our sense of intimacy with the world around us.

GRAND CANYON **PLATE 27**

Since time immemorial, the Colorado River has been carving out this awesome spectacle, unequalled elsewhere on this earth. Prehistoric man penetrated the place four thousand years ago—a mere moment in time to the Colorado. The river moves half a million tons of the earth's surface per day, and during the floods of 1927 it moved twenty-seven million tons per day. Multiply such figures by tens of thousands of years, and the answer is the Grand Canyon—a mile deep.

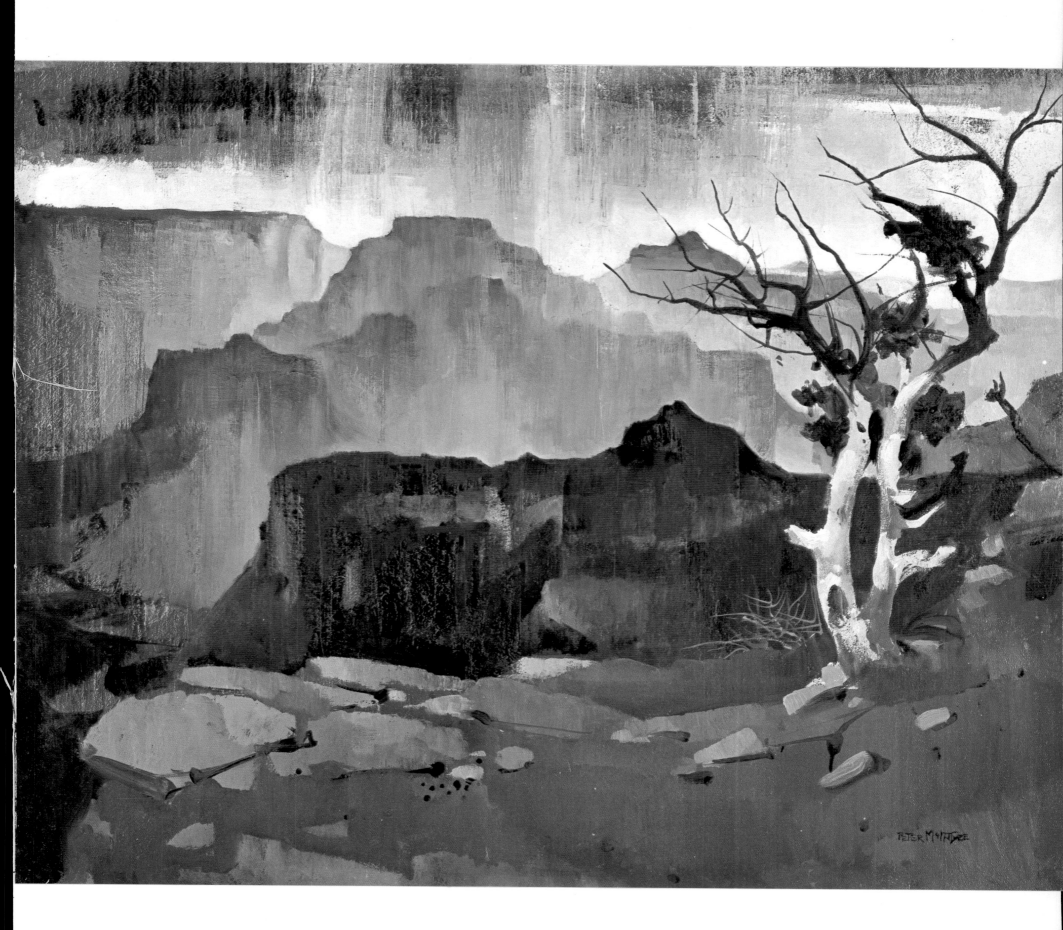

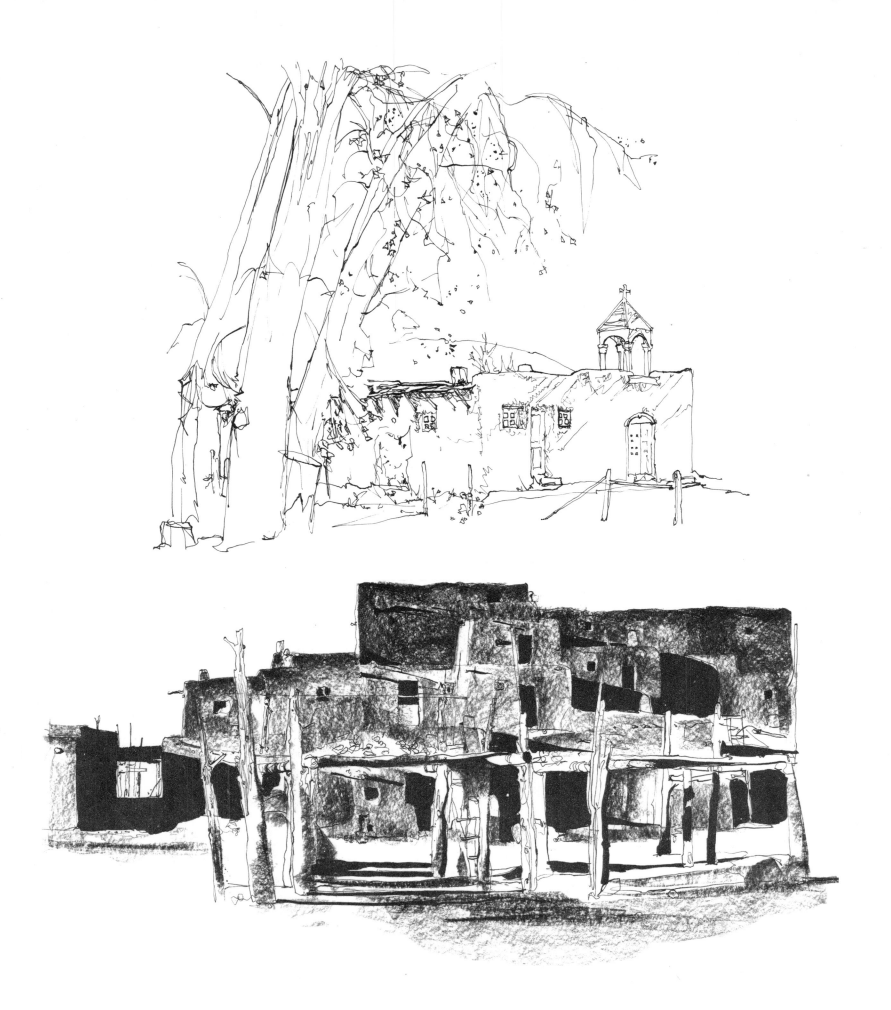

ADOBE CHURCH—TAOS, NEW MEXICO **PLATE 28**

Taos Pueblo provides one of those glimpses into the Western past. For somewhere around a thousand years this pueblo has been in constant occupation. The town of Taos is the most delightful small town in the whole world. Artists discovered it in 1900 and have never left it, so that even today it has an interesting community living in wonderful, old, spacious adobe houses.

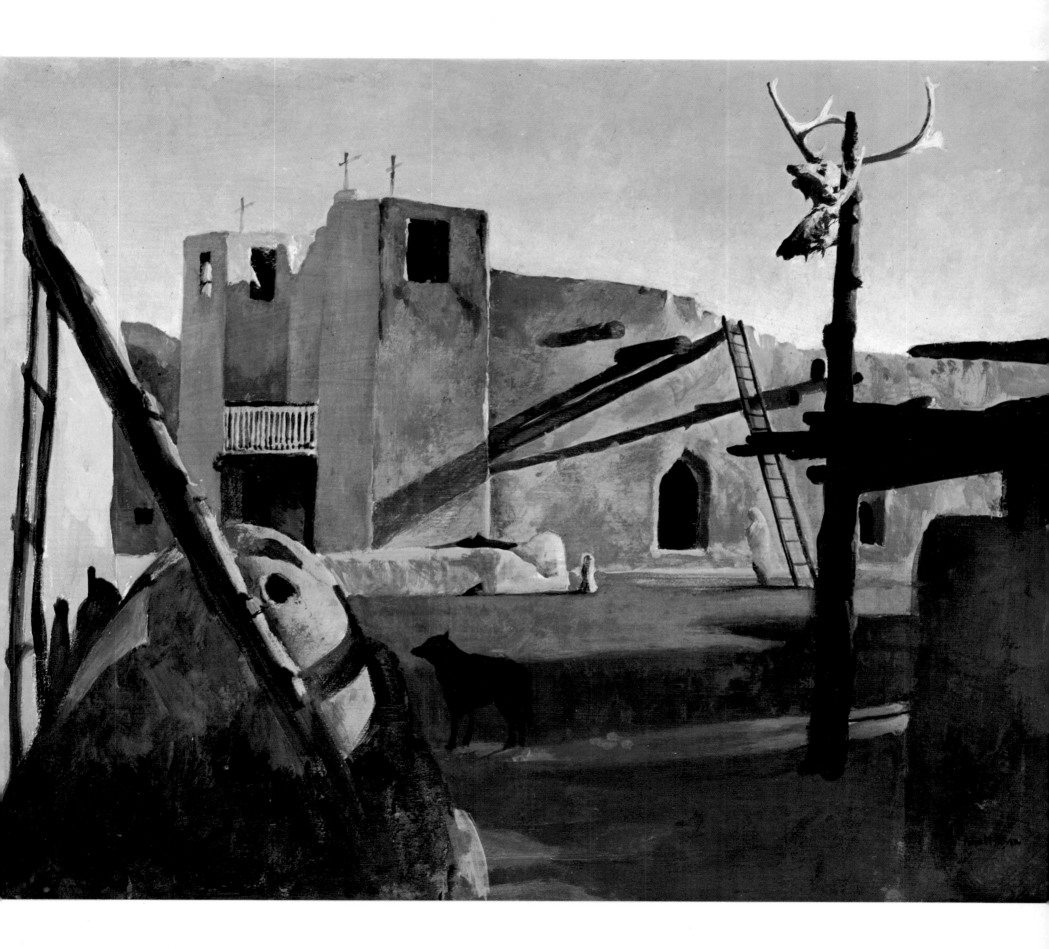

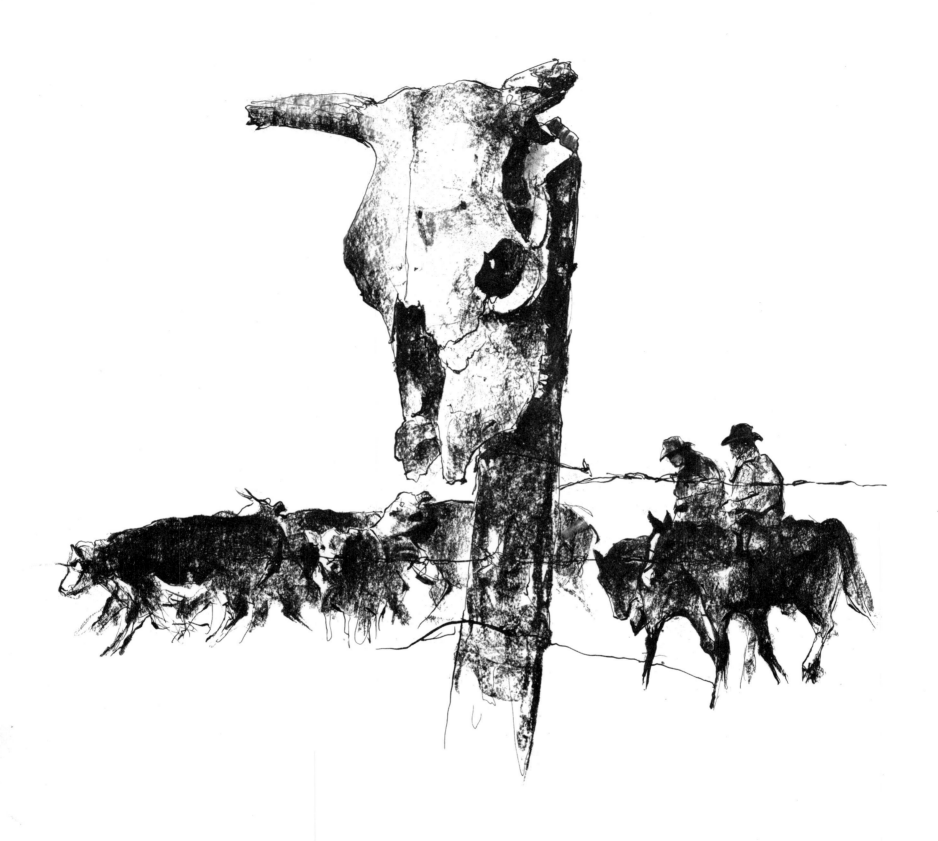

START OF THE ROUNDUP **PLATE 29**

On a ranch near Wagon Mound, New Mexico, we went out in the grey dawn to
watch the roundup across the vast vistas of yellow grass. The old West dies slowly
out here, where Spaniard fought Indian on the Santa Fe Trail. In nearby Cimarron
there are still bullet holes in the ceiling of the bar.

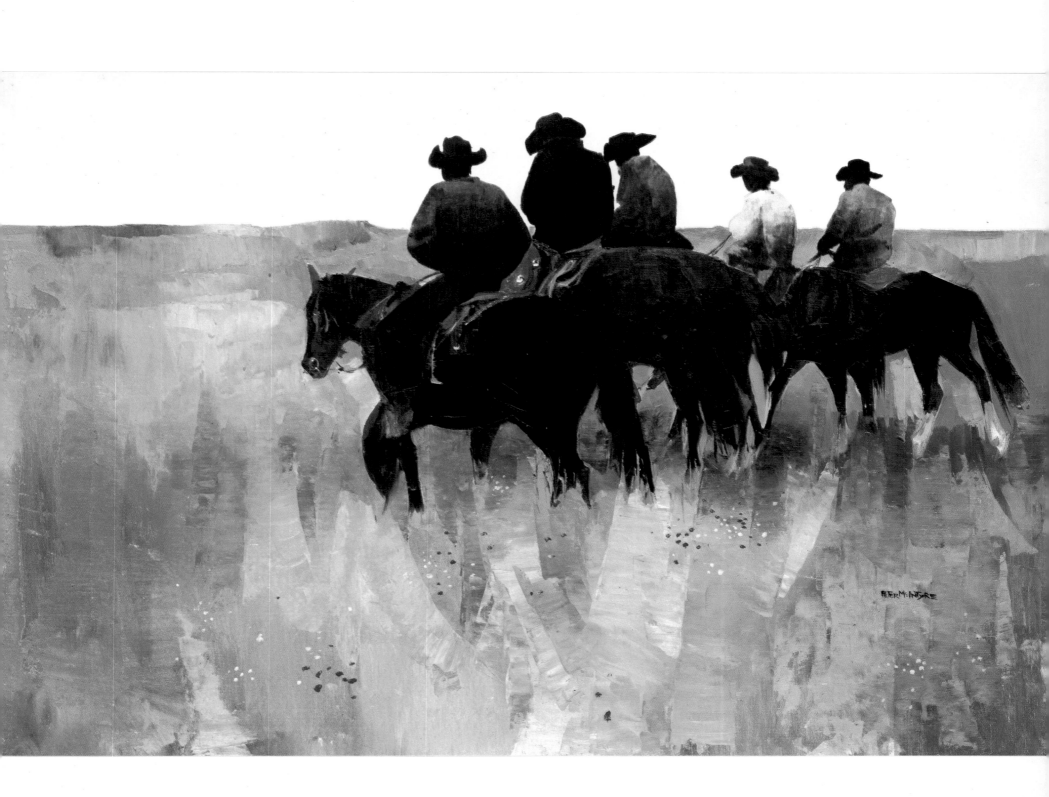

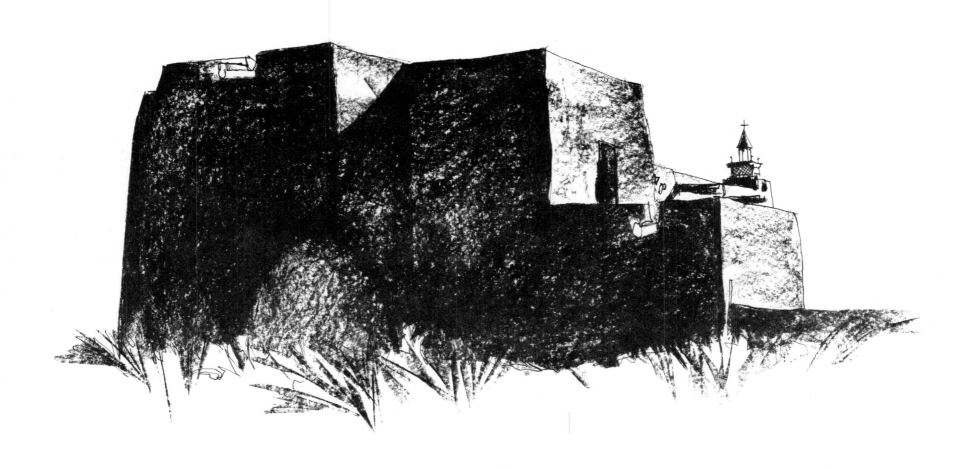

OLD CHURCH AT TRUCHAS, NEW MEXICO.
Bypassed and forgotten in the hills beyond Taos,
this perfect example of adobe is so old that
there are no records of its origin. Its lines seem
to rise out of the earth itself.

GHOST TOWN—MADRID, NEW MEXICO **PLATE 30**

Empty windows stare sightlessly into space, and whispers of forgotten voices seem
to echo in the evening stillness. In all the sad emptiness I found one shop where a
coin-operated box ground out a tune by mechanically
pulling a bow across a nostalgic violin.

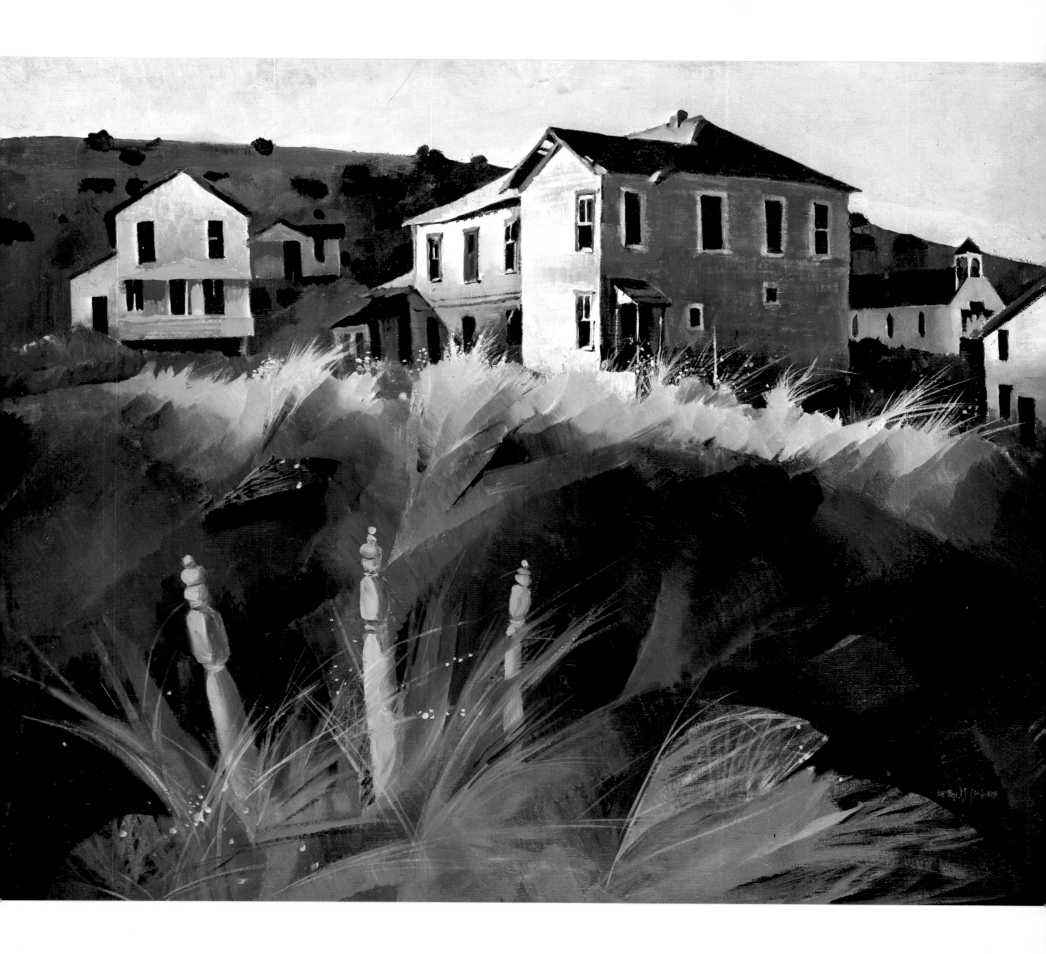

GOLD HILL—VIRGINIA CITY, NEVADA **PLATE 31**

The fabulous Eilley Orrum, Queen of the Comstock, staked her claims here on Gold
Hill in 1863, after consulting a crystal ball, and in one year alone the Comstock
mines yielded $20,000,000 in bullion. The total yield from the Virginia City mines
was $500,500,000 in silver and $700,000,000 in gold. Here also on Gold Hill young
Sam Clemens was held up and robbed. He was a reporter on the local
Territorial Enterprise and signed himself Mark Twain.

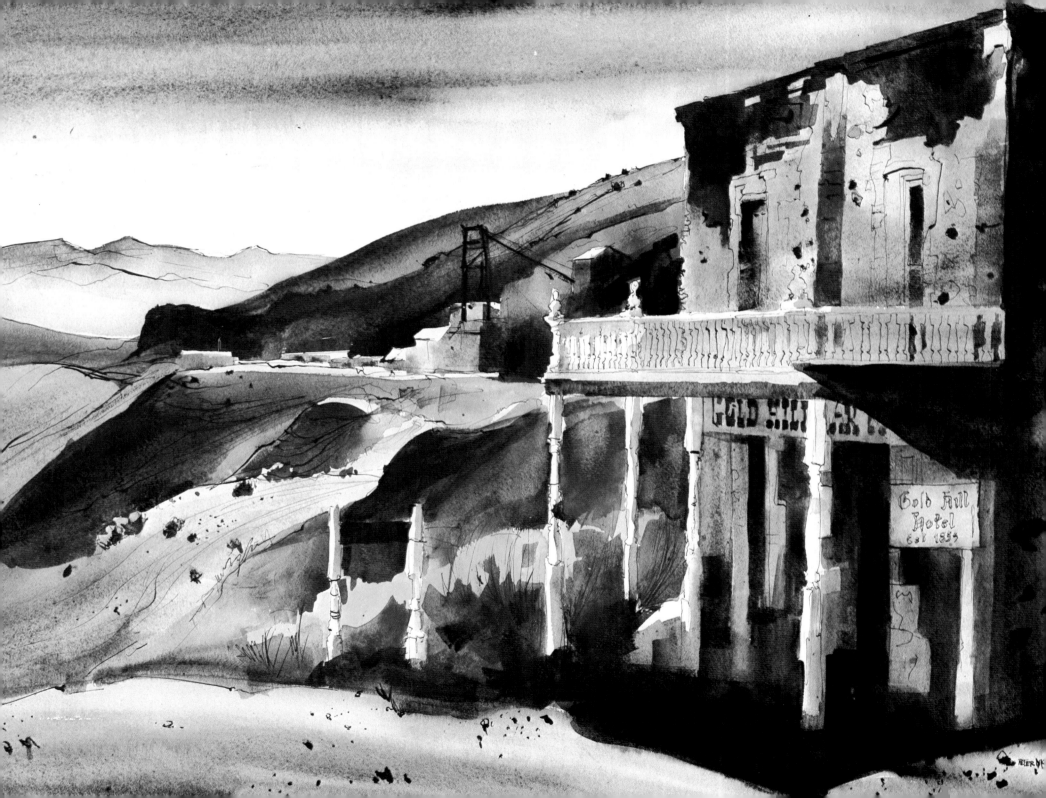

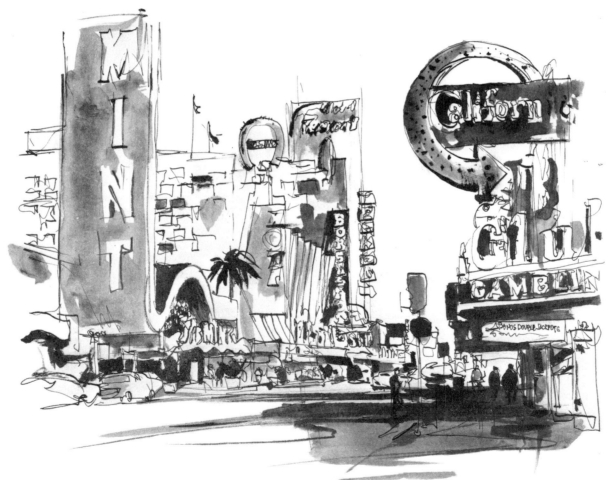

LAS VEGAS, NEVADA **PLATE 32**

The Circus, The Strip, and Caesar's Palace have never met reality except perhaps in
the early morning. Even at such an hour, superbly stacked Roman slavegirls in their
mini-togas were serving drinks to hard-faced men in shirt sleeves, still seated around
the tables. The efficient management had even moved the tables—gamblers and all—
without stopping the games so they could put down a new carpet for Frank Sinatra,
who was doing one of his $100,000 specials that evening.

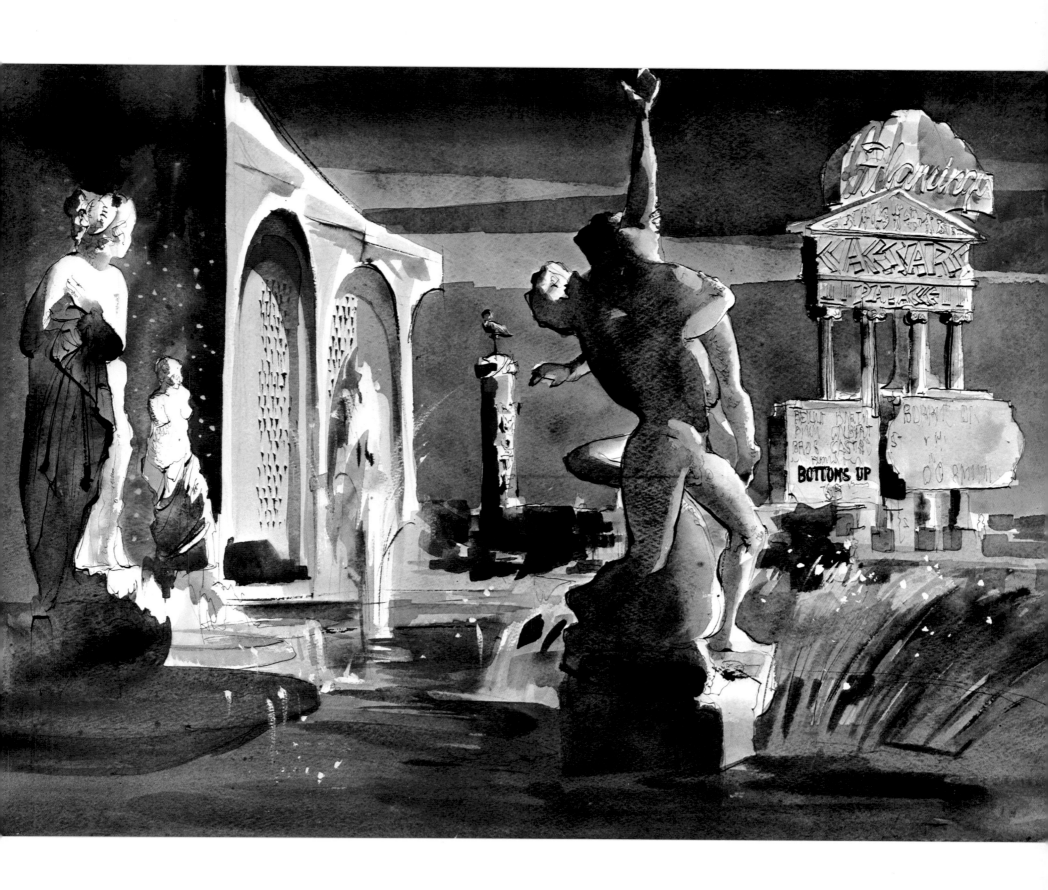

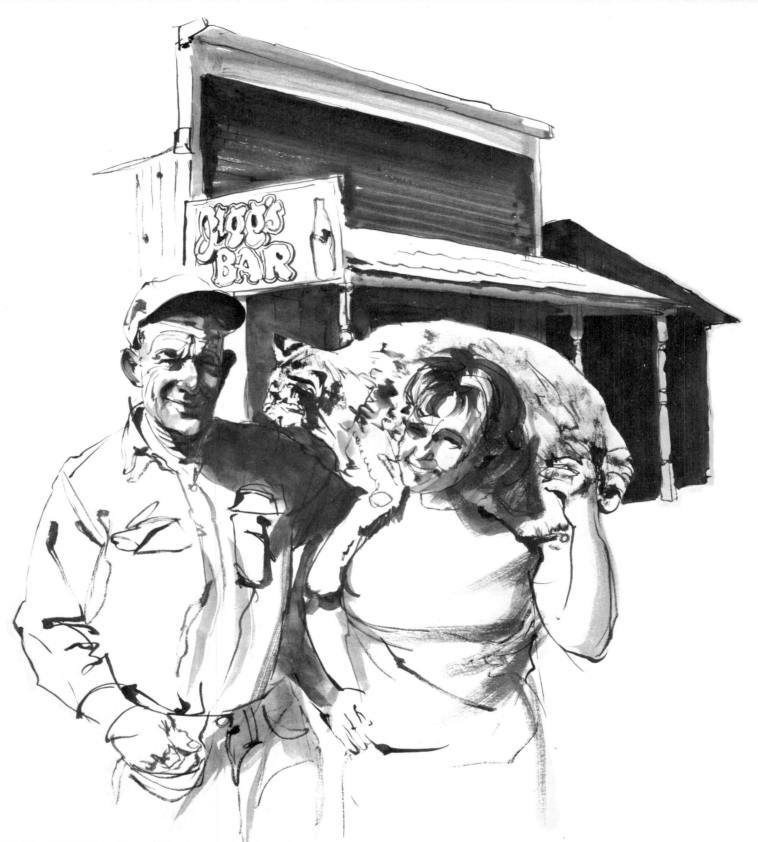

JIGGS, NEVADA. Get off the beaten track and you discover America. Way off the highway from Elko we came on Jiggs—bar and postoffice. In the bar there's a photograph of the entire population of Jiggs in a Volkswagen—all nine inhabitants. The pubkeeper's wife even showed off her tame bobcat for us.

From a hill in Nevada you can look down into Utah, across the salt-white Bonneville Flats, and there in one vista lies the awesomeness and the terror that must have faced the early pioneers.

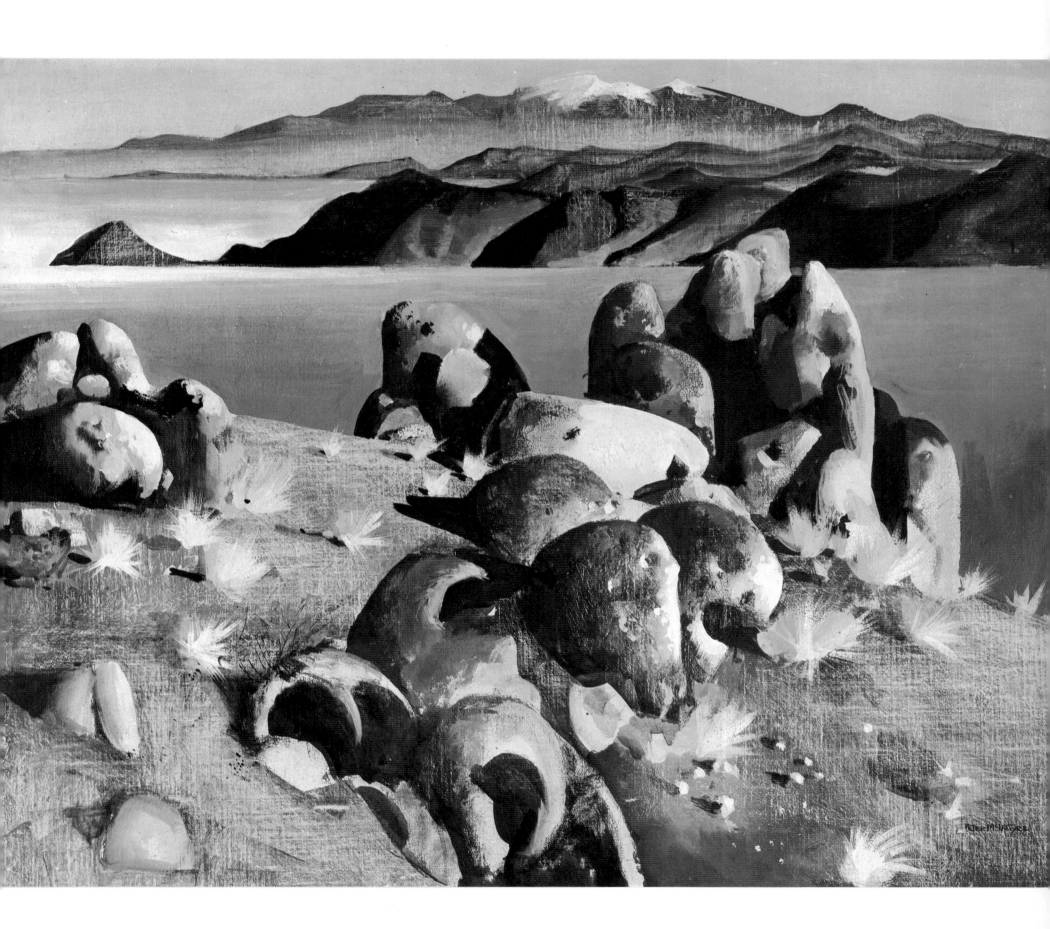

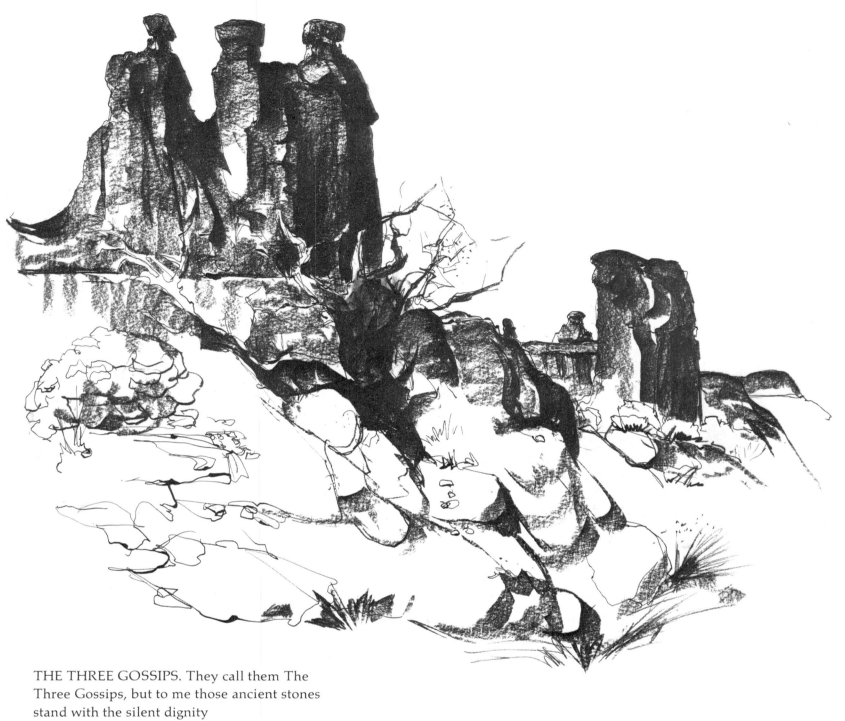

THE THREE GOSSIPS. They call them The
Three Gossips, but to me those ancient stones
stand with the silent dignity
of countless ages.

ARCHES NATIONAL MONUMENT, UTAH **PLATE 34**

Early morning across a landscape where wind and water over millions of years
have wrought a world of huge and often slender arches flanked by giants and goblins.

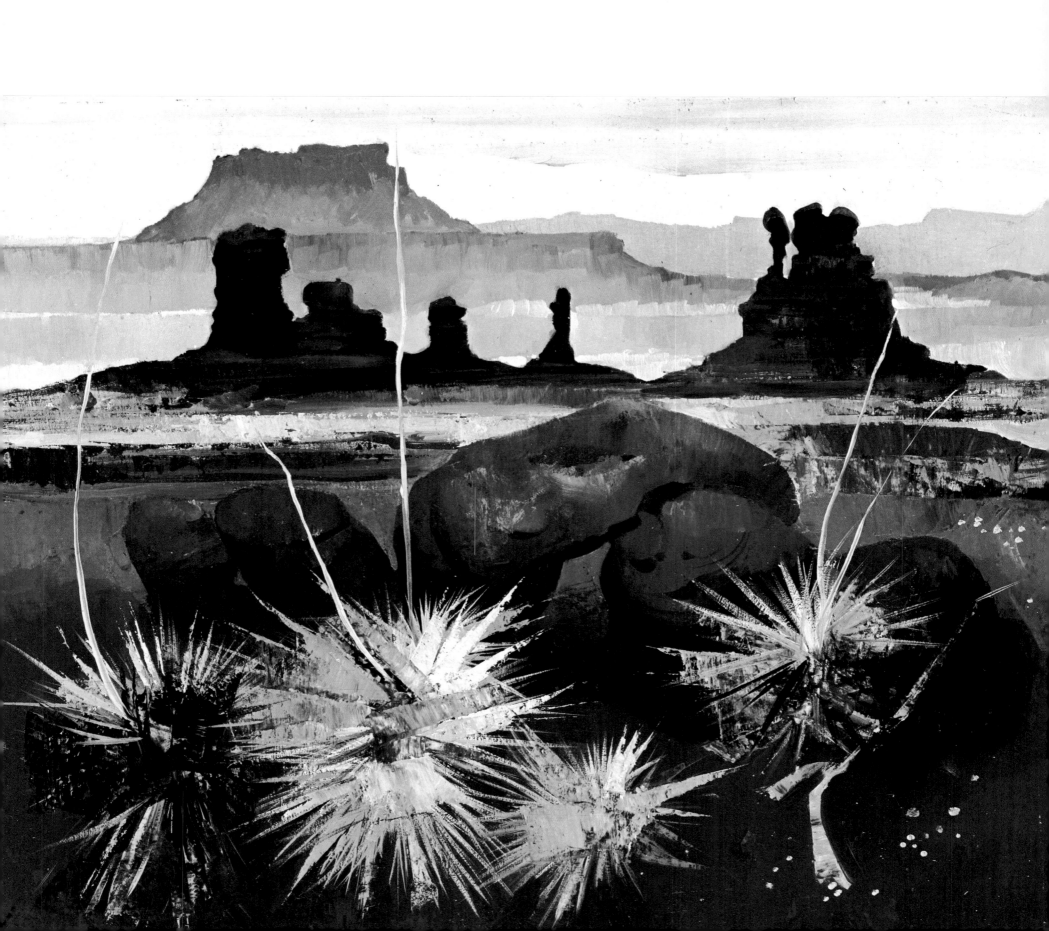

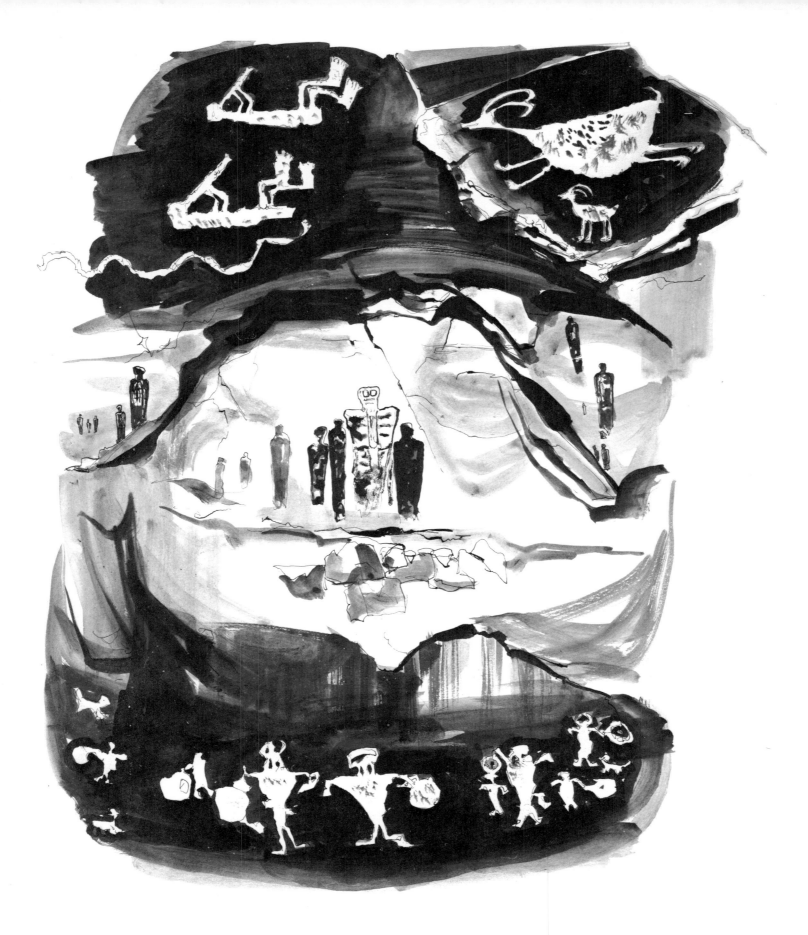

PICTOGRAPHS—MONUMENT VALLEY,
UTAH. Out on a jeep tour we camped in a deep
canyon under strange figures that were painted
nearly a thousand years ago. The joy of the
ancient, happy flute player lives on for us.

NAVAJO DWELLING **PLATE 35**

A wooden hut replaces the Indian hogan, but the Navajo still lives in Utah's
Monument Valley much in the manner he has always lived.

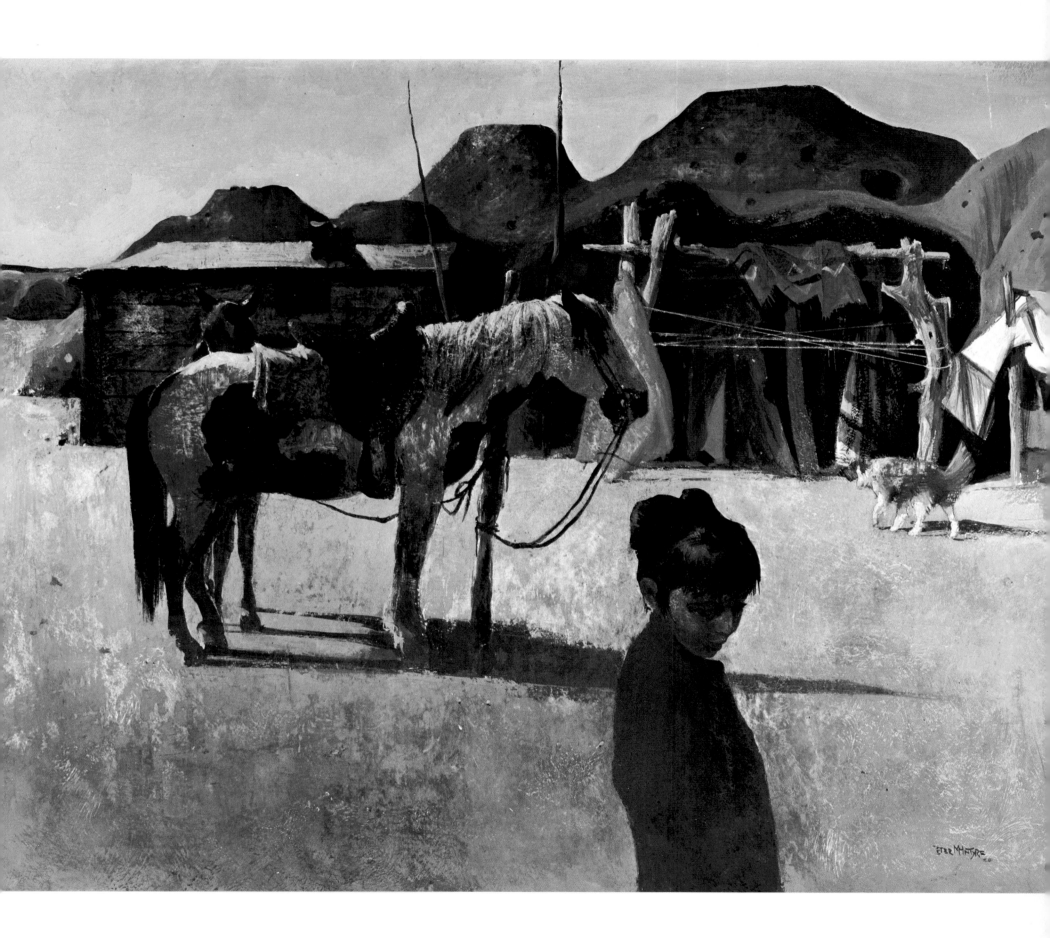

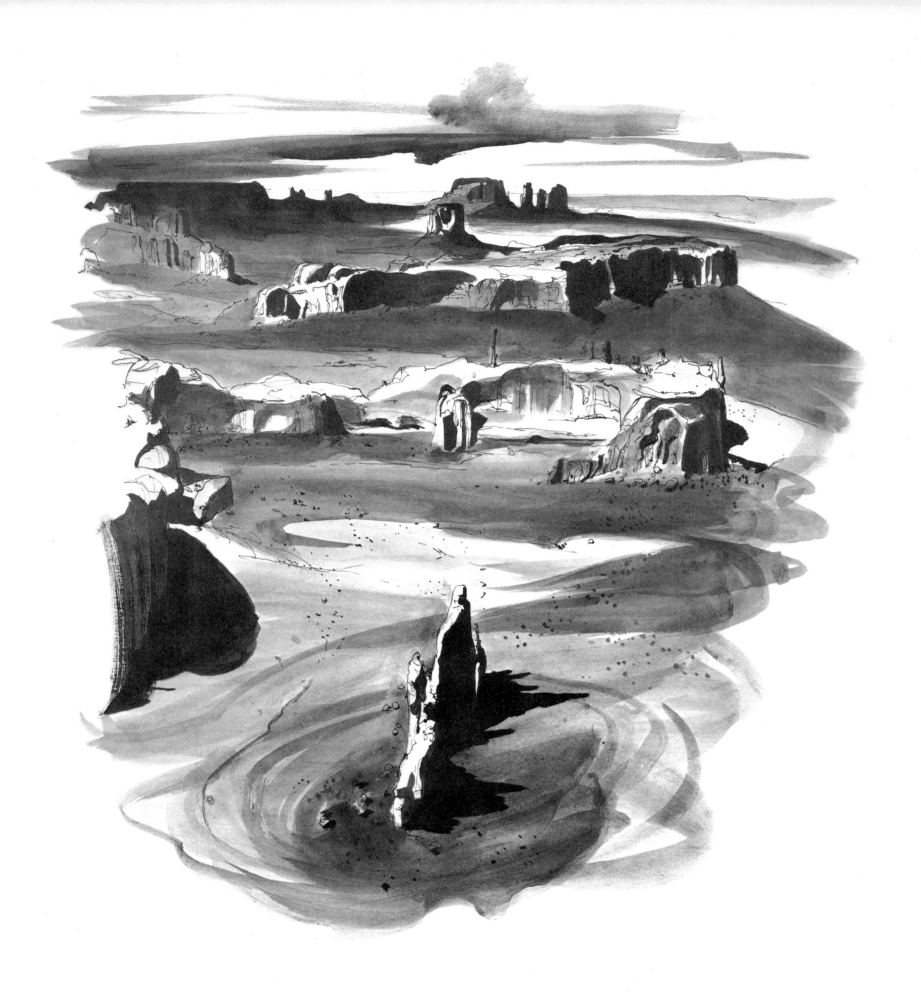

MONUMENT VALLEY LANDSCAPE **PLATE 36**

For 50,000,000 years the sun, the sand, and the wind have shaped the red rock into a
superb and stately wonderland of monumental shapes. "The Totem Pole," most
slender of the columns in the painting, also peeping over the top of the mesa in mid-
distance in the drawing, is as high as a 45-story building.

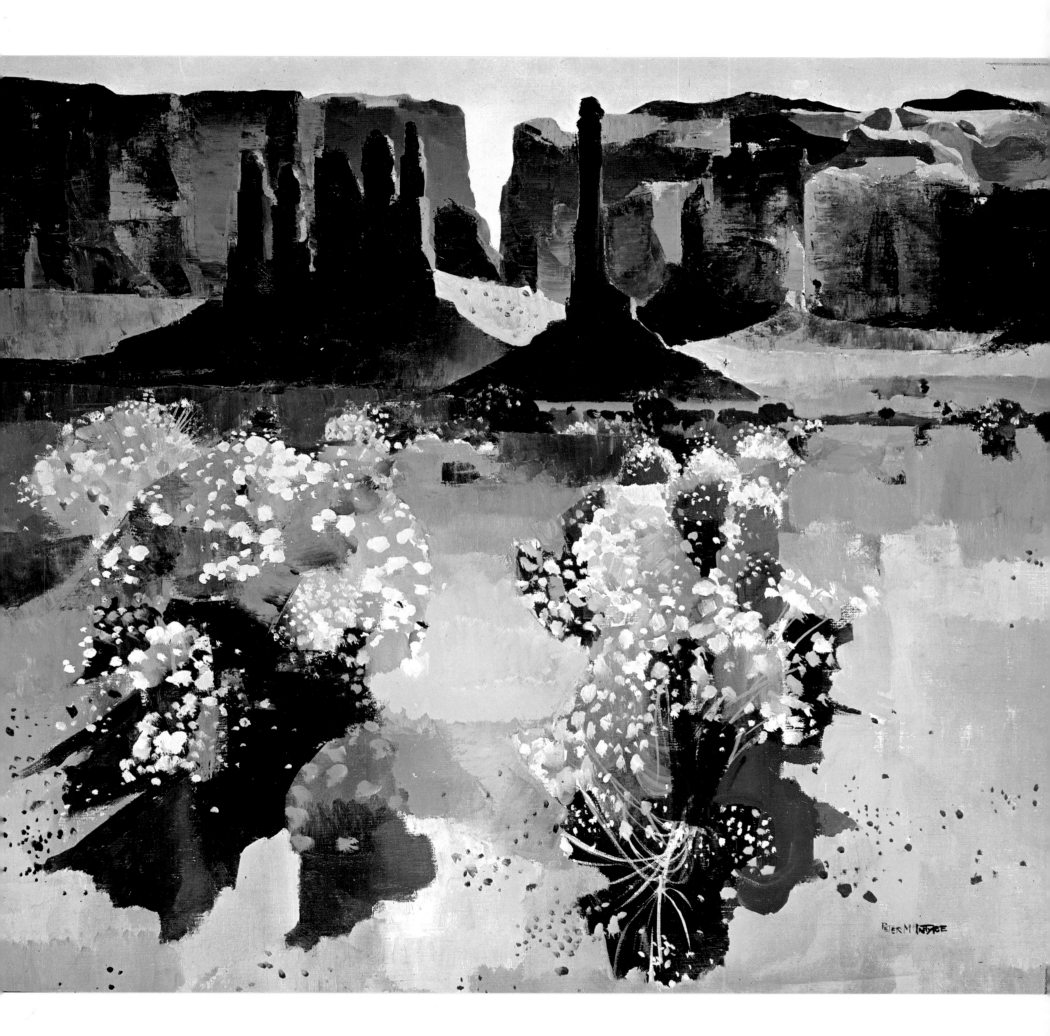

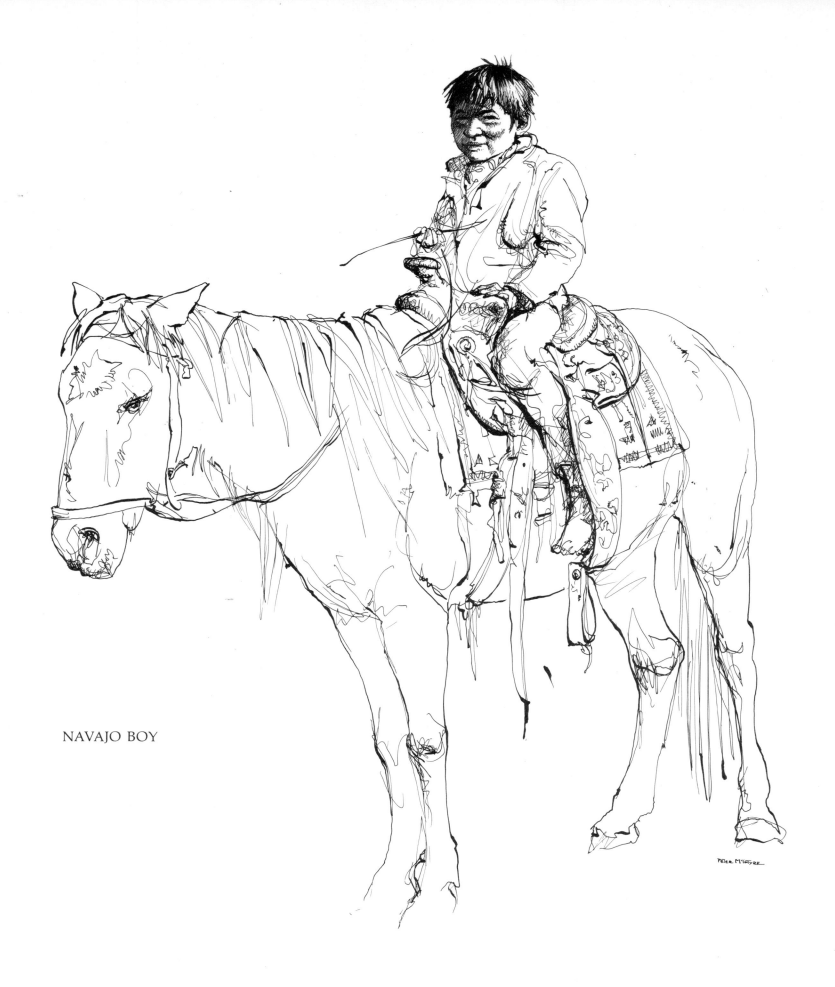

NAVAJO BOY

NAVAJO MOTHER AND CHILD **PLATE 37**

The Navajos of Monument Valley were never rounded up as were the rest of the
Navajos. Even Kit Carson couldn't subdue them. Under their last great leader,
Chief Hoskinini, they held out on the heights of the Mesa and never surrendered.
The boy in the drawing is holding out too—he refuses to go to school.

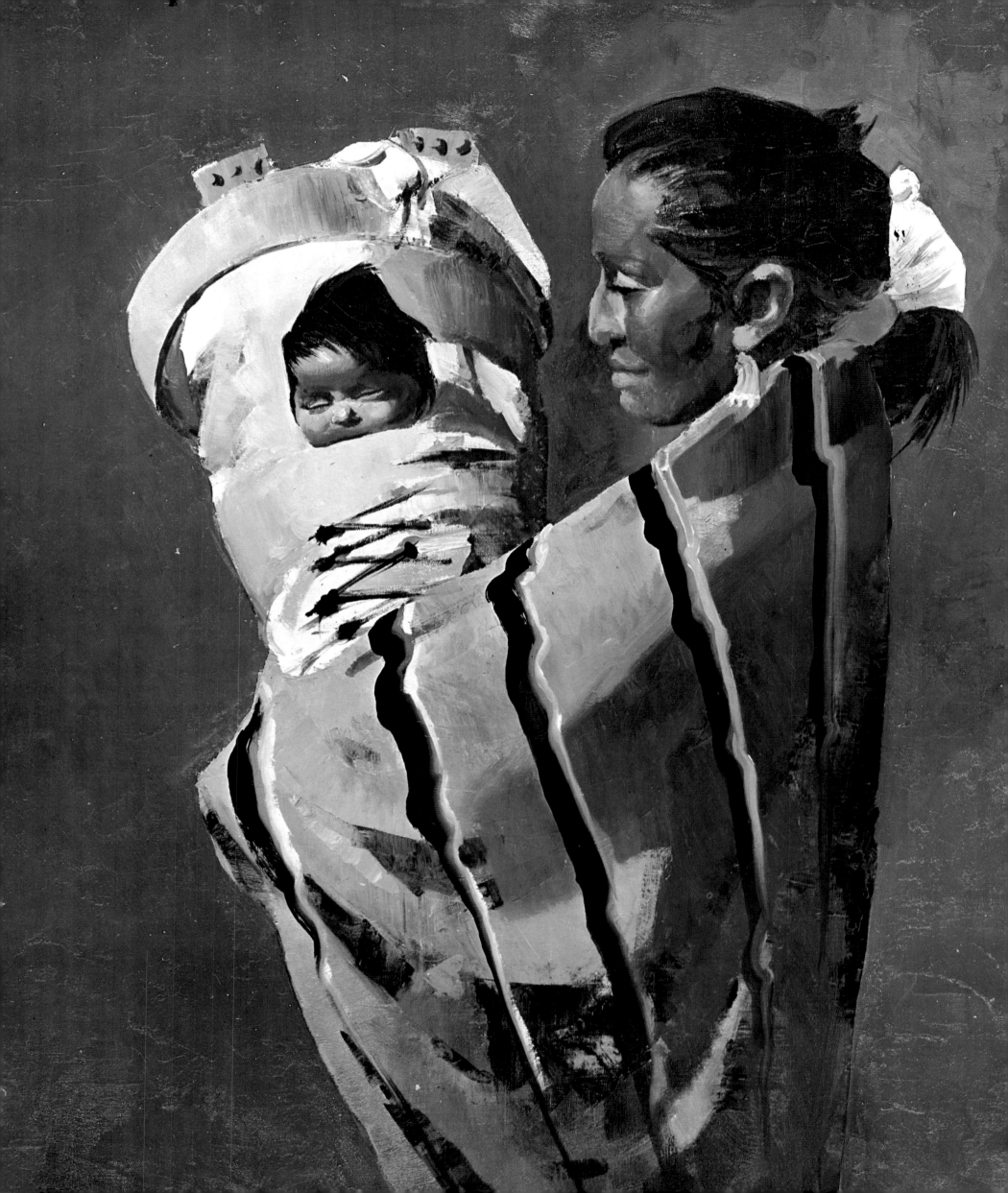

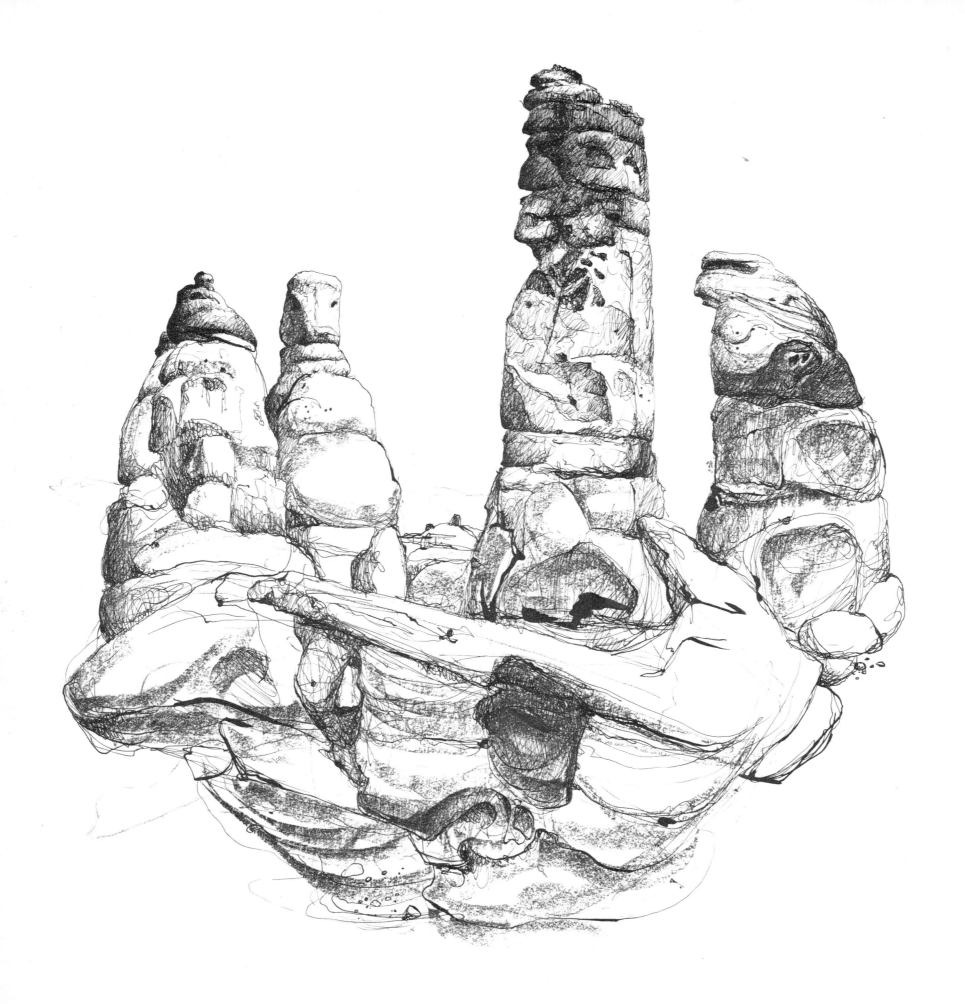

STANDING ROCK COUNTRY—UTAH **PLATE 38**

Out from Moab by jeep, through deep canyons and across high mesas, we travelled
into a land empty of people but populated with creatures of rock that towered above us,
seeming to mock our smallness and the fleeting moment of our time.

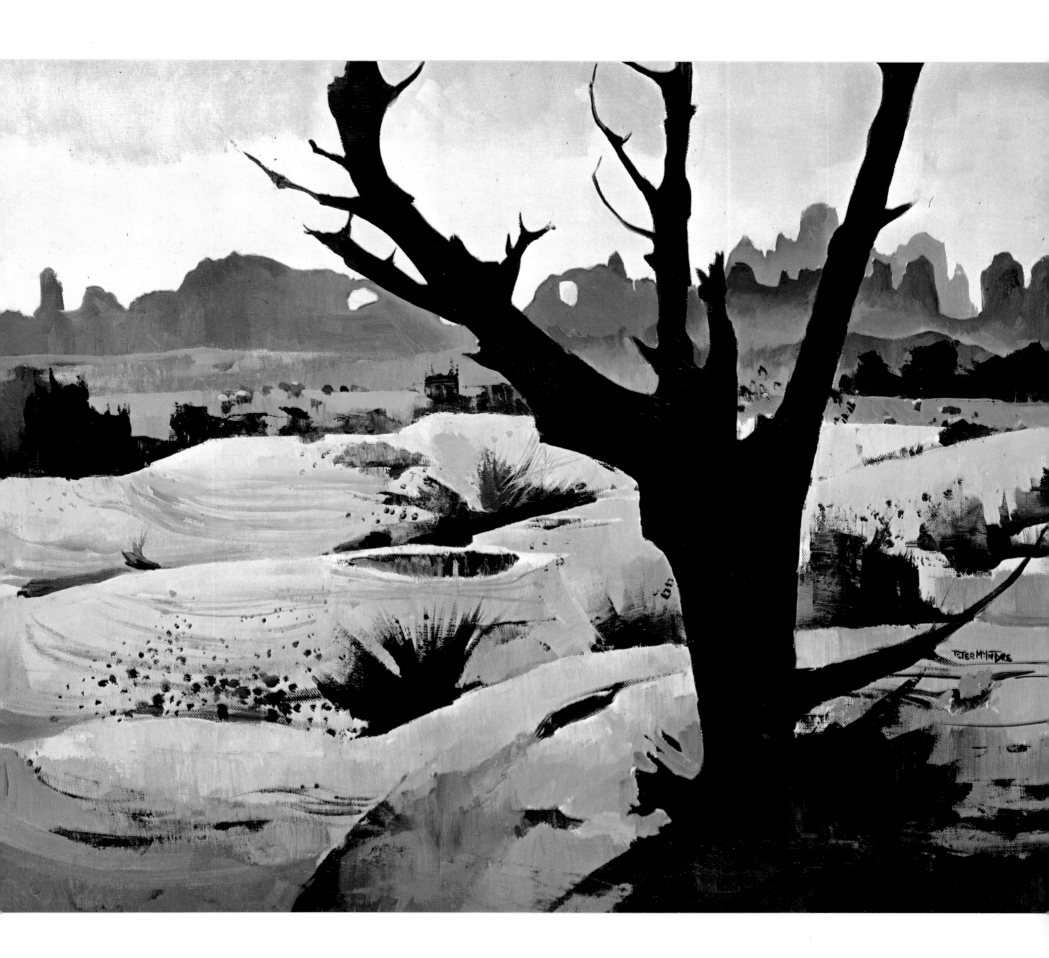

FORT GARLAND, COLORADO. In the
great thrust westward, Fort Garland was
a garrisoned outpost against the Indians. The
fort is not far from the old Santa Fe Trail.

COLORADO MOUNTAIN LANDSCAPE **PLATE 39**

The aspens are a particular feature of Colorado, marking the seasons with their colour,
and in just such country as this the gold miners of '58 delved, fought, and froze.

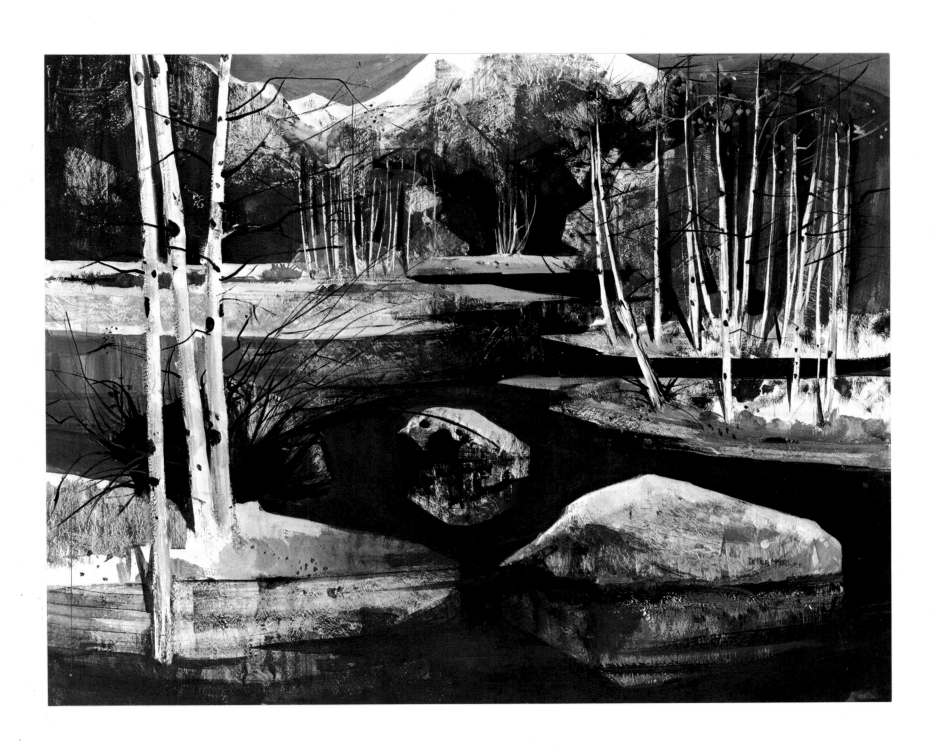

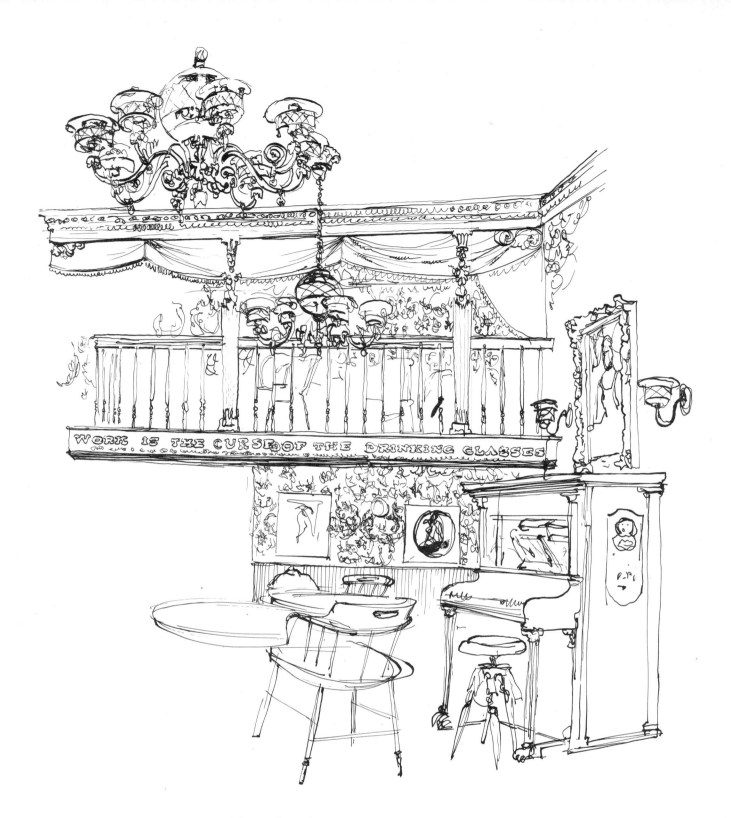

The sketch includes the hand-lettered sign: WORK IS THE CURSE OF THE DRINKING GLASSES

OLD BAR IN DURANGO. When gold was found
in Colorado in 1858 they called the place "the
new El Dorado." This bar brings back something
of the atmosphere of those great days when gold
and silver poured from the mountains.

LATE FALL—COLORADO **PLATE 40**

Colorado is always beautiful, but in fall there is a soft loveliness as the riot of
gold and yellow changes to deep greys and clear whites.

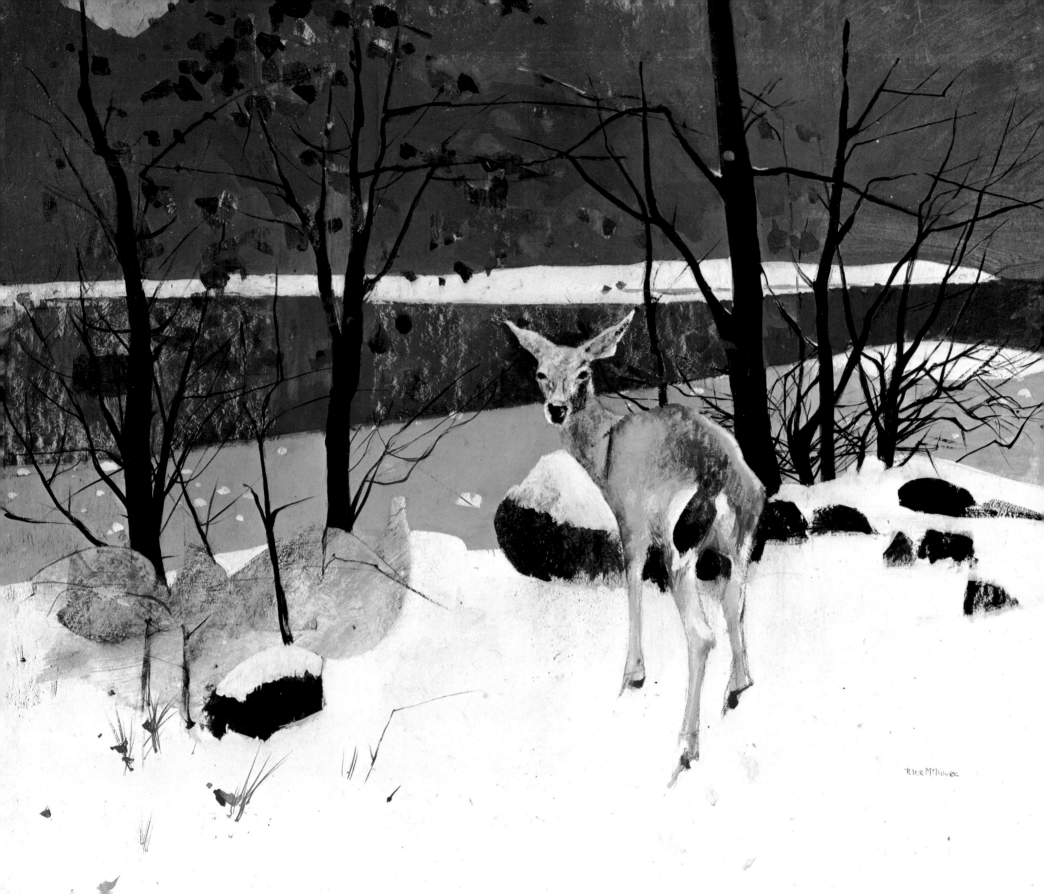

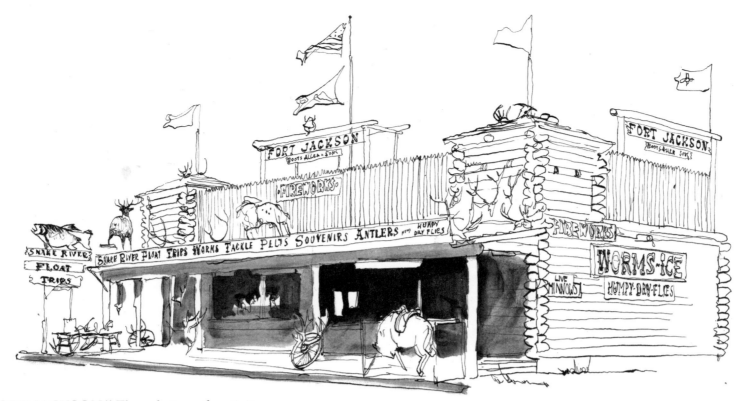

"FORT JACKSON." Though its authenticity as a
fort leaves something to be desired, the nostalgic
charm of this store in Jackson is genuine.

WYOMING LANDSCAPE. In just a few miles
the landscape of Wyoming can change from vistas
of grassland to craggy mountains.

JACKSON HOLE, WYOMING **PLATE 41**

Once a hell-raising rendezvous for fur trappers and later the scene of bitter wars
between sheep men and cattle men (remember the movie *Shane*?), this remains one
of the most strikingly beautiful places in the whole of America.

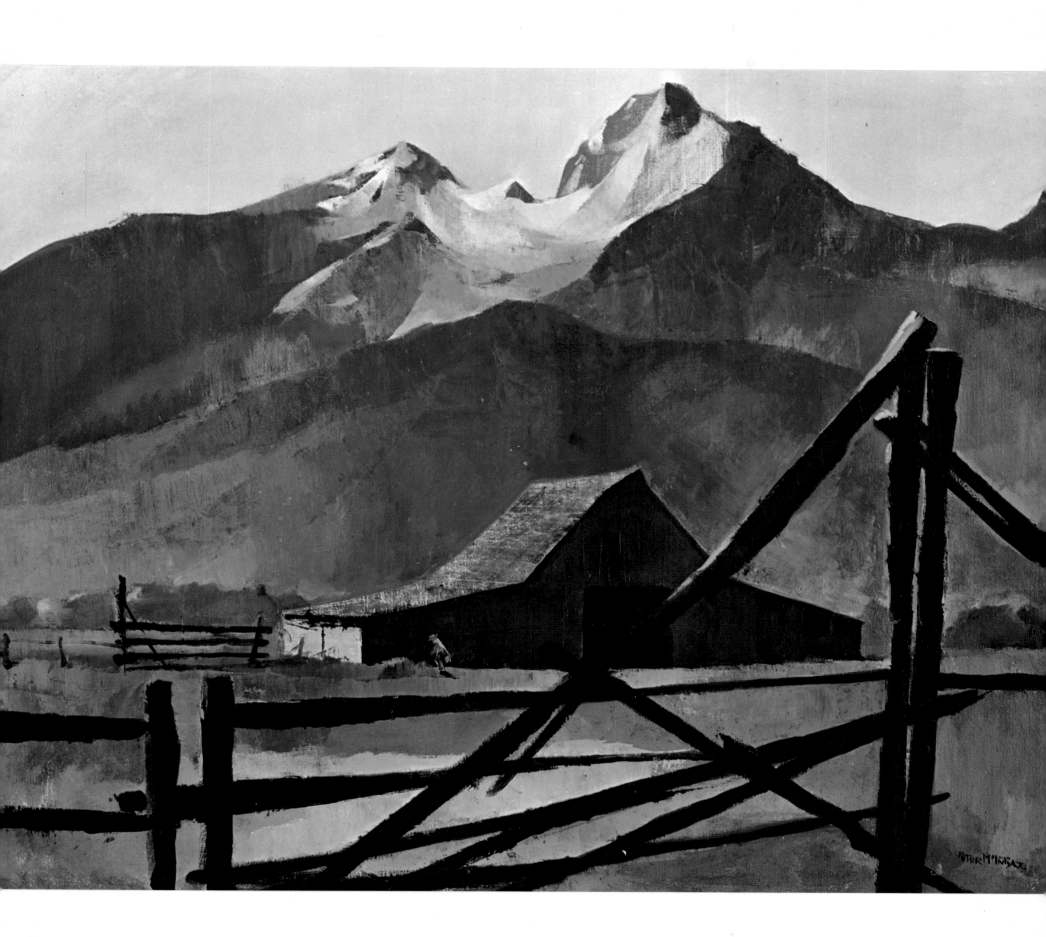

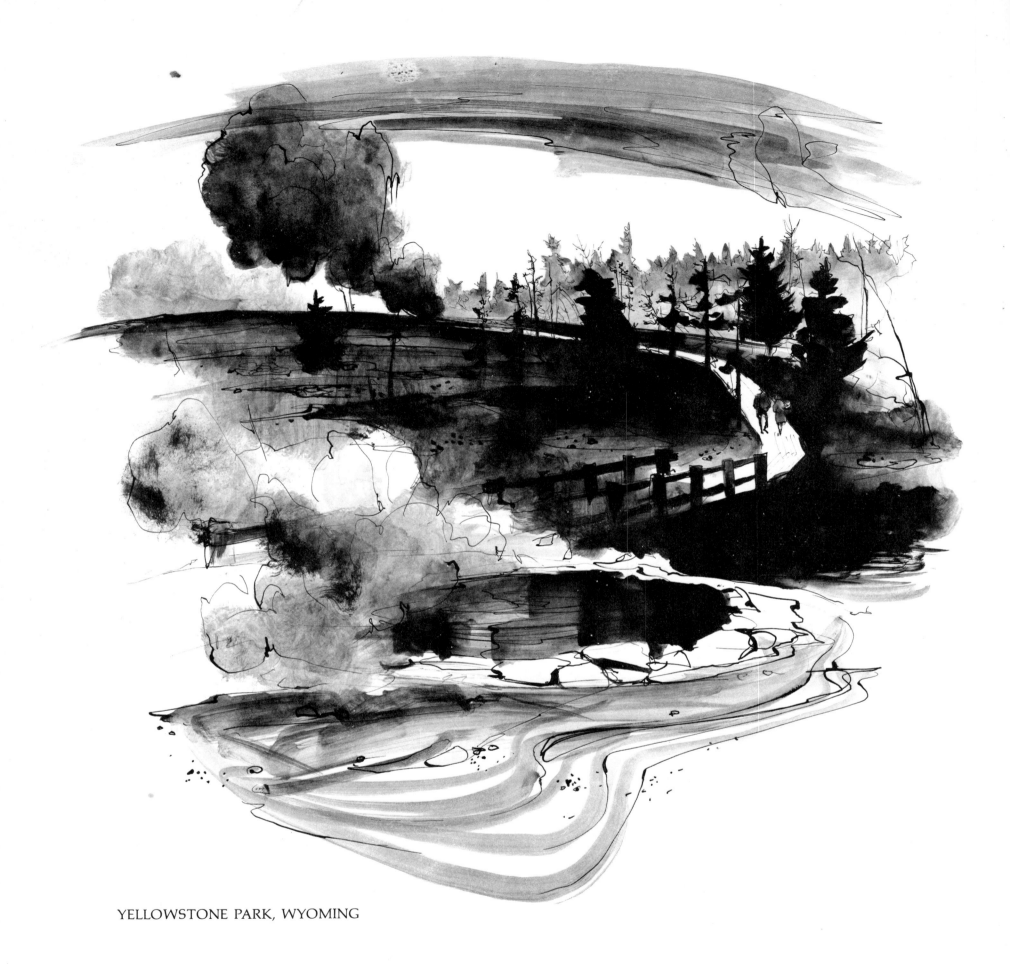

YELLOWSTONE PARK, WYOMING

YELLOWSTONE CANYON **PLATE 42**

In 1807, John Colter, who came west with Lewis and Clark, made an incredible
500-mile midwinter trek through this region of geysers, shaking earth, and boiling
mud. The area became known to the outside world as "Colter's Hell." Today
you can watch the spouting geysers in comfort or
fish for trout in what is now called Yellowstone.

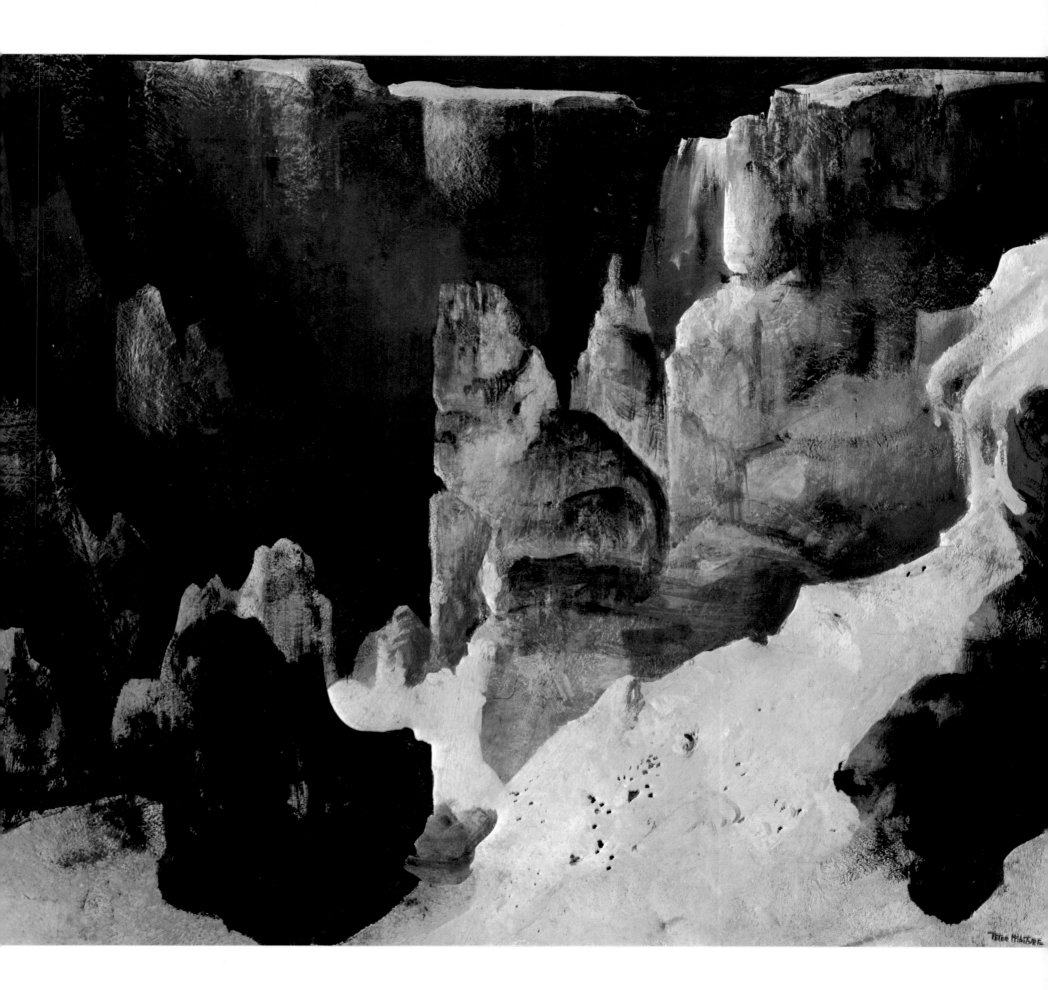

MONTANA LANDSCAPE. The lonely
sweep of grassland to the far-off barn, and
the woods that walk up the mountain to the
snow this was so often the scene as
we drove across Montana.

GOING-TO-THE-SUN ROAD, GLACIER PARK **PLATE 43**

Banks of yellow flowers were breaking through the snow, a stream meandered
across a snow meadow to disappear under a bridge of ice, reappearing as a
waterfall. Like a high backdrop, the mountain "goes to the sun."

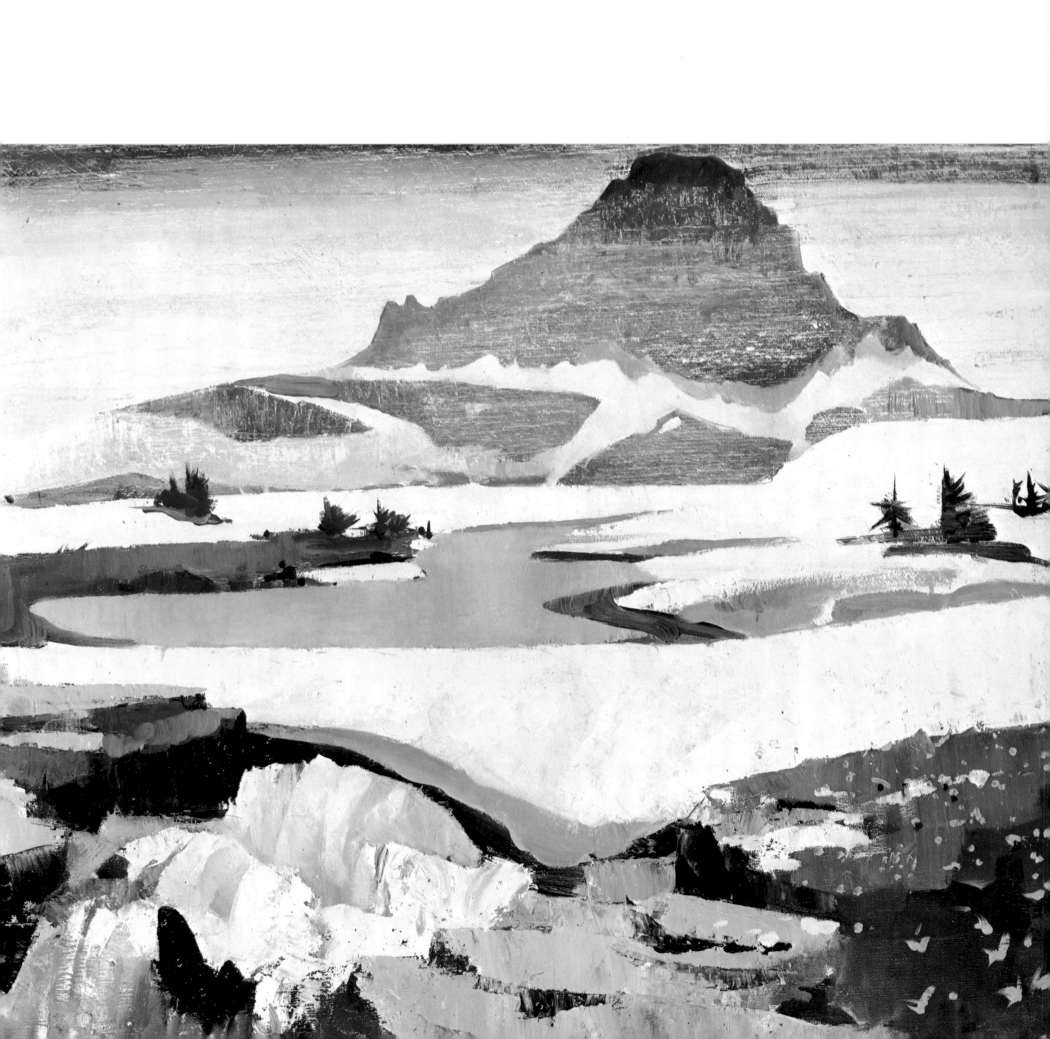

IDAHO LANDSCAPE. In Idaho, rivers flow
through lakes where, as one roadside sign warned
us, "you are leaving the best fishing in the world."

LAKE COEUR D'ALENE **PLATE 44**

Above Lake Coeur d'Alene the Syringa blooms. The Indians made their bows from
lilac branches, and Lewis and Clark found them using soap made from its leaves.
The State of Idaho has made the Syringa its State Flower.

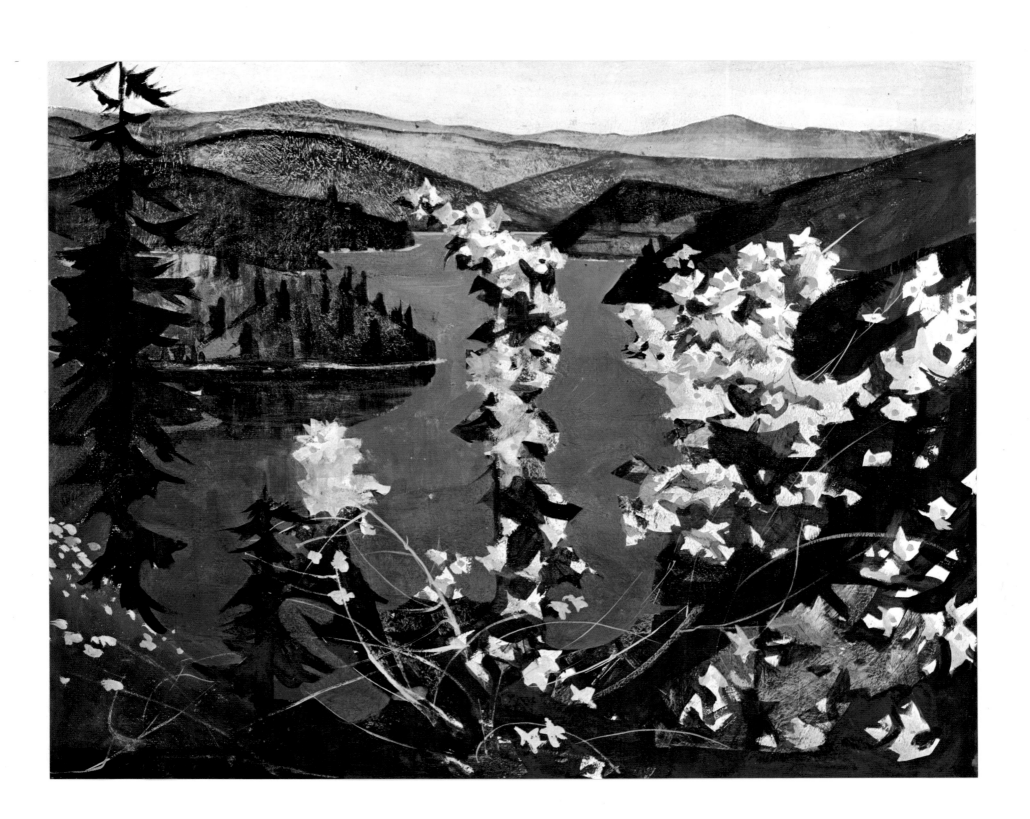

WHEATFIELDS. In southeastern Idaho the
landscape is etched in great swooping swatches
like the flight of a flock of birds.

In the north the pine woods come down to the shores of myriad lakes where squirrels
scamper in the scented air or pause to watch interlopers on their domain.

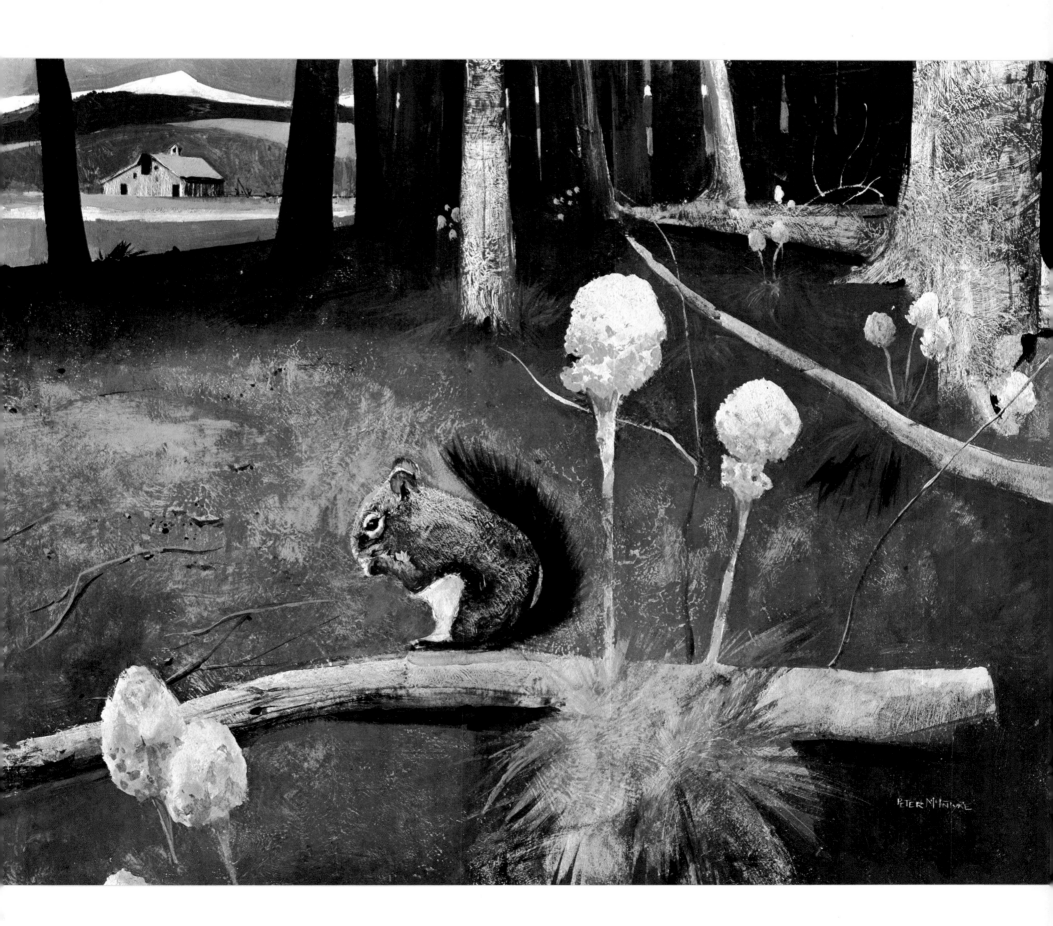

Peter McIntyre

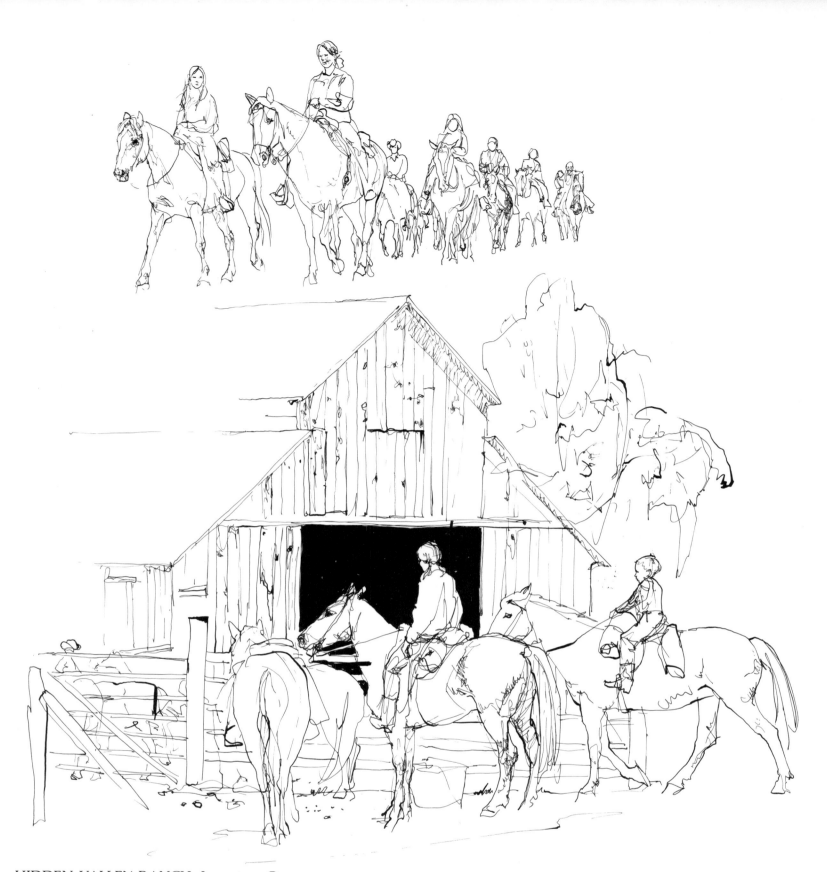

HIDDEN VALLEY RANCH. In eastern Oregon
we stayed with friends Buddy and Louise Morgan
on their dude ranch in Hidden Valley. This was a
piece of Americana that we loved, where children
learn to ride superbly, where I caught thirty trout
from the brook, and where we
tired travellers were supremely happy.

BARN IN EASTERN OREGON **PLATE 46**

I was charmed by the sombre old barns with their weathered boards. The building
beyond is a long-forgotten, old blacksmith's shop.

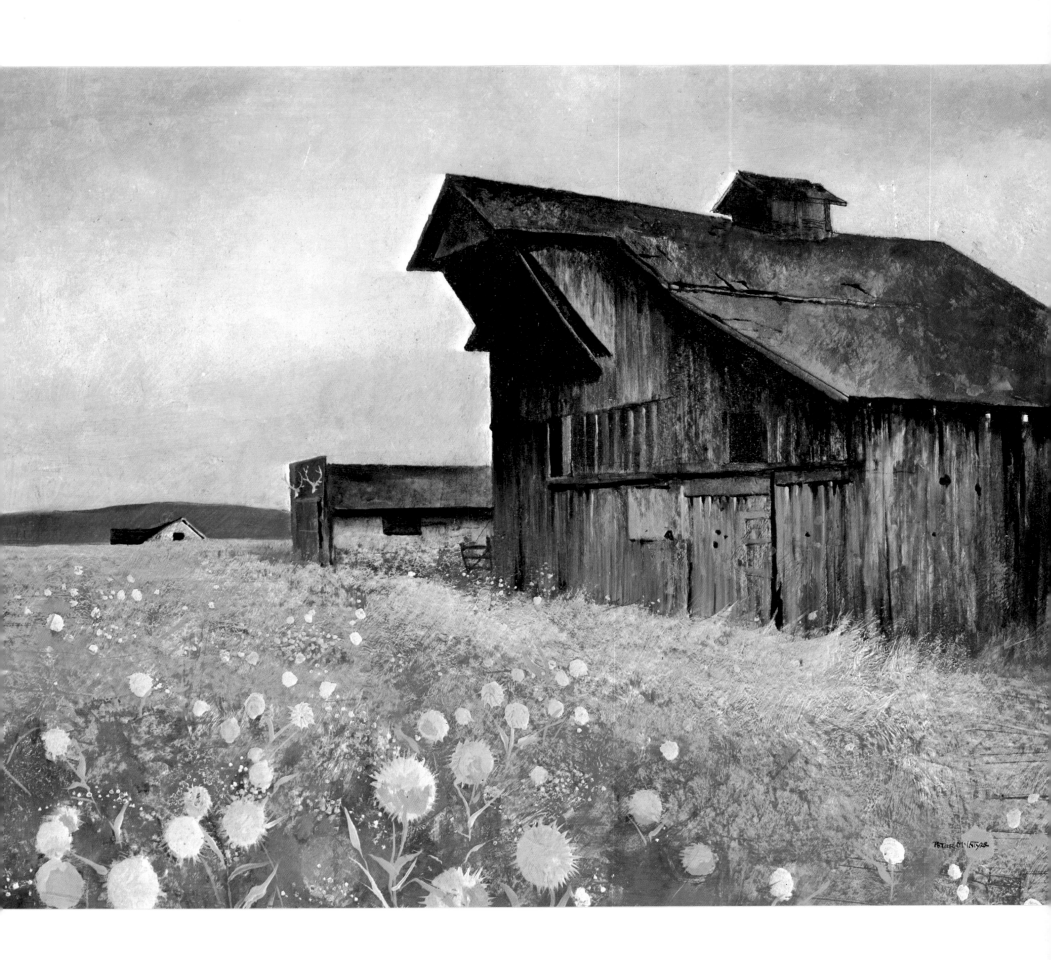

MULTNOMAH FALLS. Along the Columbia
River, waterfalls cascade into the river gorge. This
was just one of the many wonders we found along
the great river, where we also watched the salmon
leaping up the fishways and the eels going up by
fixing their mouths to the walls and literally
sucking their way up against the current.

CHIPMUNKS—OREGON WOODS **PLATE 47**

These bright-eyed creatures charmed us throughout the West, often eating from
Patty's hand as they scampered like flickerings of light.

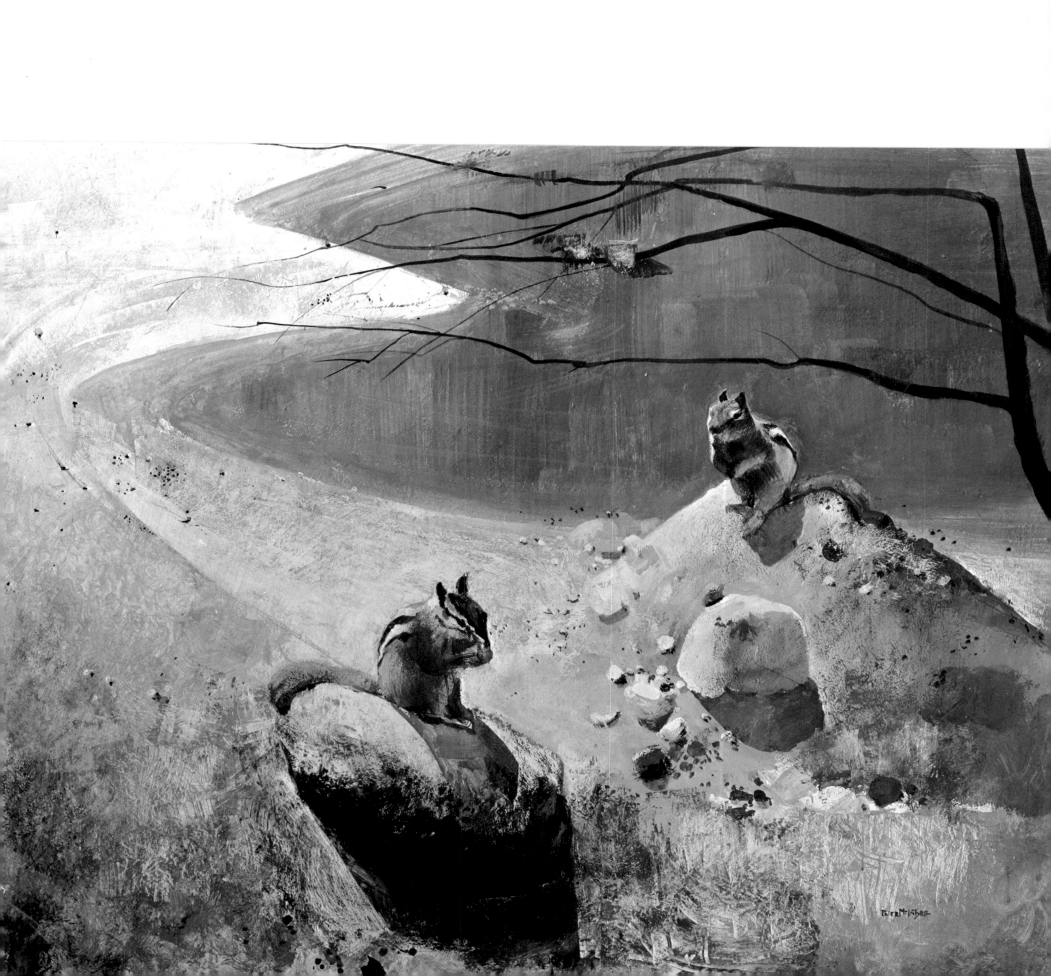

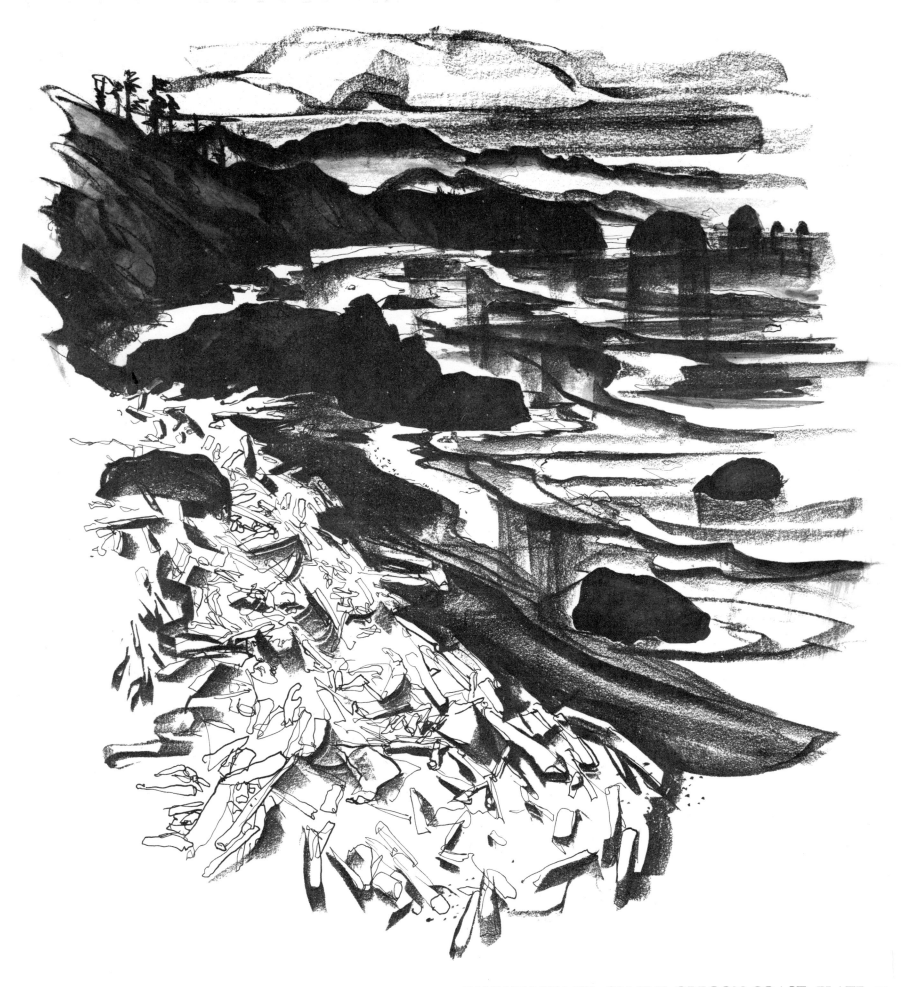

CANNON BEACH, ON THE OREGON COAST **PLATE 48**

There is a wildness to the Oregon coast that is strangely compelling—the tall, sharp
rocks that loom like teeth out of a swirl of sea mist, the logs heaped by the surf in
wild profusion or rearing like strange animals caught in the sand.

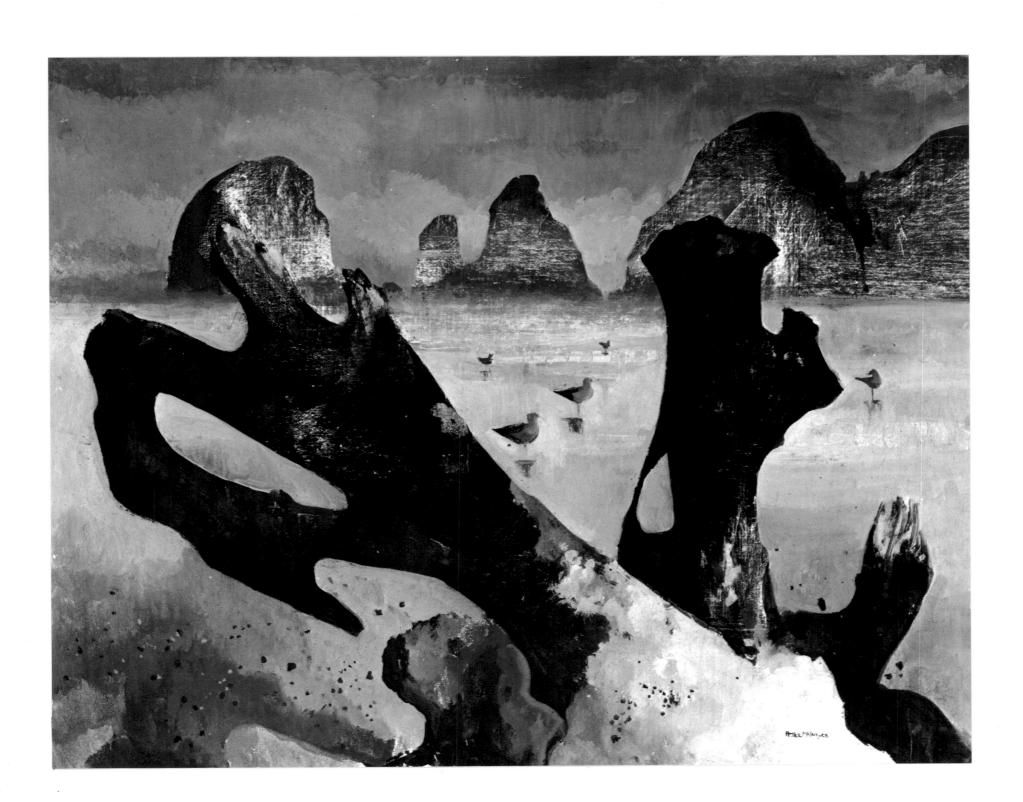

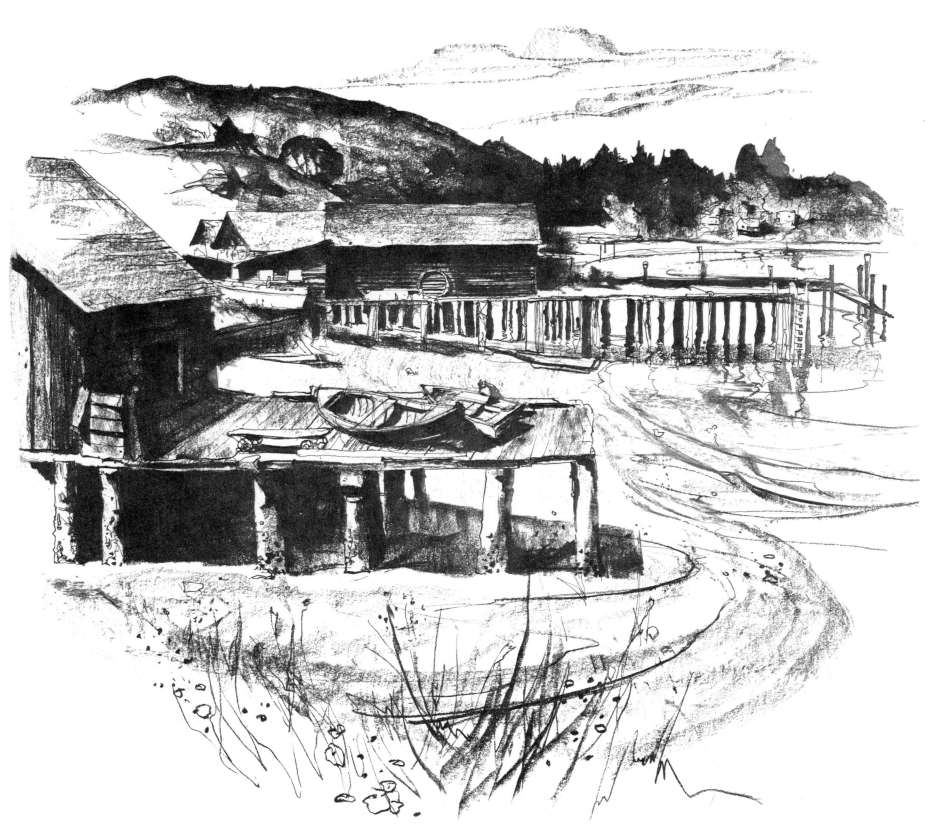

GIG HARBOR, WASHINGTON. Near Tacoma
we spent a happy, lazy day in this old fishing port
so dreamily free from modern bustle.

WASHINGTON RAIN FOREST **PLATE 49**

In the rain forest of the Olympic Peninsula the greens seem to glow with a soft light.
It filters through the translucent leaves to reflect back again from the mosses that
hang in ghostly festoons from the limbs and cover the ground with a rich carpet.

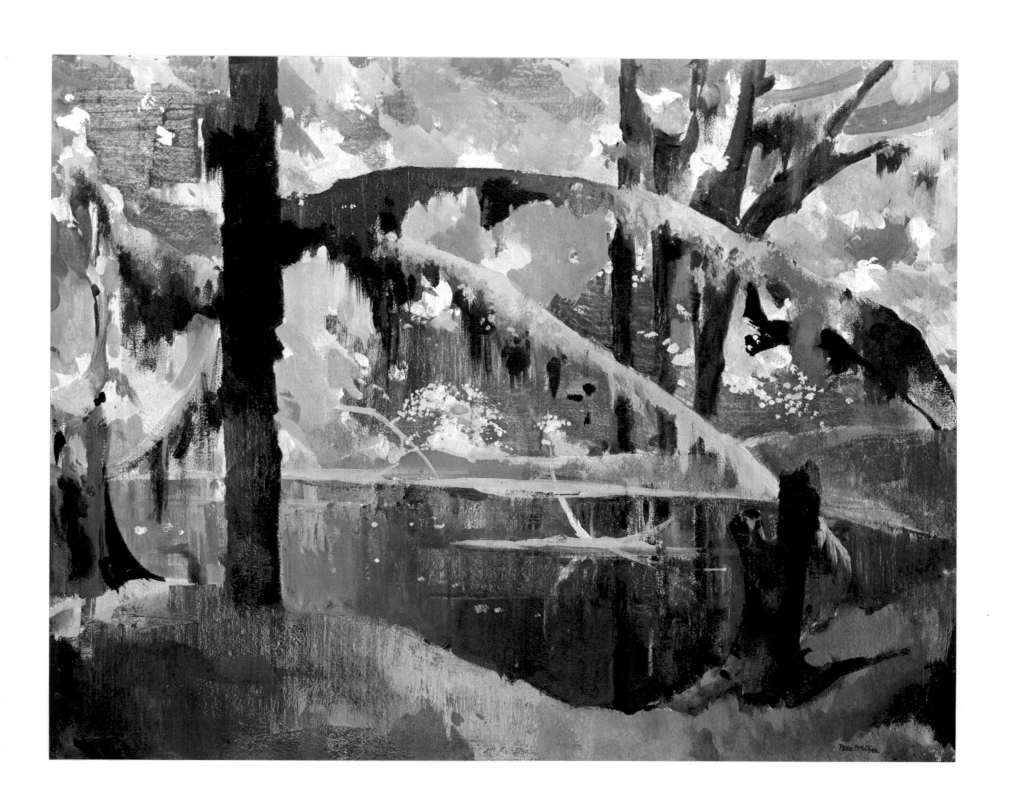

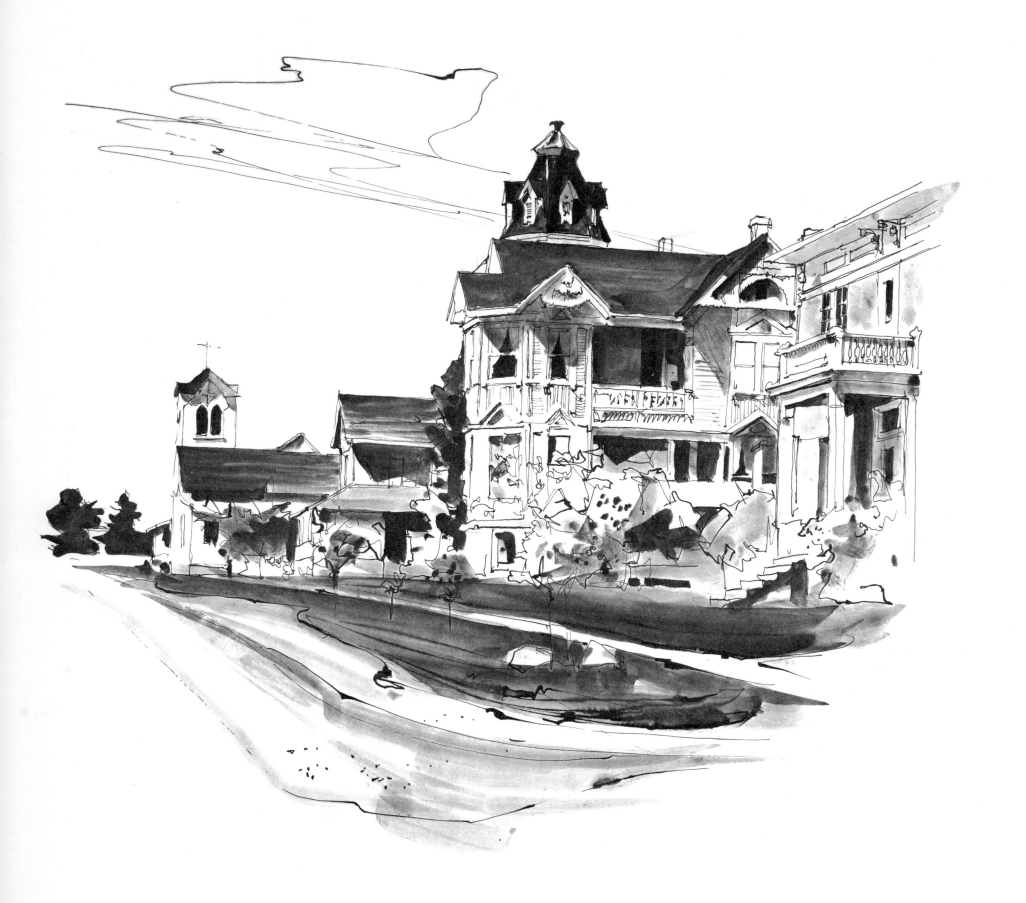

PORT TOWNSEND, WASHINGTON **PLATE 50**

In 1792, the English seafarer George Vancouver sighted this harbour and named it
after the Marquis of Townsend. I loved the quiet, elegant little town, which was once
known as the wickedest city west of San Francisco. It thrived until the 1880s, when
the collapse of the land boom embalmed and preserved it. Its streets are dotted with
stately Victorian houses, and its port is gay with boats that sail from Puget Sound
to the San Juan Islands.

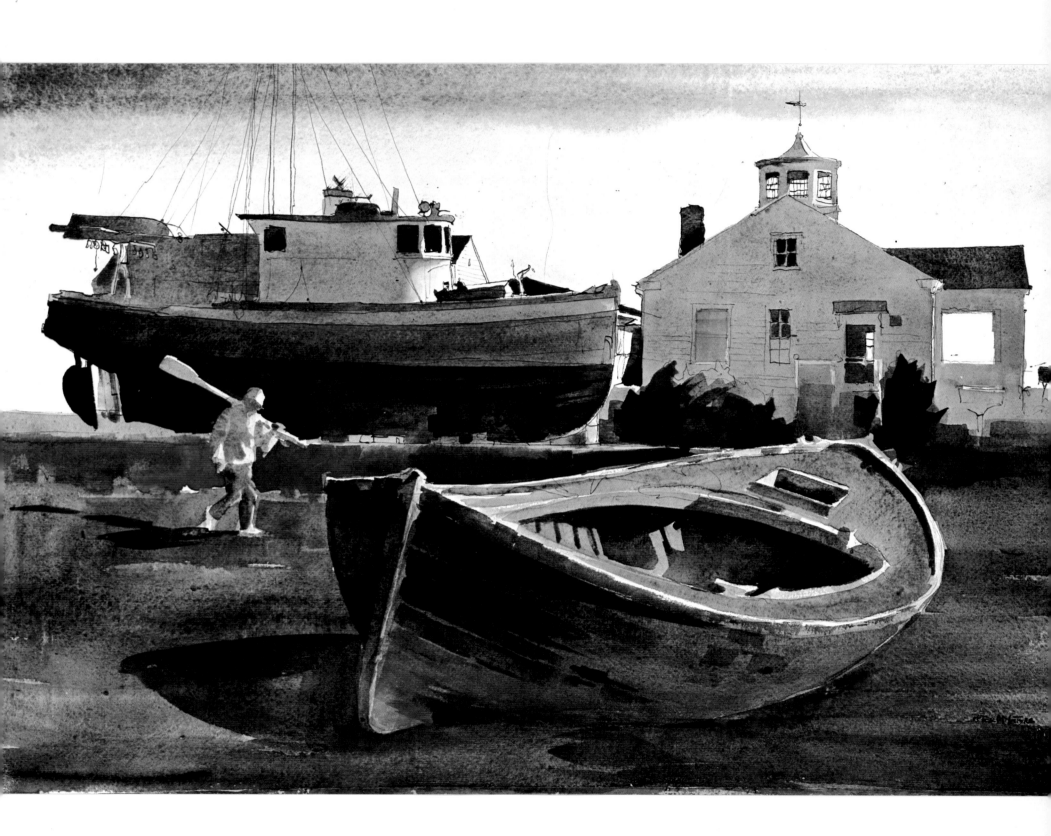

FRIDAY HARBOR

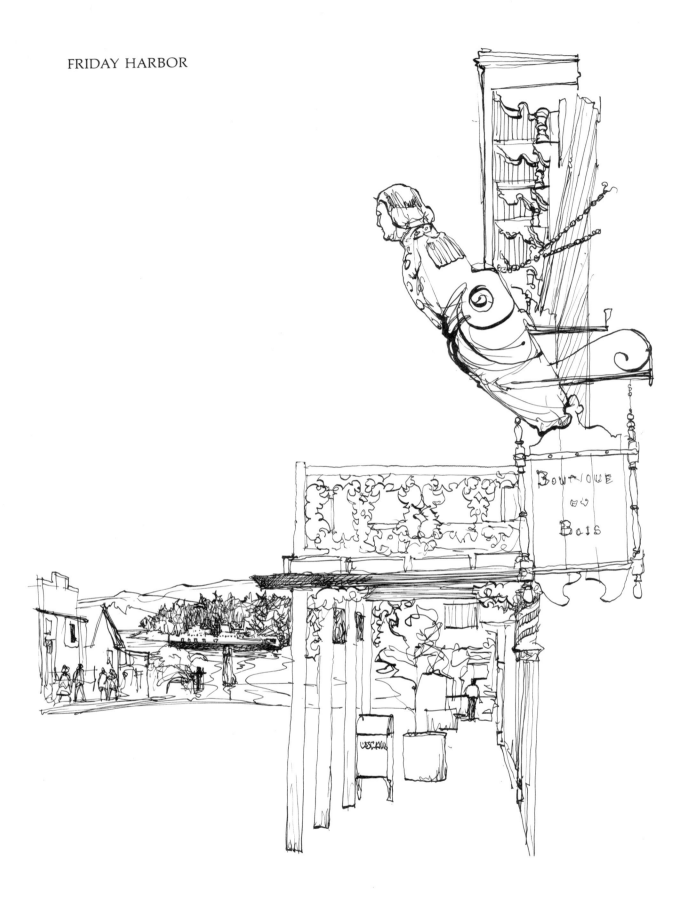

SAN JUAN ISLANDS, WASHINGTON **PLATE 51**

On a lovely morning of sparkling blue water we took the ferry out from Anacortes
through the maze of wooded islands, skirting the shores so close that we could smell
the pines, calling in at sleepy little communities. Life goes slowly here in the San
Juans, as one would want it to in such a heaven of a place.

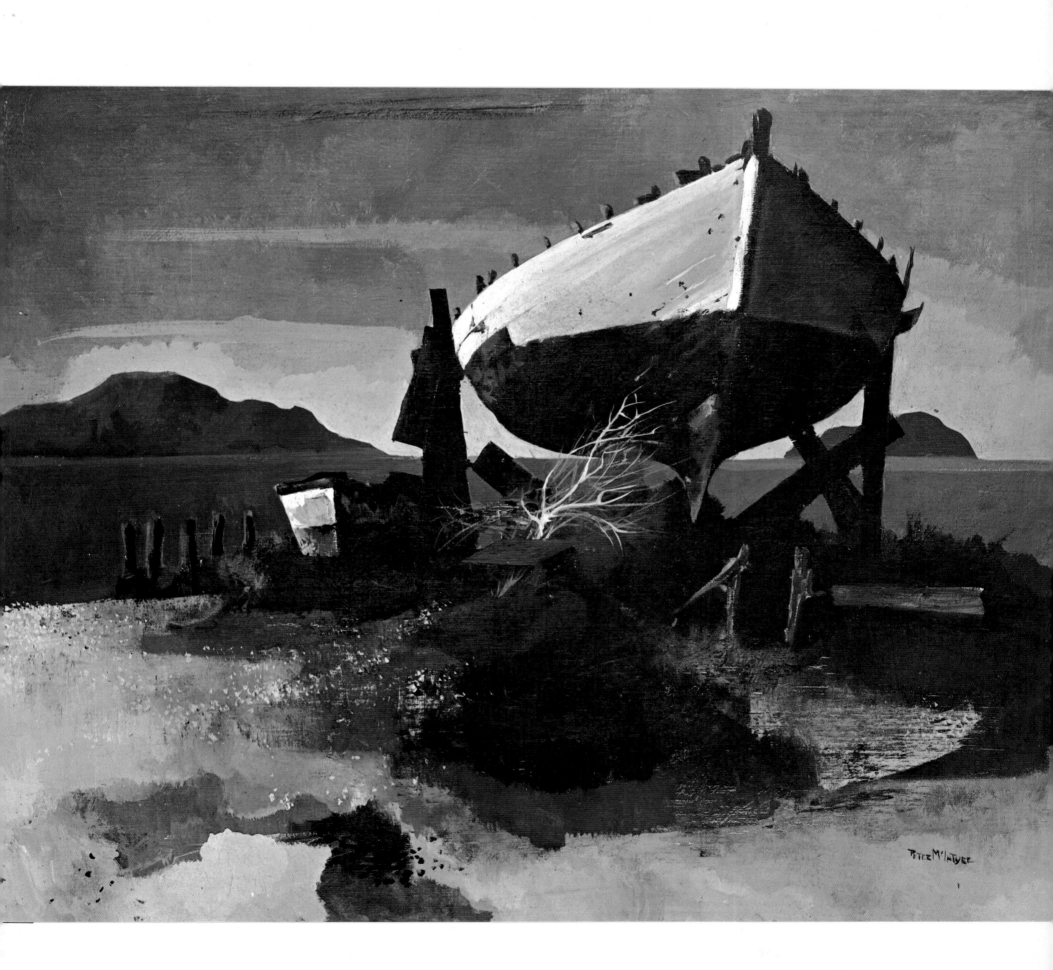

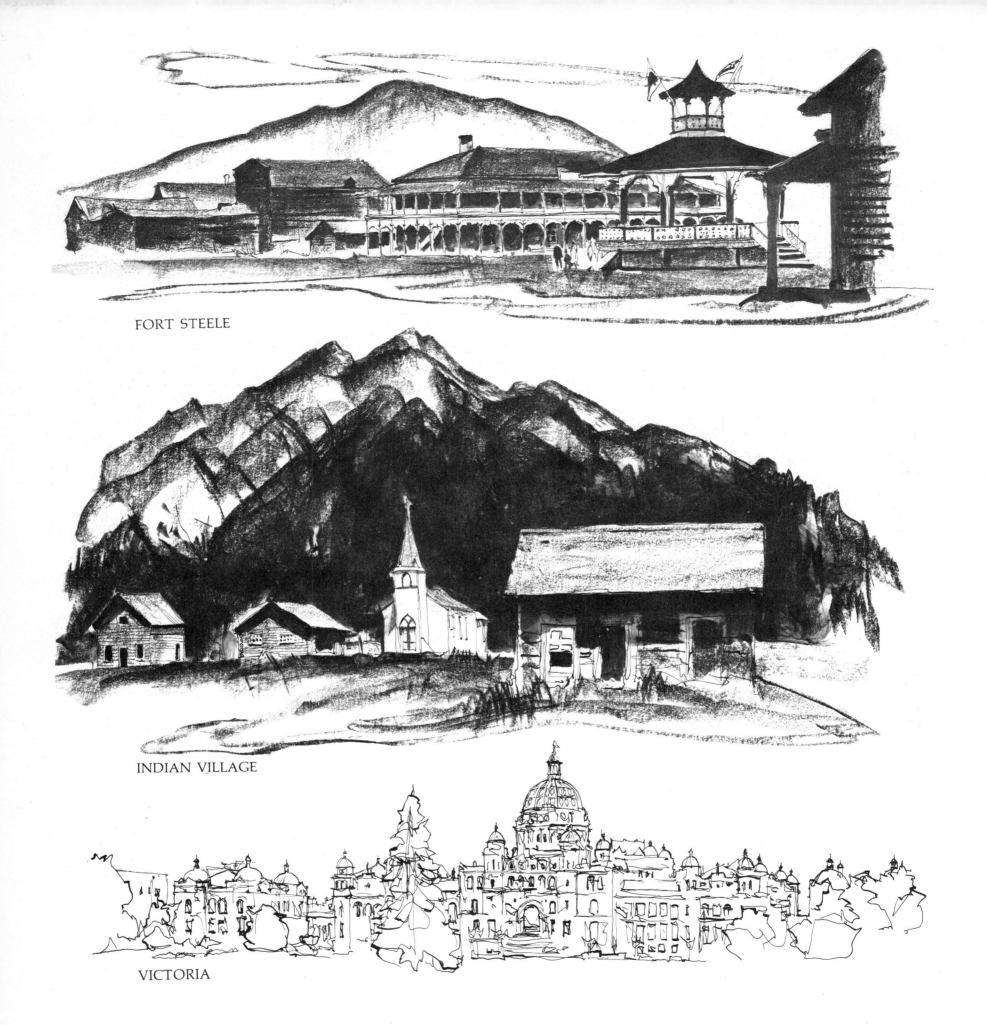

FORT STEELE

INDIAN VILLAGE

VICTORIA

TOTEM POLES—VANCOUVER, BRITISH COLUMBIA **PLATE 52**

The totem poles in Stanley Park stare out of the past at the modern skyline of the
city of Vancouver, spanning the efforts of men that mark a country's history.
The drawings are glimpses of places seen across British Columbia: Fort Steele,
where gold was found in 1864; the frugal lines of an Indian village;
the stately British lines of Victoria on Vancouver Island.

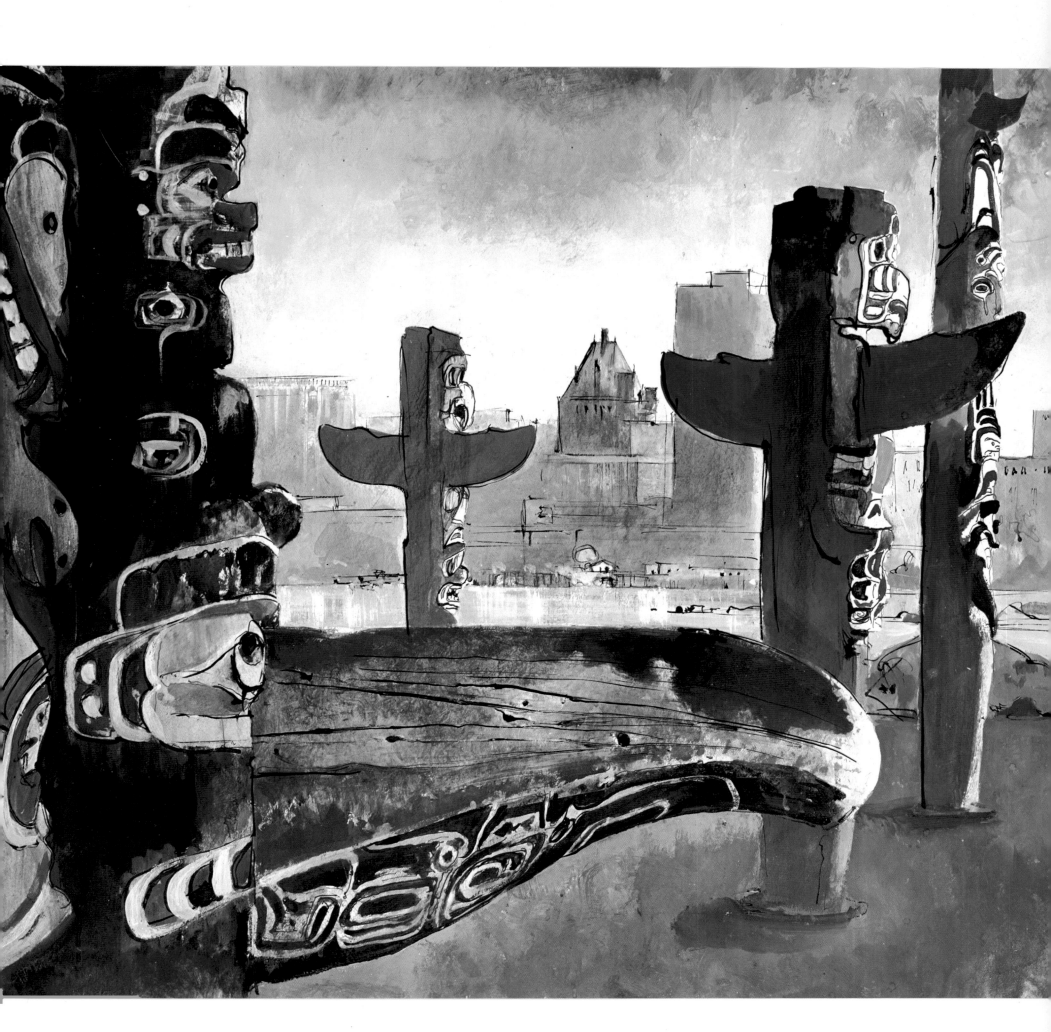

WATERTON LAKES

THE PIPER OF LAKE LOUISE **PLATE 53**

Two of the world's most beautiful lakes are Waterton Lakes, half in Canada, half in
the United States. The hotel where we stayed was so peaceful and pleasant that I
watched a deer come and eat all the geraniums undisturbed. At Lake Louise
in Alberta, my Scottish blood ran high to see a piper in full-dress kilt pipe the flag up
in the morning and down in the evening against a superb Canadian background.

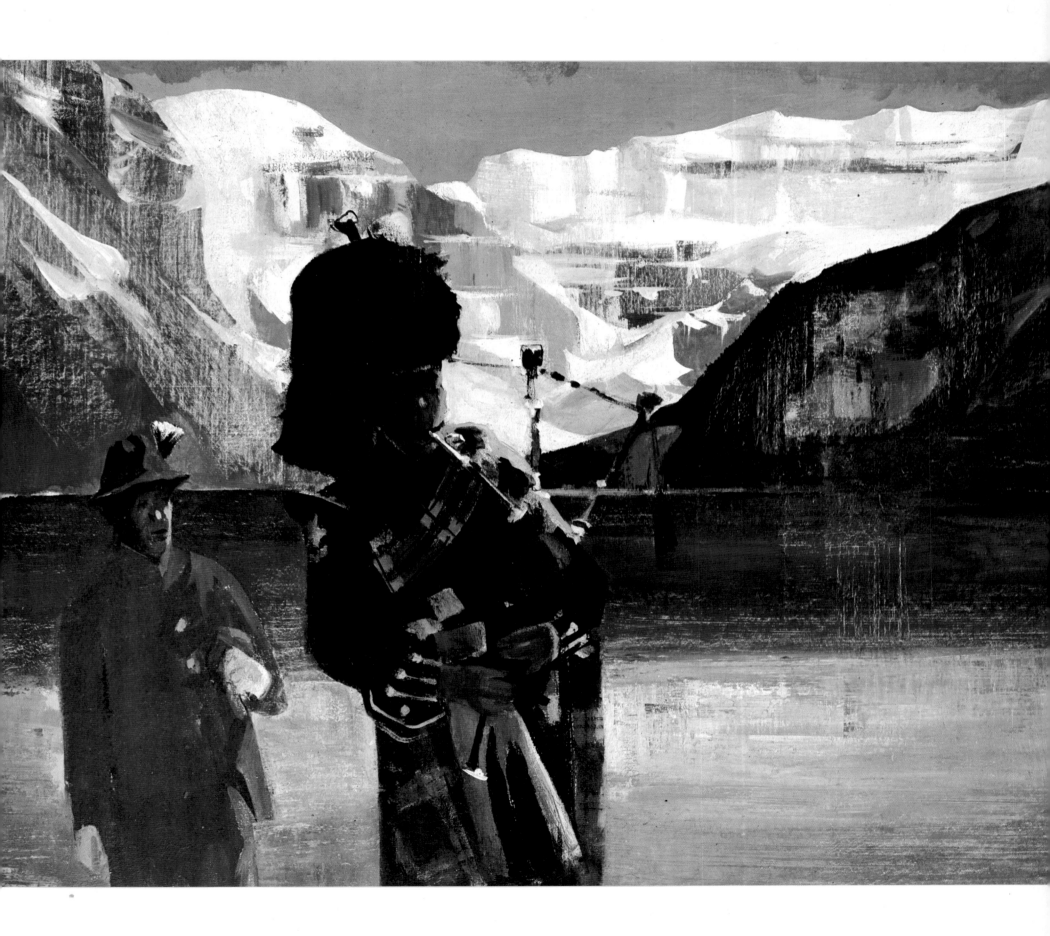

PETERBURG, ALASKA. Along the Alaskan
coast the snow capped mountains send glaciers
down to the water's edge. Man's habitation seems
to cling in clusters on the shore ledges made
small by the gloomy grandeur around them.

TOTEM POLE IN WRANGELL, ALASKA **PLATE 54**

Totem poles were the means of telling a story or a legend, sometimes to ridicule
another tribe, sometimes to honour an event. This one of the Tlingit Indians stands
in Wrangell on tiny Shakes Island, which was the site of a
Russian trading post back in 1811.

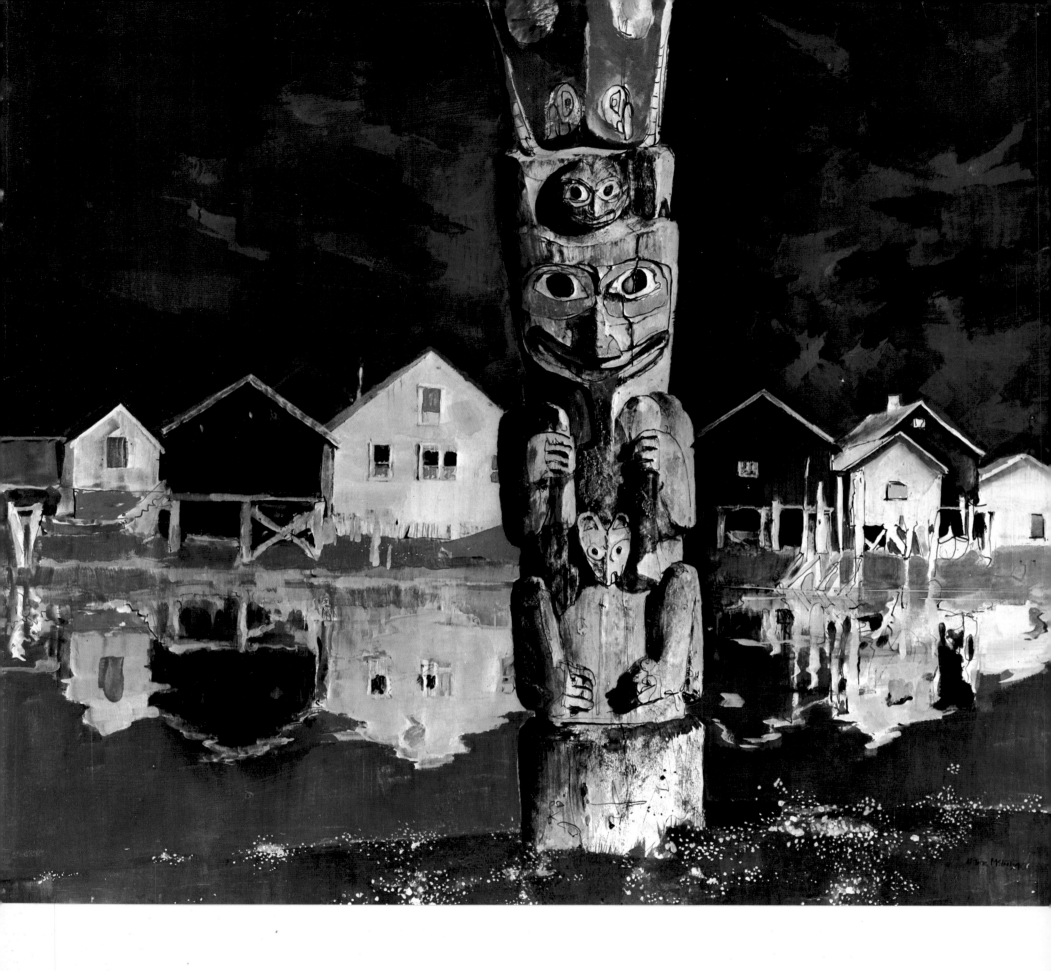

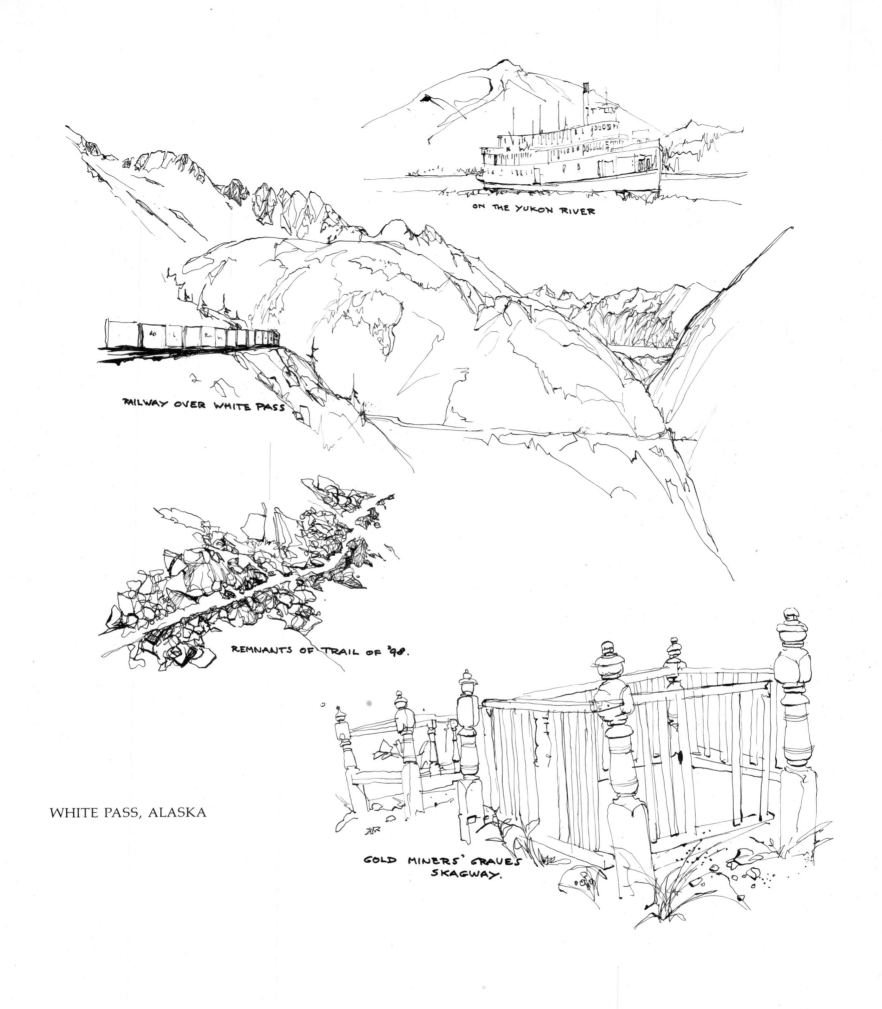

ON THE YUKON RIVER

RAILWAY OVER WHITE PASS

REMNANTS OF TRAIL OF '98.

WHITE PASS, ALASKA

GOLD MINERS' GRAVES
SKAGWAY.

A MAIN STREET IN SKAGWAY **PLATE 55**

In the Yukon Gold Rush of 1898, Skagway was the gateway to the Yukon, and
thousands of men struggled up over White Pass to reach the Yukon River.
You can still see the remains of the trail through Dead Horse Gulch, where
countless numbers of horses died. Skagway looks much as it did when it had a
population of 20,000 and was described as "little better than a hell on earth."

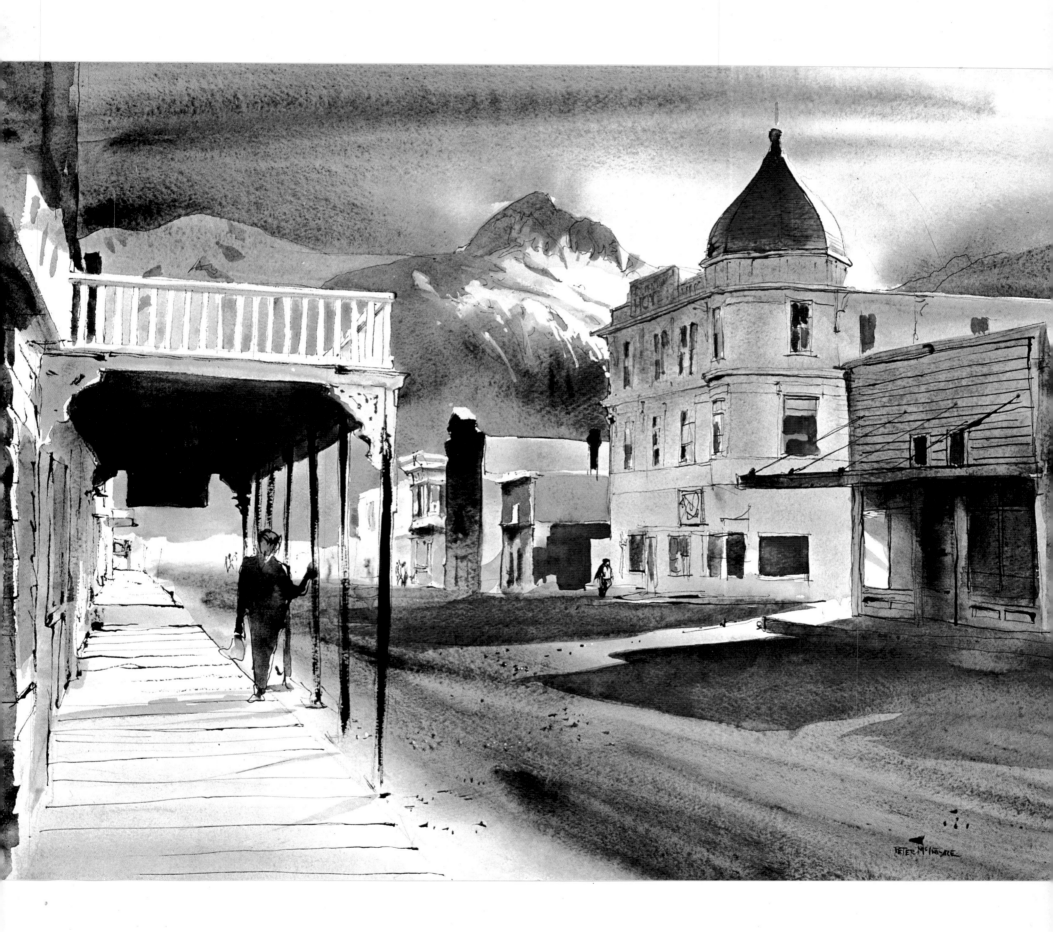

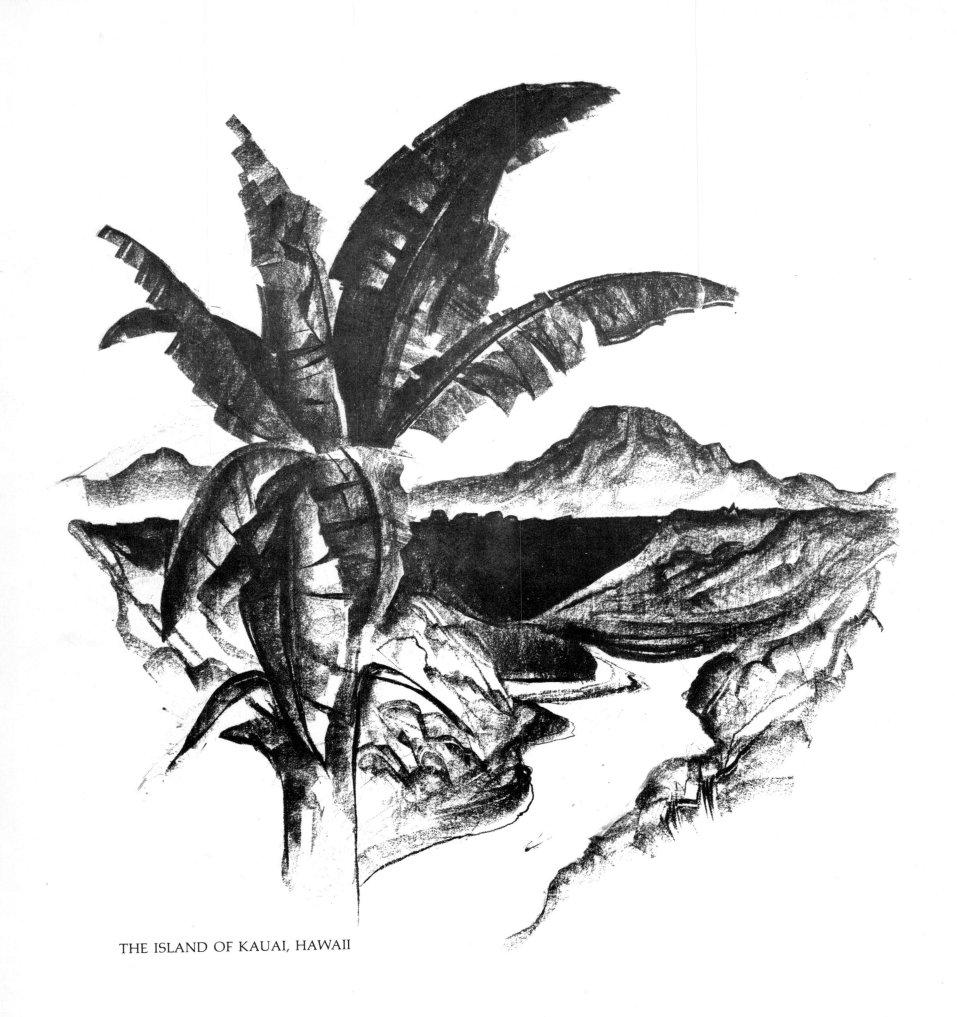

THE ISLAND OF KAUAI, HAWAII

NA PALI CLIFFS **PLATE 56**

Along the Pali coast of Kauai, the cliffs rise from the sea to a breathtaking 3,000 feet. To some minds Hawaii seems to have little place in the American West, but it has won that place in spirit if not in geography. It was for us our last glimpse of America on our way back to our own country, New Zealand.

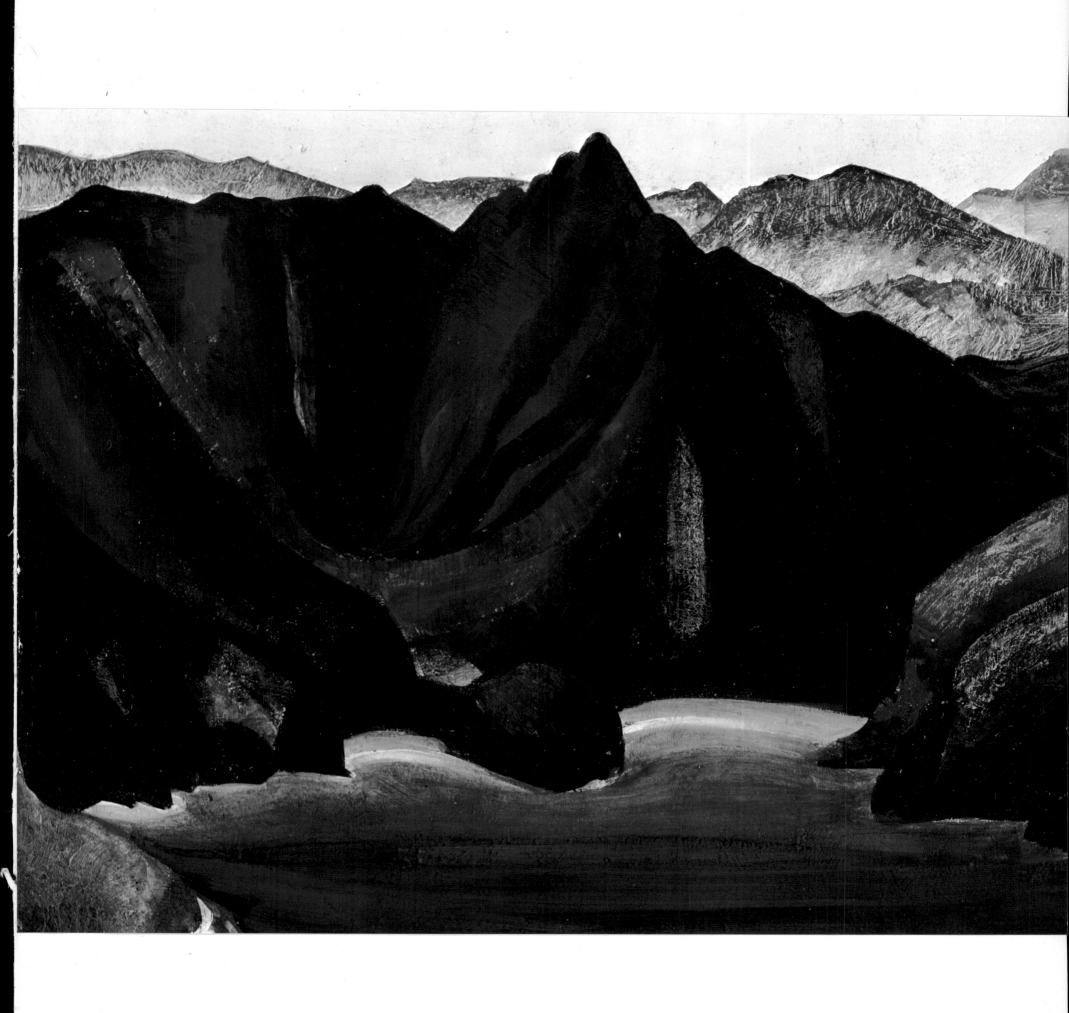

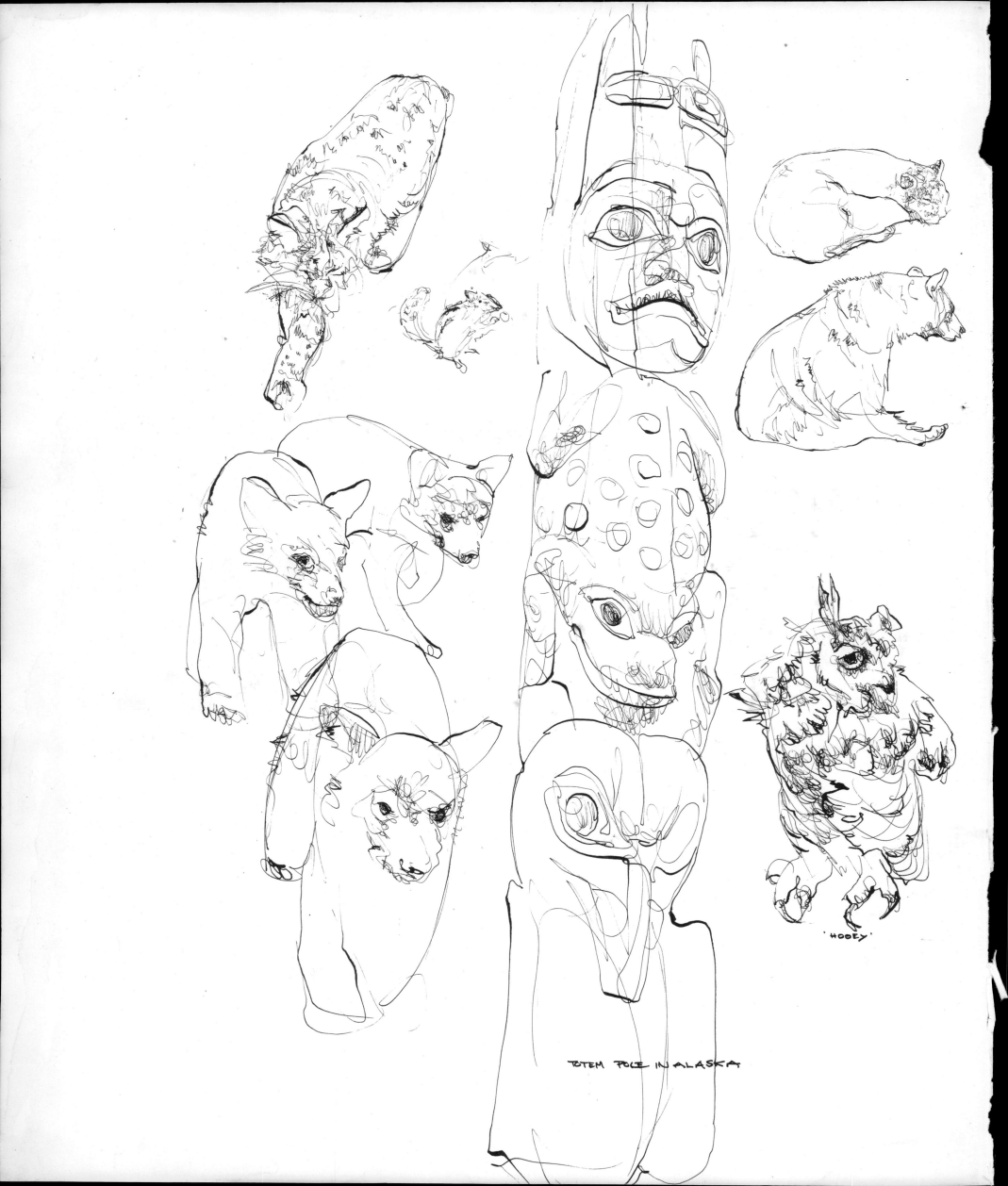

'HOOEY'

TOTEM POLE IN ALASKA